# The Fundamentals of
# FIGURE
# DRAWING

D1350263

# The Fundamentals of
# FIGURE
# DRAWING

## BARRINGTON BARBER

ARCTURUS

Arcturus Publishing Limited
26/27 Bickels Yard
151–153 Bermondsey Street
London SE1 3HA

Published in association with
foulsham
W. Foulsham & Co. Ltd,
The Publishing House, Bennetts Close, Cippenham,
Slough, Berkshire SL1 5AP, England

ISBN 0-572-03140-8

This edition printed in 2005

British Library Cataloguing-in-Publication Data: a catalogue record for this
book is available from the British Library

Printed in China

# Contents

*Introduction*                                6

First Steps to Figure Drawing                 8

Drawing the Whole Figure                      50

Drawing Clothed Figures                       76

Drawing from Life                             94

Composition                                   108

Figures in Action                             128

Figures in Detail                             148

Styles of Figure Drawing                      176

Step-by-Step to a Final Composition           188

*Index*                                       208

# Introduction

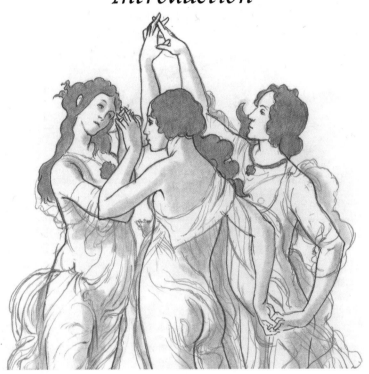

From the mid-1500s onwards, composition was considered to be the most prestigious area of art, which made it of primary interest to the greatest artists of the time. Of course they were skilled in all areas of drawing and painting, but when the great art workshops (bottegas) of the Renaissance period were in full swing it was the master painter who would often be the only artisan to put in the figures, leaving the rest of the composition to be completed by his pupils. So be prepared for the most interesting and most difficult stage in your drawing

career – but don't feel too daunted. I have found in many years of teaching that anyone can learn to draw anything competently, with the combination of a certain amount of hard work and the desire to achieve success.

The aim of this book is to explore all the practices necessary to achieve a good level of drawing of the human figure. I shall first look at how the human body is formed, from its skeleton – the scaffolding that all figures are based on – down to the details of the limbs, the torso, the hands and feet and the head. It is always useful to have some idea as to the body formation beneath the skin, and some knowledge of how the muscles wrap around the bone structure and each other is of great use when you look at the shapes on the surface of the body. Without any knowledge of the underlying structure it is much harder to make sense of the bumps and furrows that are visible.

I shall also look at the balance of the limbs when the body is in motion, and how the artist can produce the effect of movements that appear natural and convincing to the viewer of the picture.

The techniques of drawing will also be examined, and the different ways in which different artists have made efforts to show us how the human figure can be portrayed, from the most detailed to the most expressive. The book also includes a look at the ways that clothing helps to convince the viewer that there is a solid form under the surface material. Of course this book does not pretend to be exhaustive, as figure drawing has been developed and explored over centuries as artists sought new ways of portraying the human form. Nevertheless, enjoy this foray into the challenging but fulfilling task of portraying the human figure, and revel in the development in your own ability as artist.

# First Steps to Figure Drawing

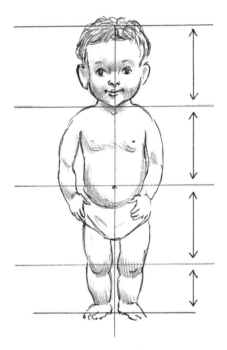

*T*he first section of this book explores the basic physiology of the human body, looking at the proportions, the structure and the obvious variations between male and female, child and adult. To draw the human figure successfully it is essential to have some acquaintance with what lies beneath the skin, for if you lack that your drawing will at best have a superficial slickness and at worse will not be at all convincing.

The bone structure is the basic scaffolding of the body, more visible in some places than others but everywhere

dictating size and proportions. To a greater or lesser degree, the skeleton is enveloped in muscles, again with varying visibility. Consider the way the wrist bone is so obvious to the eye, while the thigh bone is hidden by muscle that, in someone athletic, forms distinct bulges that disrupt the smooth line of the thigh; such observations should become second nature to you as you study the model you are drawing.

All artists, certainly since the Renaissance era, have studied the structure of the human body with great interest and this has enabled them to produce drawings of distinction and conviction from which we can also learn. There is nothing like studying the underlying structure of the form to understand how best to portray it in your art and the more you practise drawing the forms of the body the more you will find yourself looking to see how the particular surface shape and appearance comes about. Your knowledge of this information will be translated into your drawings and will help to carry conviction that you have seen not just the surface of the body but also have some understanding of the way it works.

This is perhaps the most academic part of the book, but don't be tempted to skip the diagrams to get on quickly to drawing the whole figure. Putting in the groundwork at this stage will make your figures look more solid and more real, and will make viewers see exactly the human quality you wish to portray. You probably will not remember all the scientific names any more than I do, but the effort to learn something about them is never wasted and, in my experience, often comes back to help you when you least expect it. When you come to draw the figure from life you may also wish to refer back to these diagrams to clarify in your own mind what you have actually seen and drawn.

## PROPORTIONS OF THE HUMAN FIGURE

Here I have a front view and a back view of the male and female body. The two sexes are drawn to the same scale because I wanted to show how their proportions are very similar in relation to the head measurement.

Generally, the female body is slightly smaller and finer in structure than that of a male, but of course sizes differ so much that you will have to use your powers of observation when drawing any individual.

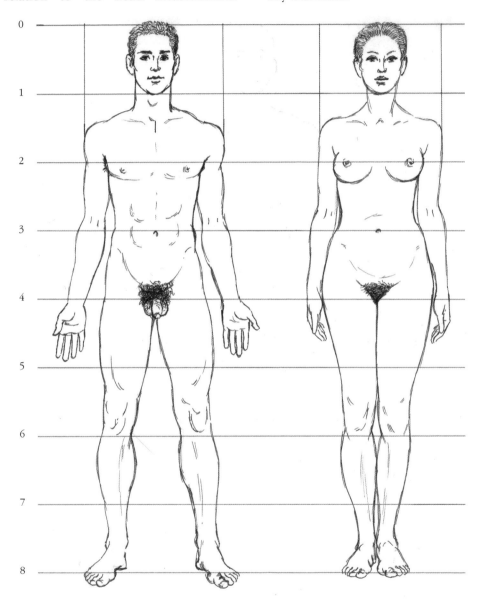

*These drawings assume the male and female are both exactly the same height, with both sexes having a height of eight times the length of their head. As you can see, this means that the centre of the total height comes at the base of the pubis, so that the torso and head are the upper half of this measure, and the legs alone account for the lower half. Note where the other units of head length are placed: the second unit is at the armpits, the third is at the navel, the fifth mid-thigh, the sixth below the knee joint and the seventh just below the calf. This is a very useful scale to help you get started.*

*These two examples are of the back view of the two people opposite, with healthy, athletic builds. The man's shoulders are wider than the woman's and the woman's hips are wider than the man's. This* is, however, a classic proportion, and in real life people are often less perfectly formed. None the less, this is a good basic guide to the shape and proportion of the human body.

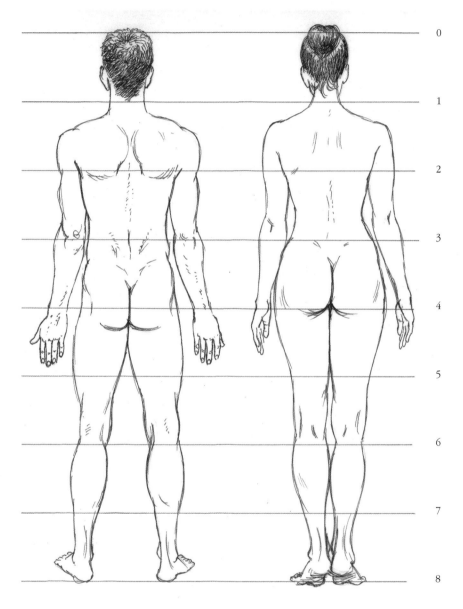

0

1

2

3

4

5

6

7

8

*The man's neck is thicker in relation to his head while the female neck is more slender. Notice also that the female waist is narrower than the man's and the general effect of the female figure is smoother and softer than the man's more hard-* looking frame. This is partly due to the extra layer of subcutaneous fat that exists in the female body: mostly the differences are all connected with childbirth and child rearing; women's hips are broader then men's for this reason too.

PROPORTIONS OF CHILDREN

The proportions of children's bodies change very rapidly and because children grow at very different speeds what is true of one child at a certain age may not always be so true of another. Consequently, the drawings here can only give a fairly average guide to children's changes in proportion as they get older. The first thing of course is that the child's head is much smaller than an adult's and only achieves adult size at around 16 years old.

The thickness of children's limbs varies enormously but often the most obvious difference between a child, an adolescent and an adult is that the limbs and body become more slender as part of the growing process. In some types of figure there is a tendency towards puppy fat which makes a youngster look softer and rounder. The differences between shoulder, hip and wrist width that you see between male and female adults are not so obvious in a young child, and boys and girls often look similar until they reach puberty.

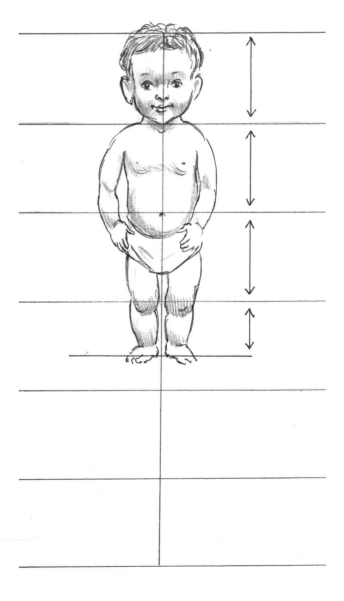

*At the beginning of life the head is much larger in proportion to the rest of the body than it will be later on. Here I have drawn a child of about 18 months old, giving the sort of proportion you might find in a child of average growth. The height is only three and a half times the length of the head, which means that the proportions of the arms and legs are much smaller in comparison to those of an adult.*

At the age of about six or seven, a child's height is a little over five times the length of the head, though again this is a bit variable. At about 12 years, the proportion is about six times the head size. Notice how in the younger children the halfway point in the height of the body is much closer to the navel, but this gradually lowers until it reaches the adult proportion at the pubic edge of the pelvis where the legs divide. What also happens is that the relative width of the body and limbs in relation to the height gradually becomes slimmer so that a very small child looks very chubby and round, whereas a 12-year-old can look extremely slim for their height.

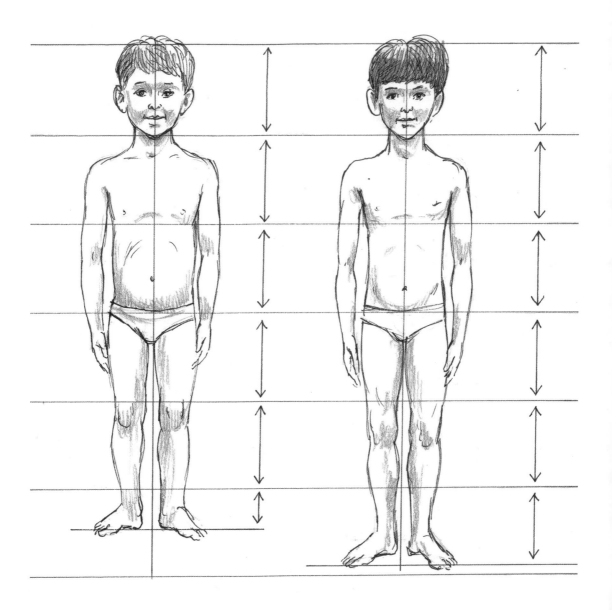

## INDIVIDUAL PROPORTIONS

The greatest difference between adult bodies tends to be in the amount of flesh spread over the skeletal frame. While the proportion of head to height may be the same, the relative width of the body can be vastly different. This may be a result of lifestyle choices such as diet and exercise or of the individual's metabolism.

A broad appearance may be caused by muscle rather than fat, but the distribution and appearance of the bulk will be very different.

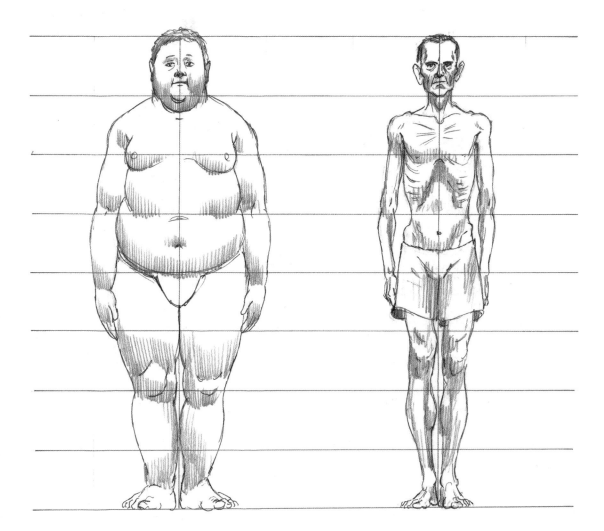

*Most extra fat gathers around the central area of the body, and the first area to increase in width is usually the waist. The upper parts of the legs and arms are often thicker and there tends to be extra bulk.around the neck and chest.*

*At the other extreme, when someone is below normal weight, the human frame is reduced to a very meagre stringy-looking shape. The width of the torso and limbs is dictated only by the bone structure.*

A man who spends time working out at the gym may have thick legs and arms and wide shoulders and chest, but will not have the large waist of a couch potato. Be aware that sportsmen may have muscular development particular to their chosen field, such as the exaggerated shoulder muscles of a boxer. Although an individual's form may be extreme in one way or another, this book mainly deals with average shapes.

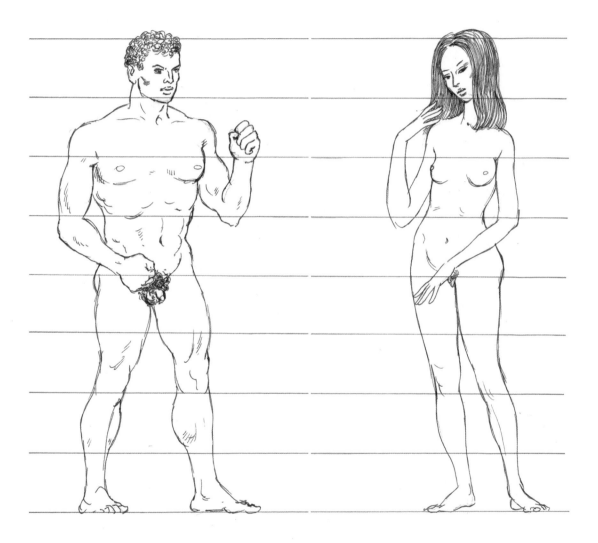

*This athletic man has very well developed muscles that enable him to be strong and powerful for his sport. Notice the large chest in relation to the narrow waist and the muscular upper arms and legs.*

*This female figure looks more like a gymnast or dancer, having a slender willowy look that is slim, lightweight and suggests extreme suppleness with strength.*

## THE SKELETON

Learning the names of the bones that make up the human skeleton and how they connect to each other throughout the body may seem rather a dry exercise, but they constitute the basic scaffolding that the body is built on and to have some familiarity with this element of the human frame will really help you to understand the figures you draw.

Just making the attempt to copy a skeleton, especially if you get a really close-up view of it,

FRONT VIEW (ANTERIOR)

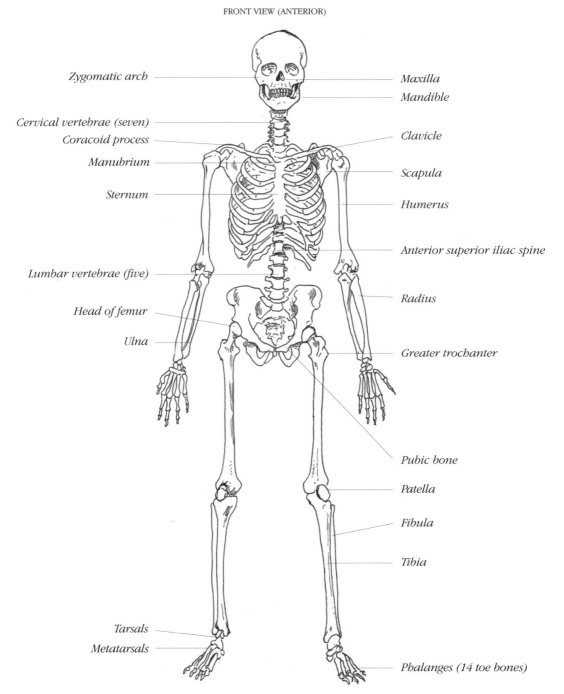

Zygomatic arch

Cervical vertebrae (seven)
Coracoid process
Manubrium

Sternum

Lumbar vertebrae (five)

Head of femur

Ulna

Tarsals
Metatarsals

Maxilla
Mandible

Clavicle

Scapula

Humerus

Anterior superior iliac spine

Radius

Greater trochanter

Pubic bone

Patella

Fibula

Tibia

Phalanges (14 toe bones)

will teach you a lot about the way the body works. It is essential that you can recognize those places where the bone structure is visible beneath the skin and by inference get some idea about the angle and form of the bones even where you can't see them. Most school science laboratories have carefully made plastic skeletons to draw from, or if you know an artist or art school where there is a real one, that is even better. It will be time well spent.

BACK VIEW (POSTERIOR)

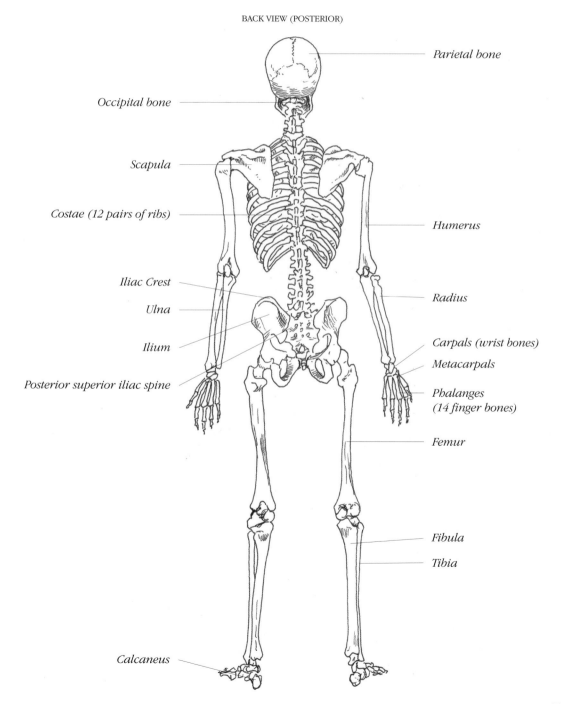

Parietal bone

Occipital bone

Scapula

Costae (12 pairs of ribs)

Humerus

Iliac Crest

Ulna

Radius

Ilium

Carpals (wrist bones)

Metacarpals

Posterior superior iliac spine

Phalanges
(14 finger bones)

Femur

Fibula

Tibia

Calcaneus

MUSCULATURE

After studying the skeleton, the next logical step is to examine the muscular system. This is more complicated, but there are many good books showing the arrangement of all the muscles and how they lie across each other and bind around the bone structure, giving us a much clearer idea of how the human body gets its shape.

As artists, our primary interest is in the structure of the muscles on the surface. There

FRONT VIEW (ANTERIOR)

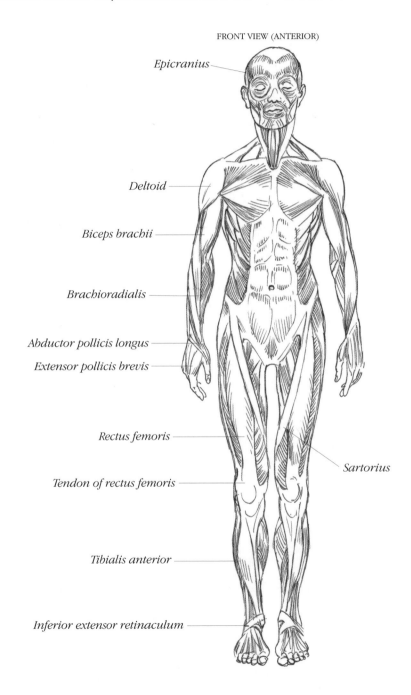

Epicranius

Deltoid

Biceps brachii

Brachioradialis

Abductor pollicis longus

Extensor pollicis brevis

Rectus femoris

Sartorius

Tendon of rectus femoris

Tibialis anterior

Inferior extensor retinaculum

are two types of muscles that establish the main shape of the body and they are either striated, or more like smooth cladding. The large muscles are the most necessary ones for you to know and once you have familiarized yourself with these it is only really necessary to investigate the deeper muscle structures for your own interest. If you can remember the most obvious muscles, that is good enough for the purposes of drawing figures.

SIDE VIEW (LATERAL)  BACK VIEW (POSTERIOR)

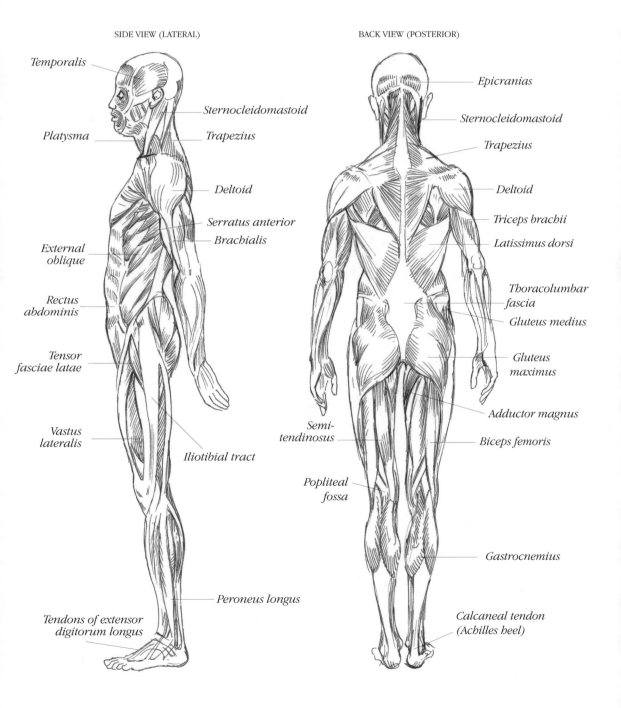

*Temporalis*

*Sternocleidomastoid*

*Platysma*

*Trapezius*

*Deltoid*

*Serratus anterior*

*Brachialis*

*External oblique*

*Rectus abdominis*

*Tensor fasciae latae*

*Vastus lateralis*

*Iliotibial tract*

*Peroneus longus*

*Tendons of extensor digitorum longus*

*Epicranias*

*Sternocleidomastoid*

*Trapezius*

*Deltoid*

*Triceps brachii*

*Latissimus dorsi*

*Thoracolumbar fascia*

*Gluteus medius*

*Gluteus maximus*

*Adductor magnus*

*Semi-tendinosus*

*Biceps femoris*

*Popliteal fossa*

*Gastrocnemius*

*Calcaneal tendon (Achilles heel)*

## THE HEAD

The first and most obvious detail of the human figure is the head, with its major role in defining the figure's appearance. Shown here are the basic proportions of the head both from the front and in profile. There are obvious differences between people's faces, especially between those of males and females, but at this stage we will just look at a youthful adult head and not concern ourselves with the particular features. It is surprising that the differences between features that we so easily recognize are not all that much in terms of measurement,

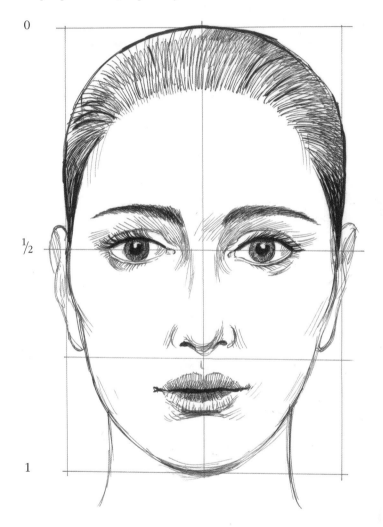

*From the front, the width of the head is about three-quarters the length. The eyes are about halfway down the head, the distance from the top of the head to the centre of the eyes being the same as from the centre of the eyes to the point of the chin.*

*The mouth is almost one-fifth of the length of the head from the base of the chin. This means it is nearer to the nose than to the point of the chin. This measure is to the line where the lips part.*

*The nose is almost halfway between the eyes and the chin, the lowest part of the nose being slightly nearer the eyes than the point of the chin.*

*The distance between the eyes is usually about the same as the width of one of the eyes from corner to corner.*

*If you look at the hairline from the front of the head it is not more than about one-fifth of the whole length of the head down the forehead.*

once proportions are taken into account.

When you are drawing the human figure it is important to treat the head as part of the whole shape and not be too caught up by the facial features. The main shape of the skull is the most important relationship when related to the whole figure. These are all typical beginners' mistakes, so watch out for them. Some things to look out for: don't make the eyes too big. Don't make the features too large for the whole head. From the side don't project the jaw too far forward.

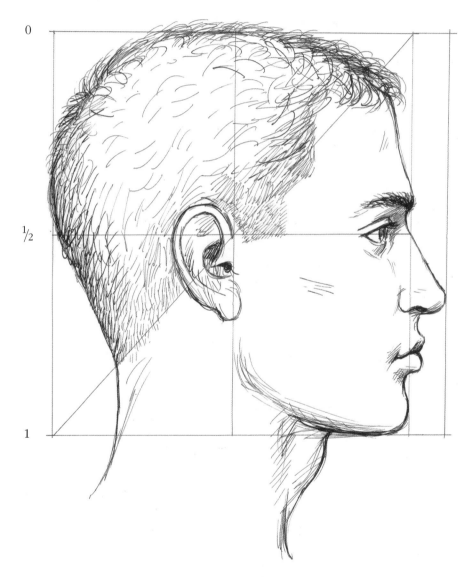

*The proportions from the side view are that the depth of the head from the front of the forehead to the back of the head comes out at about the same measurement as the width of the head. However, the nose projects beyond this point.*

*From the side, the hairline (as long as the subject has got all his hair) takes up about half the area of the head in a diagonal line across the whole shape of the head. The ear projects into this, and around the higher part of the forehead the hair may not cover the line. Just in front of the ear the hair will project across this line a little.*

BONES AND MUSCLES OF THE HEAD
As with the rest of the human frame, the appearance of the head is dictated by the underlying bone structure and the muscles that cover it. Because the bones are close to the surface, it is easier to discern their form than in most other parts of the body – particularly if the subject is thin, when you may even be able to see the bumpy surface of the bone at the temple.

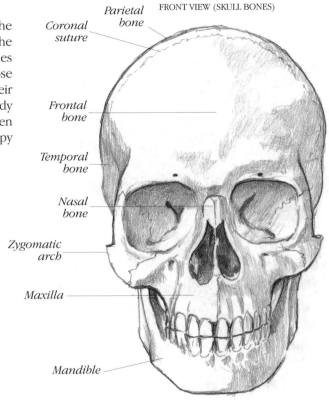

FRONT VIEW (SKULL BONES)

Parietal bone

Coronal suture

Frontal bone

Temporal bone

Nasal bone

Zygomatic arch

Maxilla

Mandible

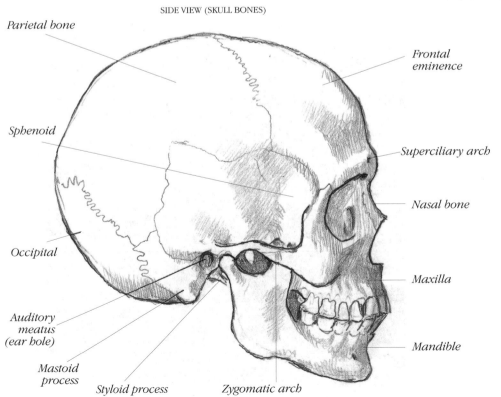

SIDE VIEW (SKULL BONES)

Parietal bone

Frontal eminence

Sphenoid

Superciliary arch

Nasal bone

Occipital

Maxilla

Auditory meatus (ear hole)

Mandible

Mastoid process

Styloid process

Zygomatic arch

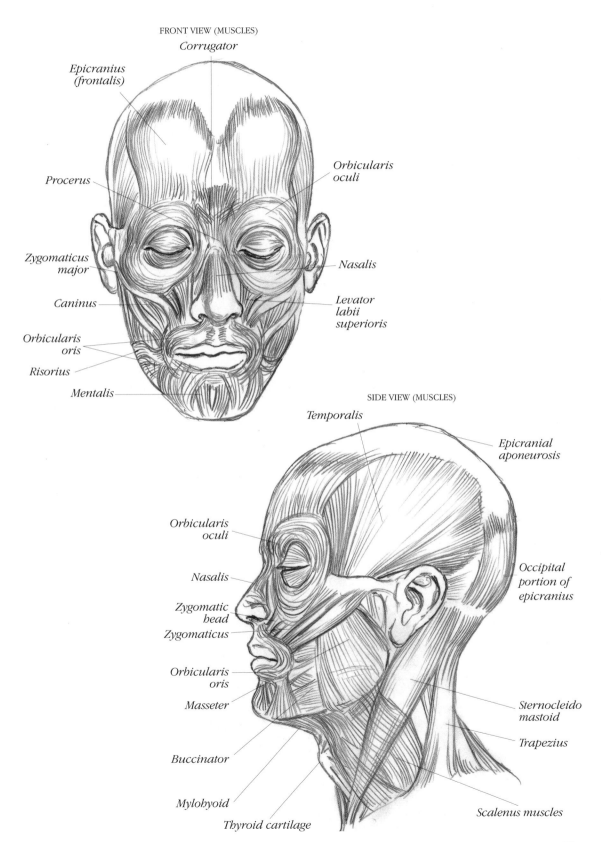

FRONT VIEW (MUSCLES)

*Corrugator*

*Epicranius
(frontalis)*

*Orbicularis
oculi*

*Procerus*

*Zygomaticus
major*

*Nasalis*

*Caninus*

*Levator
labii
superioris*

*Orbicularis
oris*

*Risorius*

*Mentalis*

SIDE VIEW (MUSCLES)

*Temporalis*

*Epicranial
aponeurosis*

*Orbicularis
oculi*

*Occipital
portion of
epicranius*

*Nasalis*

*Zygomatic
head*

*Zygomaticus*

*Orbicularis
oris*

*Sternocleido
mastoid*

*Masseter*

*Trapezius*

*Buccinator*

*Mylohyoid*

*Scalenus muscles*

*Thyroid cartilage*

THE HEAD FROM DIFFERENT ANGLES

Here I have drawn the head seen from a variety of different angles. In the main there are no particular details of the face – just the basic structure of the head when seen from above, below and the side. Notice how the line of eyes and mouth curve around the shape of the head, because if you omit to show this the features will not fit in with the curve of the head when viewed from an angle. When seen from a low angle, the curve of the eyebrows becomes important, as does that of the cheekbones so study these carefully.

Sometimes the nose appears to be just a small point sticking out from the shape of the head, especially when seen from below. The underside of the chin also has a very characteristic shape, which is worth noting if you want your drawing to be convincing. Conversely, when seen from above, the chin and mouth almost disappear but the nose becomes very dominant. From above, the hair becomes very much the main part of the head, whereas when seen from below the hair may be visible only at the sides.

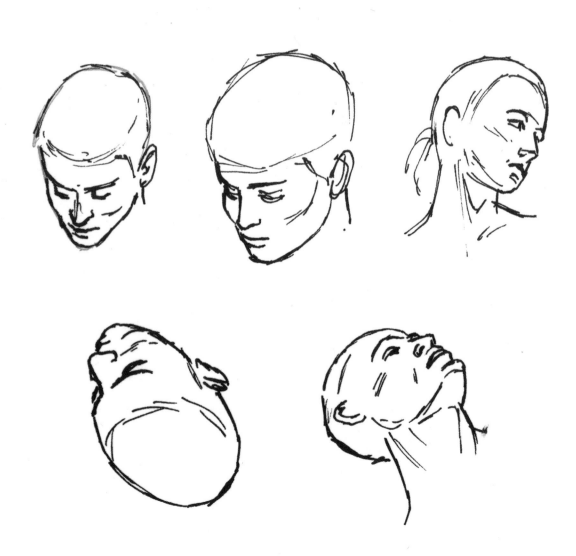

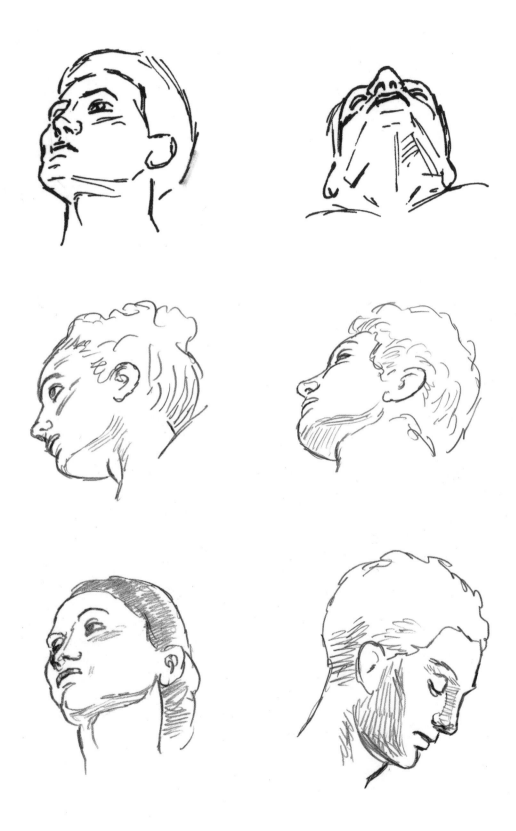

## THE MUSCLES OF THE TORSO

When you draw the torso of the human being it is very important to have some idea of what the muscle structure is like underneath. The drawings here show the major muscle groups, the visibility of which will depend upon the fitness of the figure you are drawing.

The fashion for working out in the gym to achieve a toned body means that you should not find it too hard to find someone with a well-developed torso to pose for you so that you can make the most of the musculature shown here.

FRONT VIEW

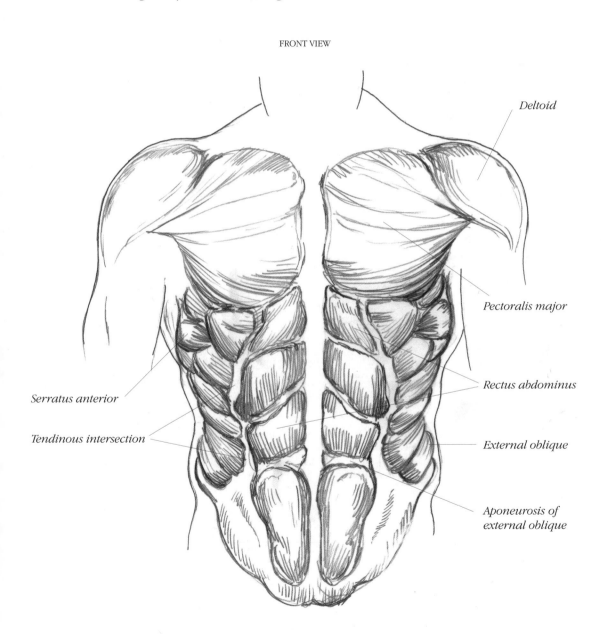

Deltoid

Pectoralis major

Serratus anterior

Tendinous intersection

Rectus abdominus

External oblique

Aponeurosis of external oblique

BACK VIEW

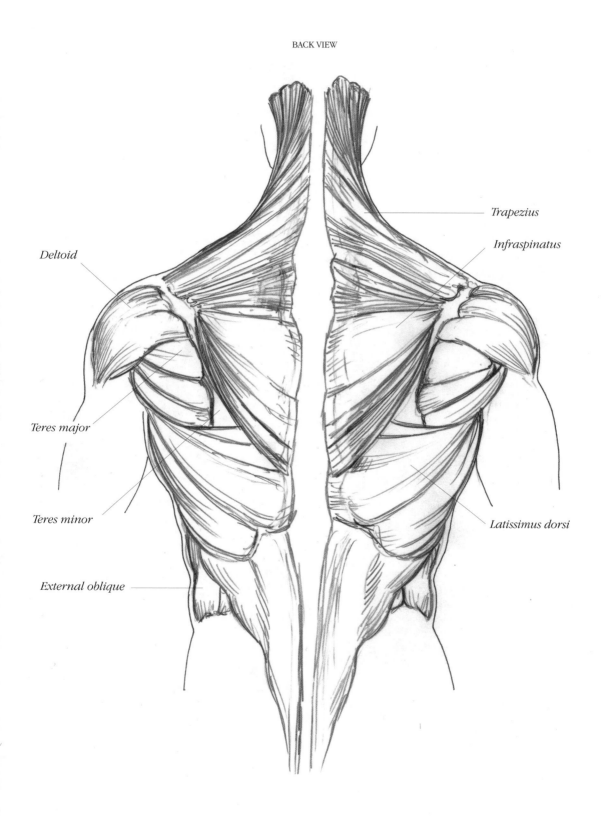

Trapezius

Infraspinatus

Deltoid

Teres major

Teres minor

External oblique

Latissimus dorsi

THE TORSO

Male and female torsos present very different surfaces for the artist to draw. Because most men are more muscular than women, light will fall differently upon the angles and planes of the body and there will be more shadowed areas where the skin curves away from the light. The viewer will immediately understand these darker areas as showing muscular structure. In the case of the female torso, the shadowed areas are longer and smoother, as the planes of the body are not disrupted by such obvious muscle beneath the skin. Of course, many of the people you draw from life will not be so well toned as these models, which is where the infinite variety that makes figure drawing so rewarding starts to show.

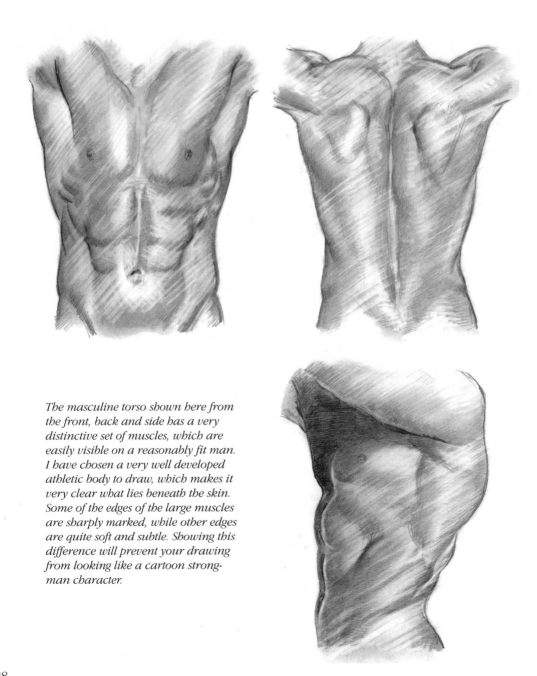

*The masculine torso shown here from the front, back and side has a very distinctive set of muscles, which are easily visible on a reasonably fit man. I have chosen a very well developed athletic body to draw, which makes it very clear what lies beneath the skin. Some of the edges of the large muscles are sharply marked, while other edges are quite soft and subtle. Showing this difference will prevent your drawing from looking like a cartoon strong-man character.*

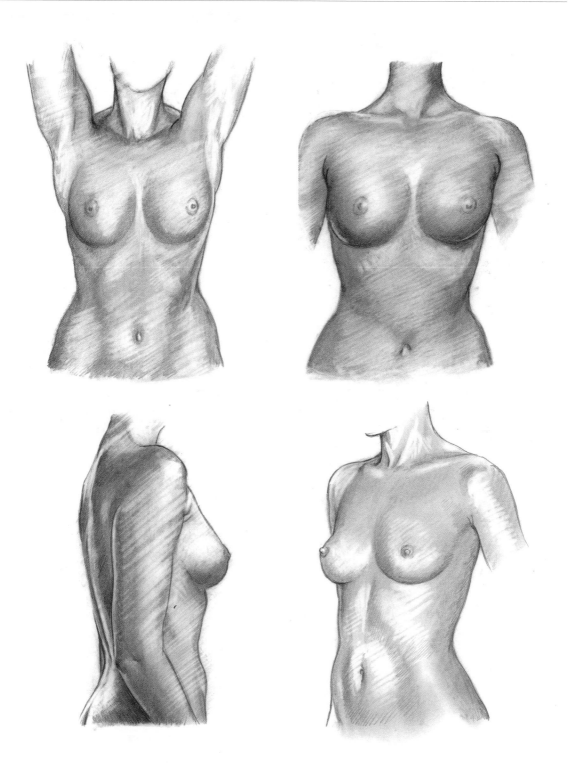

*This female figure is also very young and athletic and many women will not have quite this balance of muscle and flesh. Generally speaking, the female figure shows less of the muscle structure because of a layer of subcutaneous fat that softens all the harsh edges of the muscles. This is why women always have a tendency to look rounder and softer than men do.*

THE TORSO: BENDING AND STRETCHING
In these drawings you can see how the spinal cord is such a good indication of what is happening to the body when it bends and stretches. The curves of the spine help to define the pose very clearly and it is best to start drawing a figure by taking a note of them. All the other parts of the body's structure can then be built around that. Even if you can't see the spine, some idea of its curves will always help to keep your drawing convincing.

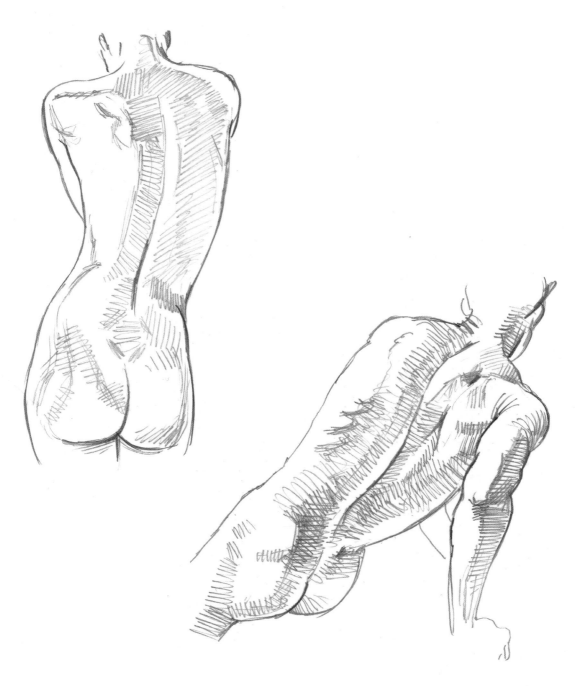

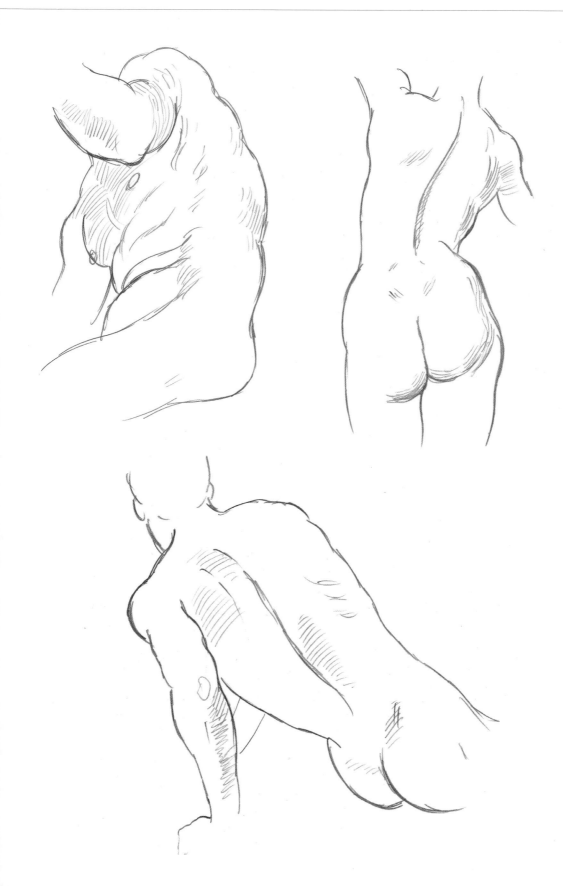

## THE TORSO: DIFFERENT ANGLES

Drawing the torso from a viewpoint at one end or the other presents new challenges. Don't forget that the part of the torso farther away will look smaller than the part closer to you, so if you're looking from the feet end the head will be minimized, the shoulders and chest will be quite small and the hips and legs will be correspondingly large. Seen from the head end, the head shoulders and chest will dominate, while the legs will tend to disappear.

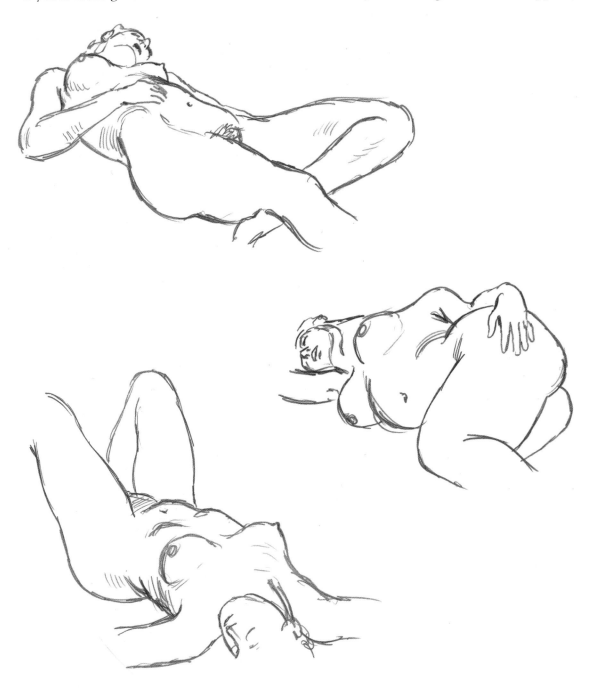

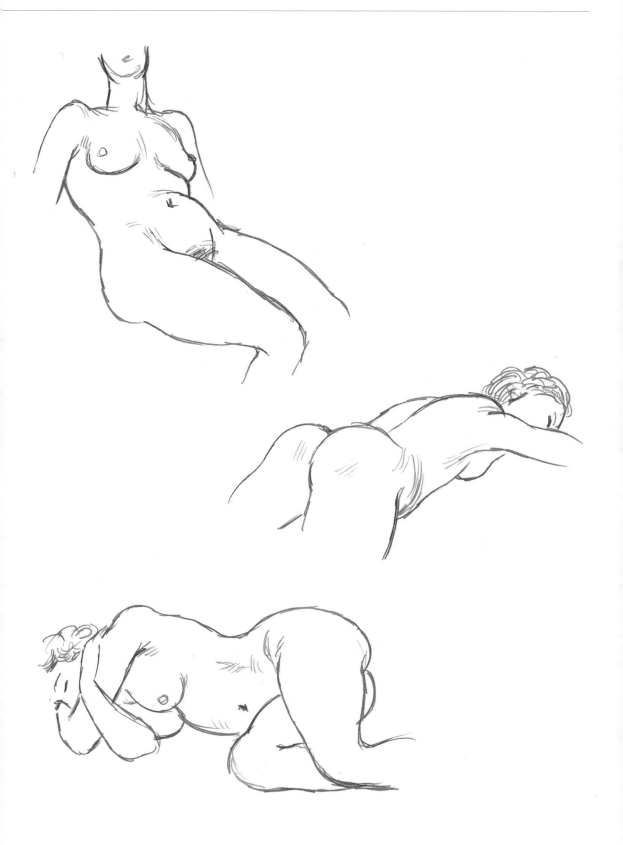

ANATOMY OF THE HAND, ARM AND SHOULDER

FOREARM AND HAND
Bone structure

Humerus

Head of ulna

Medial epicondyle

Shaft of ulna

Shaft of radius

Styloid process of radius

Radial tuberosity

Carpal bones (eight)

Capitate

Triangular

Pisiform

Base

Fifth metacarpal

Phalanges (fourteen)

FOREARM AND HAND
Musculature

Brachialis

Tendon of triceps brachii

Lateral epicondyle

Brachioradialis

Olecranon

Extensor carpi ulnaris

Extensor carpi radialis brevis

Anconeus

Extensor digitorum communis

Tendon of extensor pollicis longus

Extensor pollicis brevis

Extensor digiti minimi

Extensor retinaculum

Adductor pollicis longus

First dorsal interosseous muscle

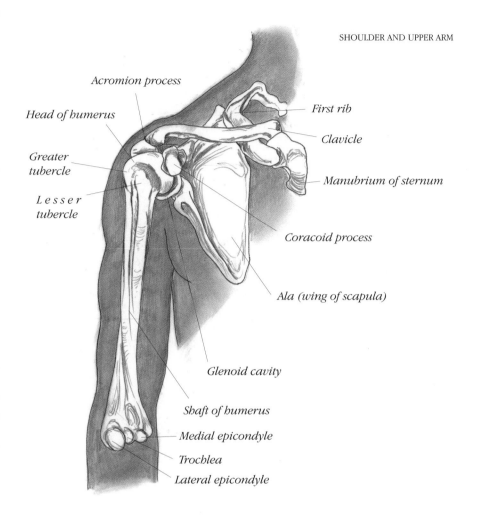

SHOULDER AND UPPER ARM

Acromion process

Head of humerus

Greater tubercle

Lesser tubercle

First rib

Clavicle

Manubrium of sternum

Coracoid process

Ala (wing of scapula)

Glenoid cavity

Shaft of humerus

Medial epicondyle

Trochlea

Lateral epicondyle

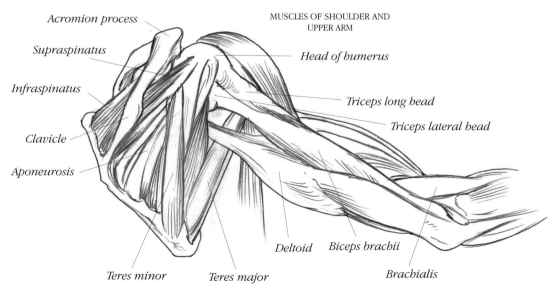

MUSCLES OF SHOULDER AND UPPER ARM

Acromion process

Supraspinatus

Infraspinatus

Clavicle

Aponeurosis

Head of humerus

Triceps long head

Triceps lateral head

Teres minor

Teres major

Deltoid

Biceps brachii

Brachialis

## ARMS AND HANDS

The narrowness of the limb makes the musculature show much more easily than in the torso say, and at the shoulder, elbow and wrist it is even possible to see the end of the skeletal structure. This tendency of bone and muscle structure to diminish in size as it moves away from the centre of the body is something that should inform your drawings. Fingers and thumbs are narrower than wrists; wrists are narrower than elbows; elbows narrower than shoulders: a surprisingly large number of students draw them the opposite way round. As always, it is a matter of observing carefully and drawing what you actually see before you.

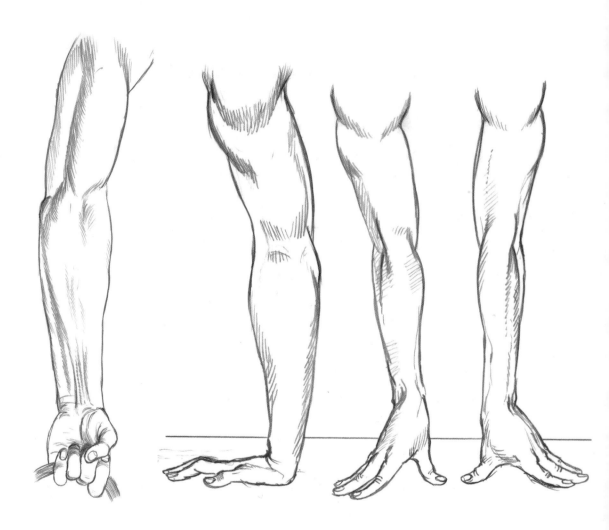

*In these examples, notice how when the arm is under tension in the act of grasping an object or bearing weight, the muscles stand out and their tendons show clearly at the inner wrist. As can be seen on the page opposite, when the arm is bent the larger muscles in the upper arm show themselves more clearly and the shoulder muscles and shoulder blades are seen more defined.*

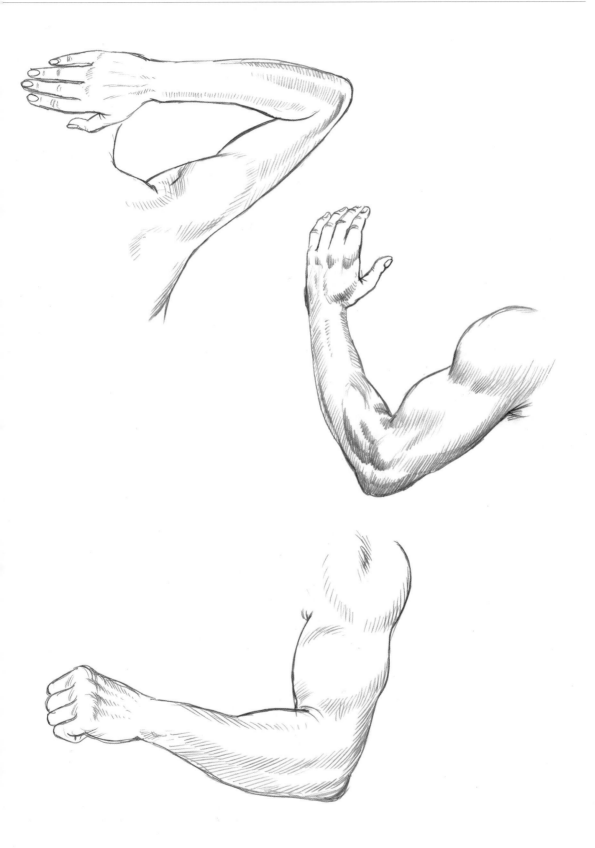

## HANDS

Many people find hands difficult to draw. You will never lack a model here as you can simply draw your own free hand, so keep practising and study it from as many different angles as possible. The arrangement of the fingers and thumb into a fist or a hand with the fingers relaxed and open create very different shapes and it is useful to draw these constantly to get the feel of how they look. There is inevitably a lot of foreshortening in the palm and fingers when the hand is angled towards you or away from your sight.

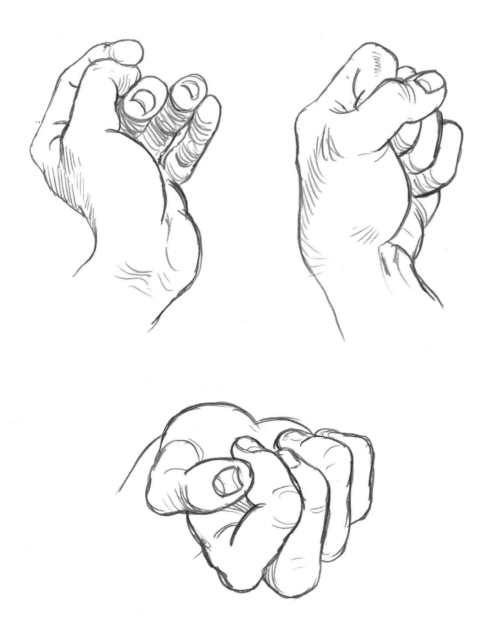

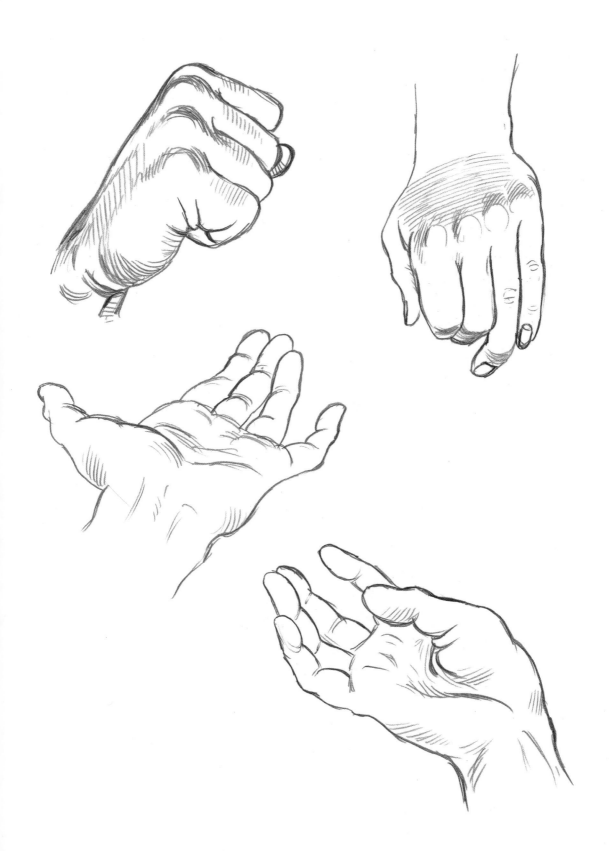

## ANATOMY OF THE UPPER LEG

The upper part of the leg is similar to the upper arm in that the bone that supports it is single and very large; in the case of the leg it is probably the largest in the body, and the muscles are large and long in shape. The hip area is defined by the pelvis, the upper edges of which usually can be seen above the hipbones. One of the longest muscles is the sartorius, which stretches from the upper pelvis to below the knee joint.

UPPER LEG BONES

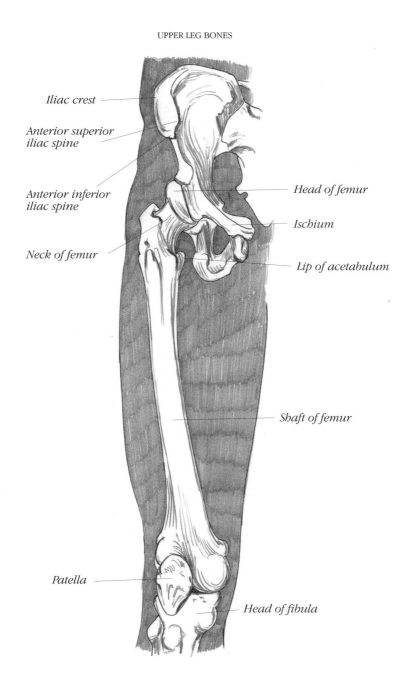

Iliac crest

Anterior superior iliac spine

Anterior inferior iliac spine

Neck of femur

Head of femur

Ischium

Lip of acetabulum

Shaft of femur

Patella

Head of fibula

FRONT UPPER LEG MUSCLES

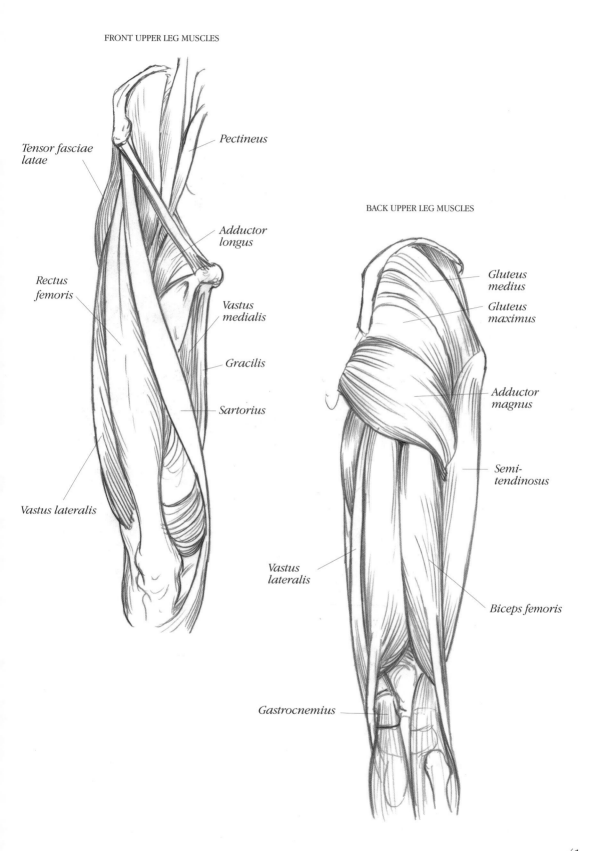

Pectineus

Tensor fasciae
latae

Adductor
longus

Rectus
femoris

Vastus
medialis

Gracilis

Sartorius

Vastus lateralis

BACK UPPER LEG MUSCLES

Gluteus
medius

Gluteus
maximus

Adductor
magnus

Semi-
tendinosus

Vastus
lateralis

Biceps femoris

Gastrocnemius

ANATOMY OF THE LOWER LEG AND FOOT

BONES OF THE LOWER LEG AND FOOT

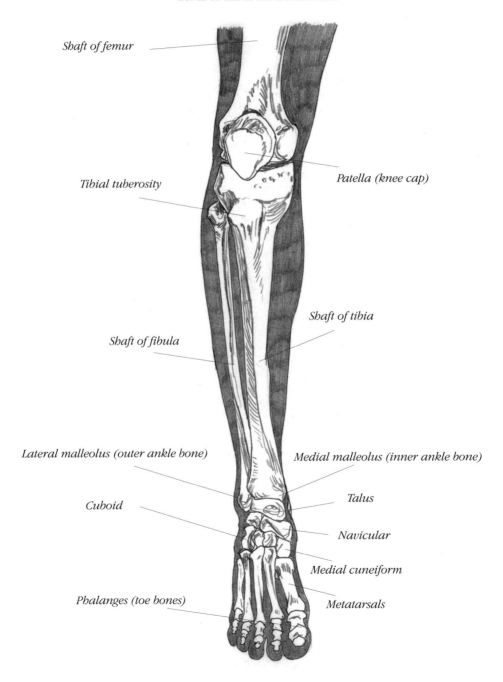

Shaft of femur

Patella (knee cap)

Tibial tuberosity

Shaft of tibia

Shaft of fibula

Lateral malleolus (outer ankle bone)

Medial malleolus (inner ankle bone)

Cuboid

Talus

Navicular

Medial cuneiform

Phalanges (toe bones)

Metatarsals

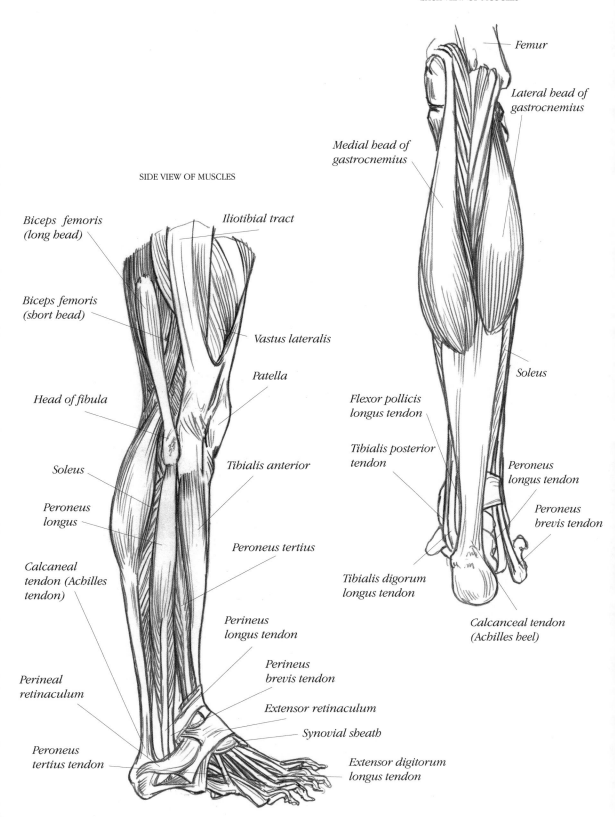

BACK VIEW OF MUSCLES

Femur

Lateral head of
gastrocnemius

Medial head of
gastrocnemius

SIDE VIEW OF MUSCLES

Biceps femoris
(long head)

Iliotibial tract

Biceps femoris
(short head)

Vastus lateralis

Patella

Head of fibula

Soleus

Flexor pollicis
longus tendon

Soleus

Tibialis posterior
tendon

Peroneus
longus

Peroneus
longus tendon

Tibialis anterior

Peroneus
brevis tendon

Calcaneal
tendon (Achilles
tendon)

Peroneus tertius

Tibialis digorum
longus tendon

Perineus
longus tendon

Calcanceal tendon
(Achilles heel)

Perineus
brevis tendon

Perineal
retinaculum

Extensor retinaculum

Synovial sheath

Peroneus
tertius tendon

Extensor digitorum
longus tendon

43

COMPLETE SIDE VIEWS

From the side, you will see that the muscles in the thigh and the calf of the leg show up most clearly, the thigh mostly towards the front of the leg and the calf toward the back. The large tendons show mostly at the back of the knees and around the ankle. Notice the way the patella changes shape as the knee is bent or straightened. As with the arms, the bones and muscles in the leg are bigger towards the body and smaller towards the extremities.

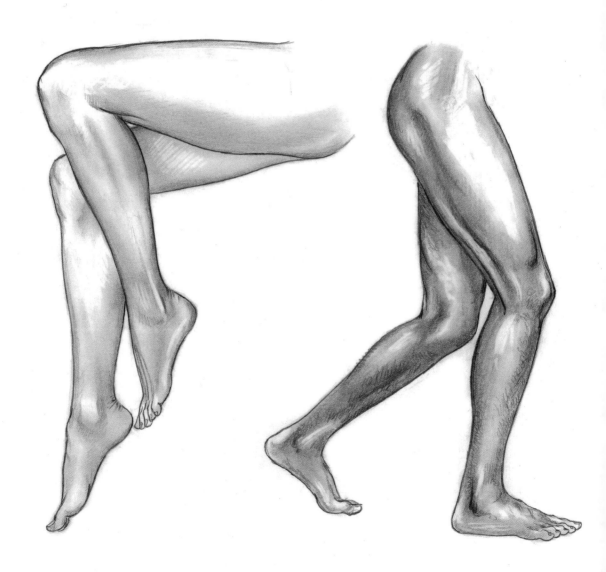

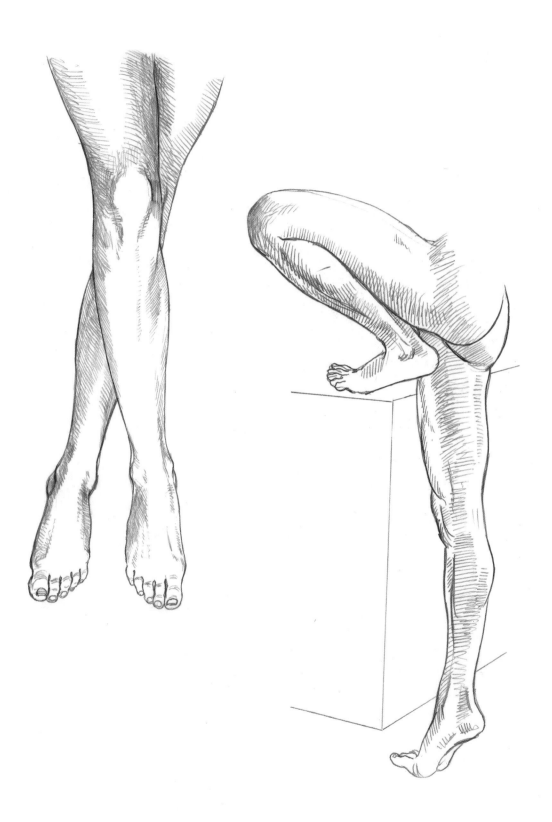

## COMPLETE BACK VIEWS
The back view of the legs shows the interesting reverse of the knee joint and looks very round and smooth, especially in the female form.

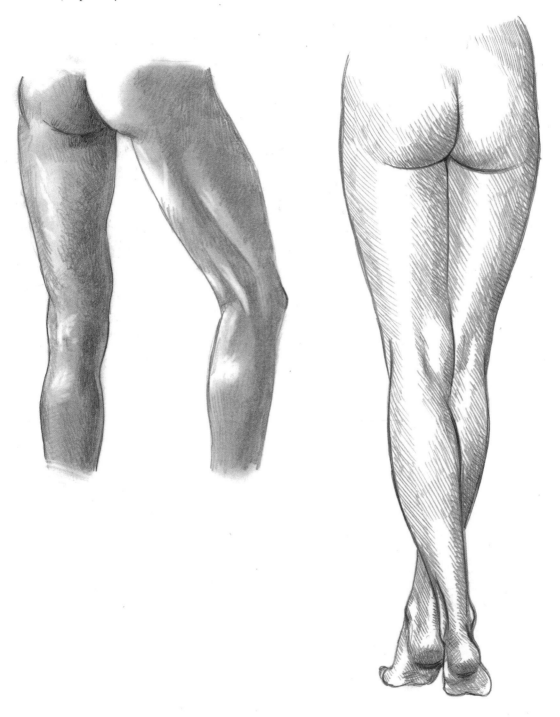

The legs bent show the distinctive effect that
this has on the knee joint, producing a largish
area of flat padded bone structure.
Foreshortening the view of the legs produces
all sorts of interesting views of the larger
muscles, which are less well defined.

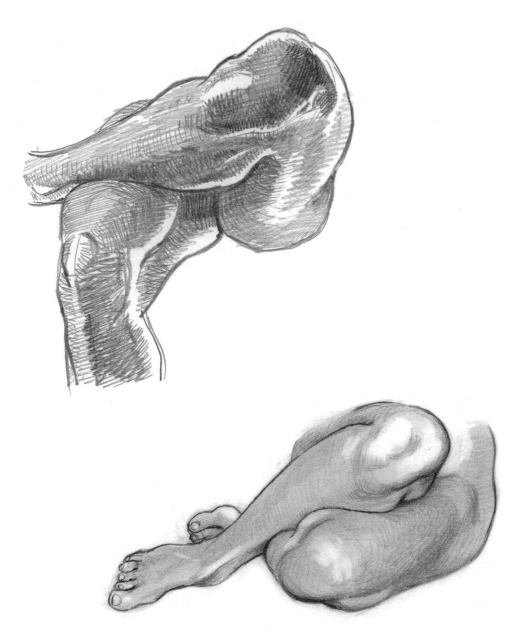

FEET
The bone structure of the foot is quite elegant,
producing a slender arch over which muscles
and tendons are stretched.

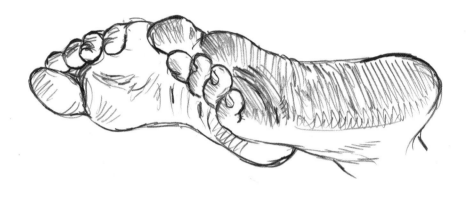

*The lower part of the foot is padded with soft subcutaneous matter and thicker skin.*

*Notice how the toes, unlike the fingers, tend to be more or less aligned although the smaller toes get tucked up into small rounded lumps.*

*The inner anklebone is higher than the outer, which helps to lend elegance to this slender joint. If the difference in the position of the ankle bones is not noted the ankle becomes a clumsy shape. The small bump of the ankle bone is most noticeable from the front or back view but if the source of light is right it can show clearly as well from a side view.*

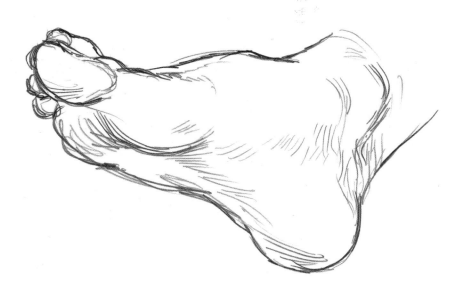

# Drawing the Whole Figure

Now that you have had a look at the skeleton and musculature of the human body you should feel that you have some knowledge of how the average figure is constructed. I now need to consider how you will go about drawing it and the problems you will come up against in doing so. This next section proceeds through the stages necessary to start drawing and what practices you will need to work on to make it easier to draw the whole figure from any angle.

Drawing the human body is probably the hardest piece of draughtsmanship that you will ever have to accomplish –

because of course you will be able to accomplish it, so long as you take the time to practise and follow through your efforts to improve your drawing techniques as you do so. Once you have accomplished a reasonable standard of competence in drawing the human figure you will find all other drawing relatively easy in comparison. Do not be put off by this challenge, because steady and careful practice is the way to overcome any difficulty that you may find, and many thousands of people have learned to draw competently without having any particular talent for this art except the desire to do it and a certain amount of intelligence and persistence. So although it is not a walkover, it is quite possible for anyone to achieve a degree of expertise in this craft.

First, for those readers who have no experience at all of drawing the human figure from life, the stages that make it easier to approach are outlined. Then this section discusses the most difficult problem that you will encounter when you draw from life, and that is the question of the figure in perspective, with the foreshortening of parts or all of the body.

There are also many techniques that need to be practised which will help to make drawing directly from a model successful. Much of this is common sense, of course, but we all invariably have preconceived ideas about what the human body looks like and often this can stop us from observing accurately what we have in front of us. Consequently, when we are embarking on using these techniques the effort to bring a fresh vision so that we can judge more accurately the proportions and shape of the body will never be wasted in our attempts to improve our drawing. Every artist, however professional, knows that when they start to draw from life, dropping these ingrained ideas of what the body looks like is about the best start that can be made – so go carefully and keep your approach as clear-sighted and fresh as possible.

DRAWING MATERIALS

Any medium is valid for drawing from life. That said, some media are more valid than others in particular circumstances, and in the main their suitability depends on what you are trying to achieve. Try to equip yourself with the best materials you can afford; quality does make a difference. You don't need to buy all the items listed below, and it is probably wise to experiment: start with the range of pencils suggested, and when you feel you would like to try something different, then do so. Be aware that each medium has its own identity, and you have to become acquainted with its individual facets before you can get the best out of it or, indeed, discover whether it is the right medium for your purposes. So, don't be too ambitious to begin with, and when you do decide to experiment, persevere.

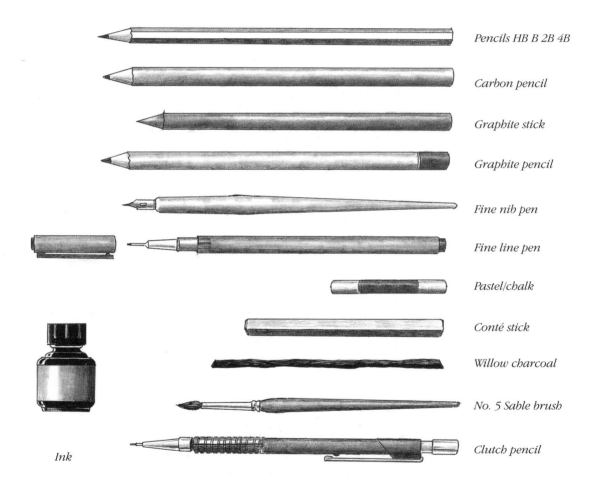

Pencils HB B 2B 4B

Carbon pencil

Graphite stick

Graphite pencil

Fine nib pen

Fine line pen

Pastel/chalk

Conté stick

Willow charcoal

No. 5 Sable brush

Clutch pencil

Ink

*Pencil*
*The normal type of wooden-cased drawing pencil is, of course, the most versatile instrument at your disposal. You will find the soft black pencils are best. Mostly I use B, 2B, 4B and 6B. Very soft pencils (7B–9B) can be useful sometimes and harder ones (H) very occasionally. Propelling or clutch pencils are very popular, although if you choose this type you will need to buy a selection of soft, black leads with which to replenish them.*

*Conté*
*Similar to compressed charcoal, conté crayon comes in different colours, different forms (stick or encased in wood like a pencil) and in grades from soft to hard. Like charcoal, it smudges easily but is much stronger in its effect and more difficult to remove.*

*Carbon pencil*
*This can give a very attractive, slightly unusual*

result, especially the dark brown or sepia, and the terracotta or sanguine versions. The black version is almost the same in appearance as charcoal, but doesn't offer the same rubbing-out facility. If you are using this type, start off very lightly because you will not easily be able to erase your strokes.

*Graphite*

Graphite pencils are thicker than ordinary pencils and come in an ordinary wooden casing or as solid graphite sticks with a thin plastic covering. The graphite in the plastic coating is thicker, more solid and lasts longer, but the wooden casing probably feels better. The solid stick is very versatile because of the breadth of the drawing edge, enabling you to draw a line 6 mm ($^1/_4$ in) thick, or even thicker, and also very fine lines. Graphite also comes in various grades, from hard to very soft and black.

*Pens*

Push-pens or dip-pens come with a fine pointed nib, either stiff or flexible, depending on what you wish to achieve. Modern fine-pointed graphic pens are easier to use and less messy but not as versatile, producing a line of unvarying thickness. Try both types.

The ink for dip-pens is black Indian ink or drawing ink; this can be permanent or water-soluble. The latter allows greater subtlety of tone.

*Pastel/chalk*

If you want to introduce colour into your still-life drawing, either of these can be used. Dark colours give better tonal variation. Avoid bright, light colours. Your choice of paper is essential to a good outcome with these materials. Don't use a paper that is too smooth, otherwise the deposit of pastel or chalk will not adhere to the paper properly. A tinted paper can be ideal, because it enables you to use light and dark tones to bring an extra dimension to your drawing.

*Charcoal*

In stick form this medium is very useful for large drawings, because the long edge can be used as well as the point. Charcoal pencils (available in black, grey and white) are not as messy to use as the sticks but are less versatile. If charcoal drawings are to be kept in good condition the charcoal must be fixed with a spray-on fixative to stop it smudging.

*Brush*

Drawing with a brush will give a greater variety of tonal possibilities to your drawing. A fine tip is not easy to use initially, and you will need to practise if you are to get a good result with it. Use a soluble ink, which will give you a range of attractive tones.

A number 0 or number 2 nylon brush is satisfactory for drawing. For applying washes of tone, a number 6 or number 10 brush in sablette, sable or any other material capable of producing a good point is recommended.

*Stump*

A stump is a tightly concentrated roll of absorbent paper formed into a fat pencil-like shape. Artists use it to smudge pencil, pastel or charcoal and thus smooth out shading they have applied, and graduate it more finely.

*Paper*

You will find a good-quality cartridge paper most useful, but choose one that is not too smooth; 160 gsm weight is about right. (If you are unsure, ask in your local art shop, where they will stock all the materials you require.)

Drawing in ink can be done on smoother paper, but even here a textured paper can give a livelier result in the drawing. For drawing with a brush, you will need a paper that will not buckle when wet, such as watercolour paper. Also see under Pastel/chalk.

*Eraser*

The best all-purpose eraser for the artist is a putty eraser. Kneadable, it can be formed into a point or edge to rub out all forms of pencil. Unlike the conventional eraser it does not leave small deposits on the paper. However, a standard soft eraser is quite useful as well, because you can work over marks with it more vigorously than you can with a putty eraser.

Most artists try to use an eraser as little as possible, and in fact it only really comes into its own when you are drawing for publication, which requires that you get rid of superfluous lines. Normally you can safely ignore erasers in the knowledge that inaccurate lines will be drawn over and thus passed over by the eye which will see and follow the corrected lines.

*Sharpener*

A craft knife is more flexible than an all-purpose sharpener and will be able to cope with any medium. It goes without saying that you should use such an implement with care and not leave the blade exposed where it may cause harm or damage.

## FOUR BASIC STAGES OF DRAWING A FIGURE

For a beginner first embarking on drawing the whole figure, the tendency is to become rather tense about the enormity of the task. The presence of a real live model, as opposed to a still-life object, can make you feel not only that your work may be judged and found wanting by your subject, but also the life class you are in and that you also perhaps cannot work at your leisure.

To begin with, just think in terms of simple shapes rather than visualizing a finished drawing that you feel you are not capable of achieving. You can stop your drawing at any stage – there is no need to feel that you have to press on to a conclusion that you are not ready for. Starting very simply, for example with a seated male figure, there are some easy ways to work your way into the task of drawing it.

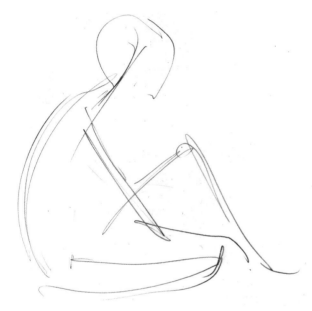

*The first stage is to see the very basic shape that the disposition of the body and limbs make in the simplest geometric way. This figure is sitting with one knee up, leaning on the lower knee with the elbow of one arm. This produces a triangular shape between the torso and head and the arm and lower leg. Set against that is the additional triangle of the bent leg, which creates another triangular shape cutting into the first shape. With very simple lines, sketch in the position and proportion of the shapes.*

*The next stage is to make the shape more like the actual volume of the figure by drawing curved outlines around each limb and the head and torso. I have left out the original lines of the above drawing so that you can see how much there is to draw in this stage. This drawing needs to be done quite carefully as it sets the whole shape for the finished piece of work*

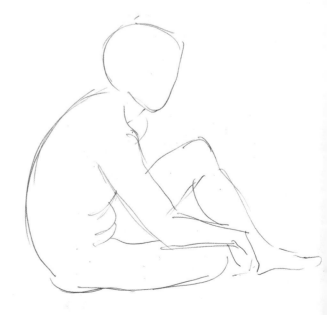

The next step is to block in the changes in the planes of the surface as shown by the light and shade on the body. This process needs only to be a series of outlines of areas of shadow and light. At the same time, begin to carefully define the shapes of the muscles and bone structure by refining your second outline shape, adding subtleties and details. Now you have a good working drawing that has every part in the right place and every area of light and shade indicated.

At this stage you will want to do quite a bit of correcting to make your shapes resemble your model. Take your time and work as as accurately as you can, until you see a very similar arrangement of shapes when you look from your drawing to the model.

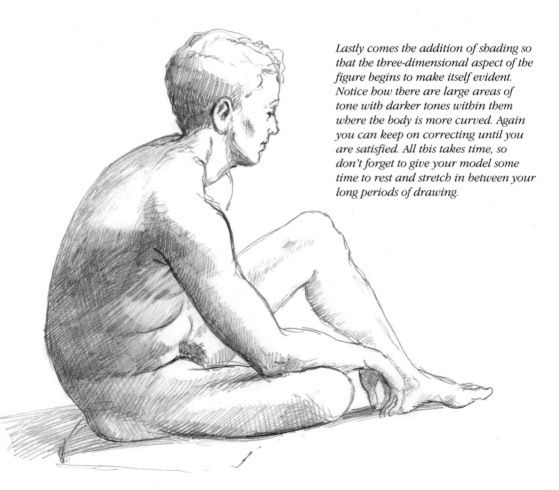

Lastly comes the addition of shading so that the three-dimensional aspect of the figure begins to make itself evident. Notice how there are large areas of tone with darker tones within them where the body is more curved. Again you can keep on correcting until you are satisfied. All this takes time, so don't forget to give your model some time to rest and stretch in between your long periods of drawing.

## TACKLING A MORE DIFFICULT POSE

Once you have drawn a simple figure successfully, it is time to move on to something a little more challenging that will expand your skills further and build your confidence. This time, you will work through a similar set of stages with a female model – but the pose is more difficult both for the model to hold and for you to draw. Go carefully, allowing yourself time for accuracy and the model adequate resting periods.

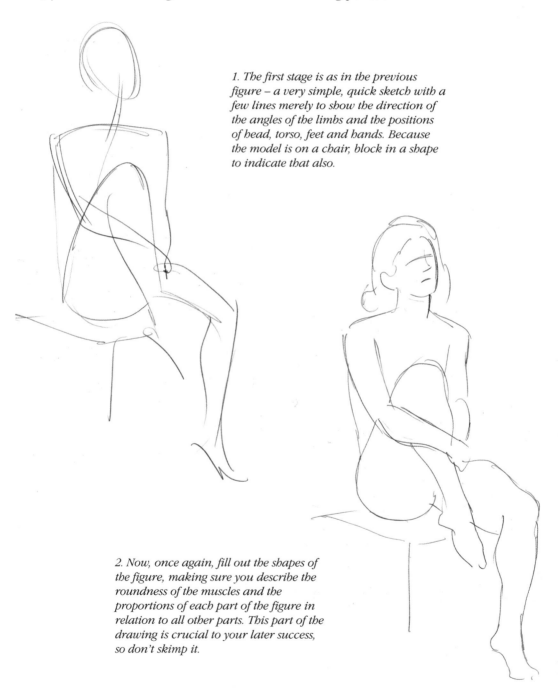

*1. The first stage is as in the previous figure – a very simple, quick sketch with a few lines merely to show the direction of the angles of the limbs and the positions of head, torso, feet and hands. Because the model is on a chair, block in a shape to indicate that also.*

*2. Now, once again, fill out the shapes of the figure, making sure you describe the roundness of the muscles and the proportions of each part of the figure in relation to all other parts. This part of the drawing is crucial to your later success, so don't skimp it.*

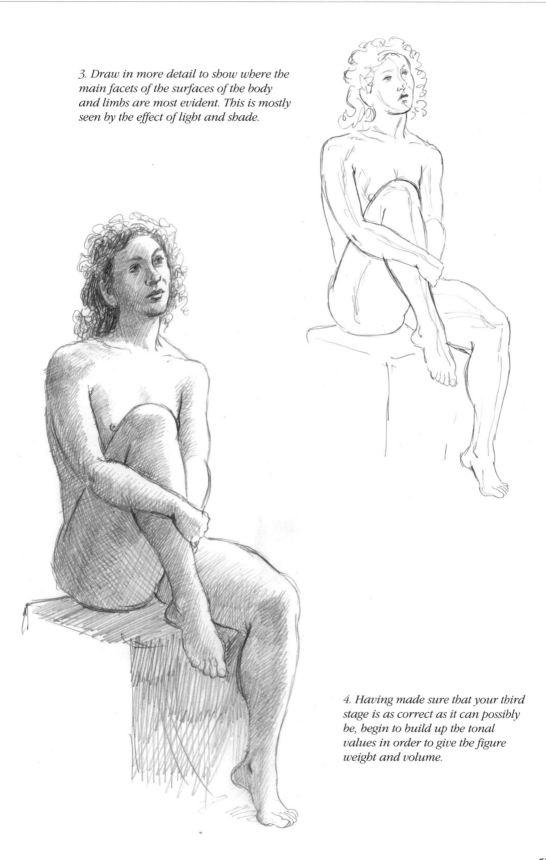

3. Draw in more detail to show where the
main facets of the surfaces of the body
and limbs are most evident. This is mostly
seen by the effect of light and shade.

4. Having made sure that your third
stage is as correct as it can possibly
be, begin to build up the tonal
values in order to give the figure
weight and volume.

## TRYING DIFFERENT APPROACHES

There are many techniques that you can follow in order to improve your drawings – though there is no easy substitute for putting in hours of practice. Try the methods suggested here and familiarize yourself with them. In doing so you will begin to develop your own style and discover which method of working suits your personality best. You may find you revel in fine line drawing, or perhaps prefer to work in heavy blocks of tone.

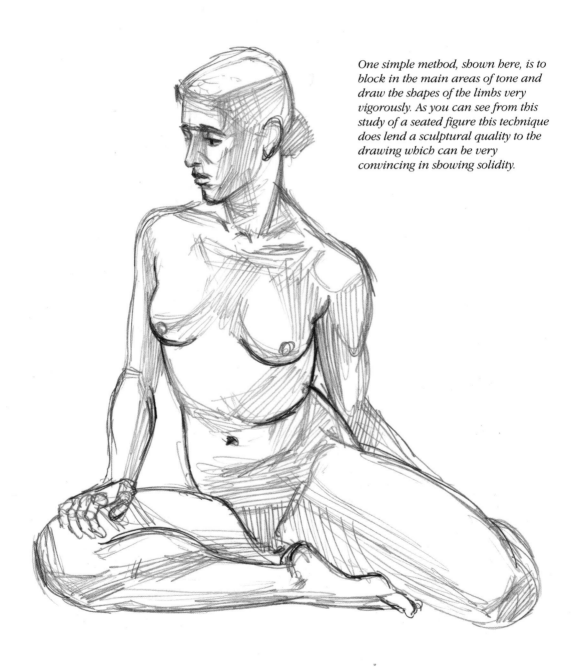

*One simple method, shown here, is to block in the main areas of tone and draw the shapes of the limbs very vigorously. As you can see from this study of a seated figure this technique does lend a sculptural quality to the drawing which can be very convincing in showing solidity.*

Another way is to draw your model's pose fairly simply from more than one angle. Therefore, if the model is sitting facing you, make a simple but effective outline sketch then move round to the side or the back in order to draw the same pose from as many different angles as you think fit. What this does is to help you to see the pose more clearly. Although you may have to do these sketches quite fast, when you come to draw from one point of view in more detail the knowledge you have gained about the model's pose and shape will inform your work, so that you will probably produce a much more accurate version of the pose.

WORKING AT SPEED

Another practice always useful for life drawing is to draw extremely quickly with just a few fluid lines to see how fast the whole figure can be sketched in. This is encouraged by many life-class tutors as it teaches students to look for the absolutely essential lines of the pose. Practice a dozen or so drawings like these of the model, taking various one- or two-minute poses and putting in the absolute minimum. You should be working so quickly you have no time to correct errors.

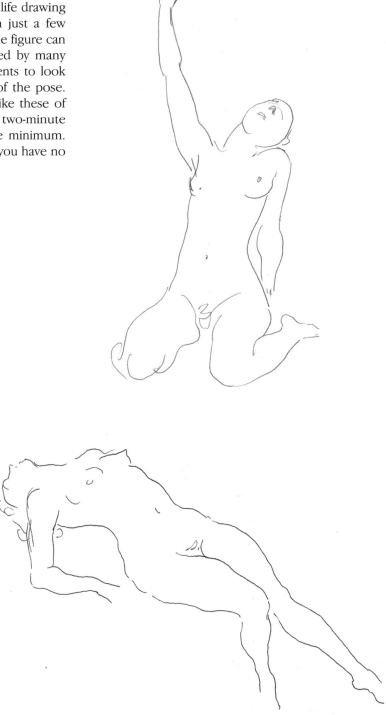

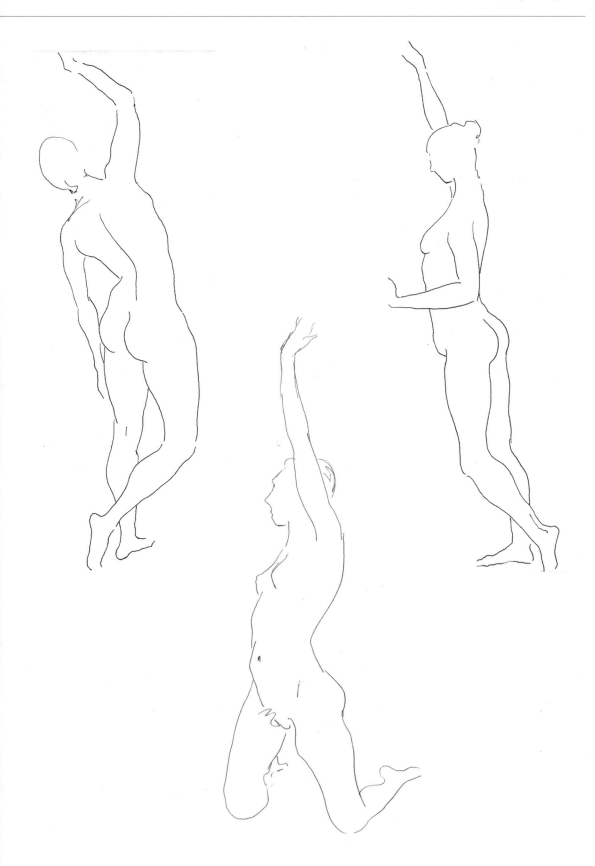

## FIGURES IN PERSPECTIVE

Once you feel confident with the early stages of getting figures down on paper, you are ready to tackle the bigger challenge of seeing the figure in perspective where the limbs and torso are foreshortened and do not look at all like the human body in conventional pose.

To examine this at its most exaggerated, the model should be lying down on the ground or a low platform or bed. Position yourself so that you are looking from one end of the body along its length and you will have a view of the human figure in which the usual proportions are all changed. Because of the laws of perspective, the parts nearest to you will look much larger than the parts farther away.

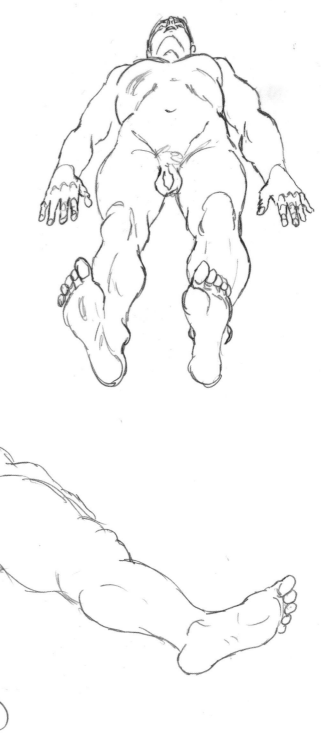

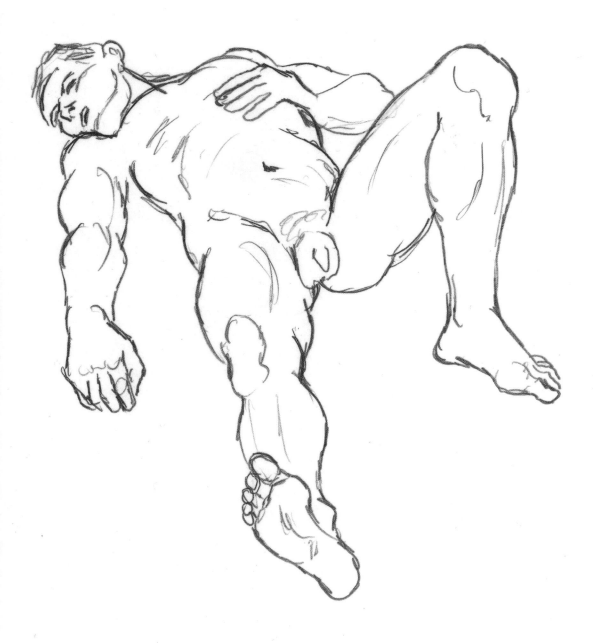

Looking at the figure from the feet end, the feet and legs look enormous and the chest and head almost disappear in relation to them. The arms, with the hands towards you, look like a series of rounded bulges, with the large hands and fingers looking much wider than they are long.

Sometimes the shoulders can't be seen and the head is just a jutting jaw with the merest suggestion of a mouth, an upwardly pointing nose and the eyes, brows and hair reduced to almost nothing.

## CHANGING ENDS

Standing at the head end, you will find that everything has to be reassessed again. This time the head is very large but you can mostly see just the top of it and the shoulders and chest or shoulder blades, which bulk large.

*As the eye travels down towards the legs, the most noticeable thing is how short and stubby they look from this angle. The feet may stick up if the model is on his or her back, but the legs themselves are just a series of bumps of thighs, knees and calves.*

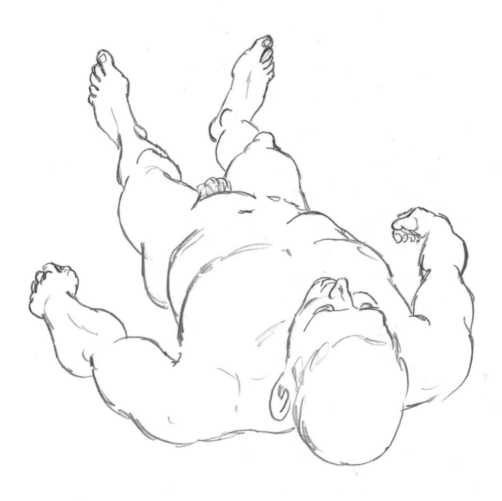

Try measuring the difference between the legs and the torso and you will find that although you know the legs are really half the length of the whole figure, from this angle they are more like a quarter of the full length. Not only that, the width of shoulders and hips are vastly exaggerated so that the body looks very short in relation to its width. Most students new to this view of the figure draw it far too long for its width because they have in their mind the proportions of how the figure looks when standing up. Make sure you observe the figure carefully to avoid this.

## THE FORESHORTENED SKELETON

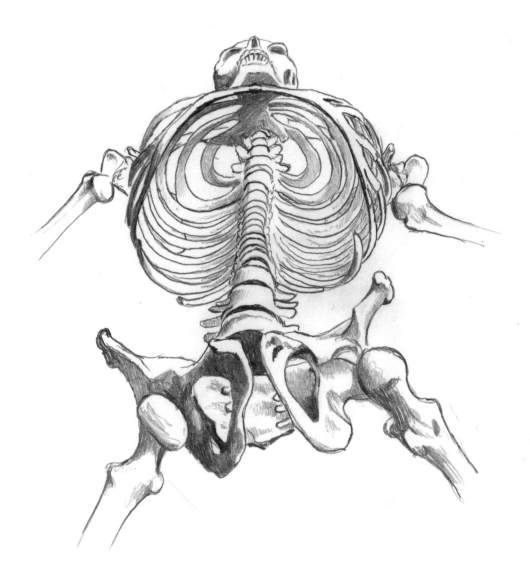

To underline the effect of perspective, let us look at the skeleton seen from either end as well. Here we have the pelvis and ribcage and the skull seen from the feet end of the figure and is obvious how the curve of the rib cage becomes such a dominant feature of this view. Notice how large the pelvic bone looks in relation to the rib cage and how tiny the skull appears.

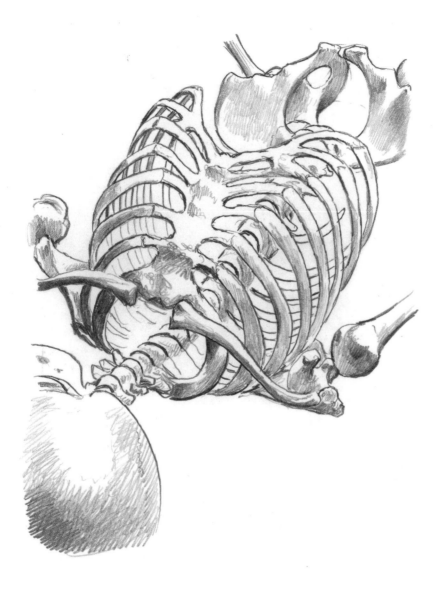

*In this drawing I have drawn the skeleton from the head end: the skull is so large it is mostly out of the picture and the ribcage is a massive curving latticework. In both of these drawings I have left out the legs and arms in order to show the structure of the torso more clearly. Once again the width is proportionately larger than the length of the ribcage.*

67

## EXPRESSING VOLUME

Showing the volume of the figure will make your drawings convincingly solid. You can make a small figure appear weighty by blocking in areas of tone, a technique used by artists when the drawing is to be painted as it clarifies how the area of tone and colour should be painted. Contour lines also give the impression of the roundness of the head and body.

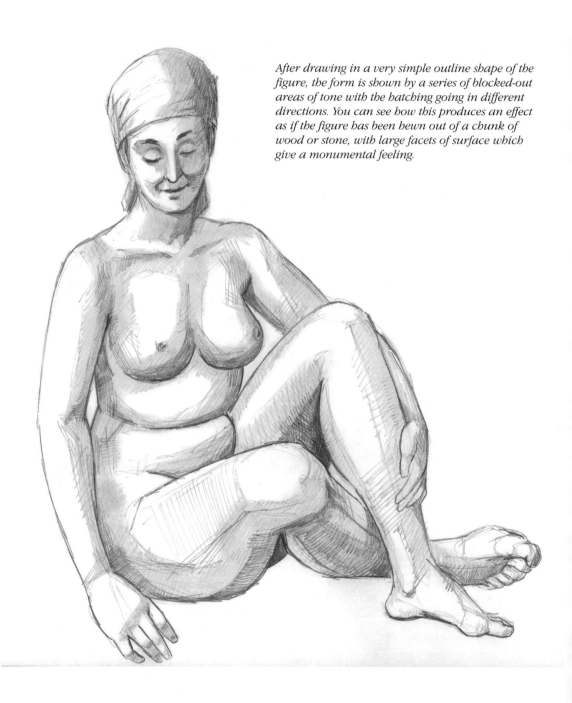

*After drawing in a very simple outline shape of the figure, the form is shown by a series of blocked-out areas of tone with the hatching going in different directions. You can see how this produces an effect as if the figure has been hewn out of a chunk of wood or stone, with large facets of surface which give a monumental feeling.*

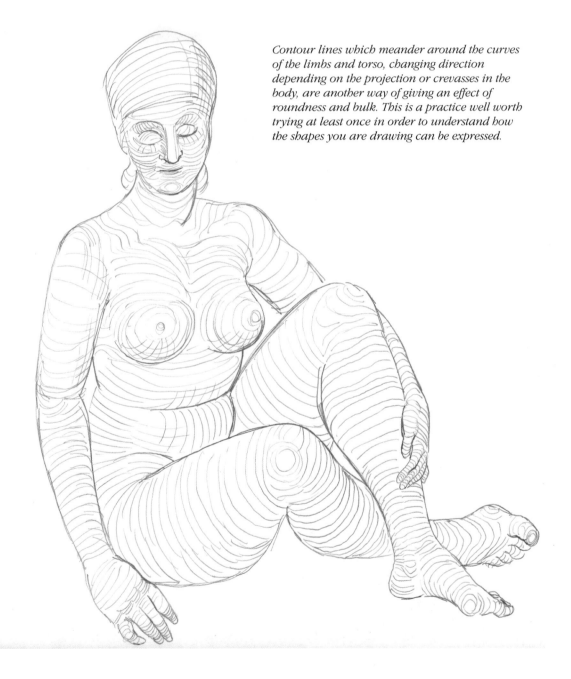

Contour lines which meander around the curves
of the limbs and torso, changing direction
depending on the projection or crevasses in the
body, are another way of giving an effect of
roundness and bulk. This is a practice well worth
trying at least once in order to understand how
the shapes you are drawing can be expressed.

HARD AND SOFT LINES

Even in a line drawing with no attempt at tone you can influence the way the viewer will see and understand your figure. Producing a hard, definite line requires a steadier nerve on the part of the artist than a softer, more tentative line, but both are an equally valid way of describing the human form and lending feeling to the image.

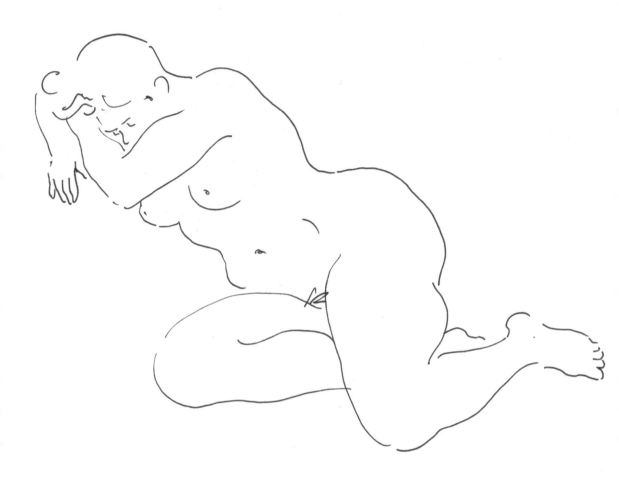

*A harder and very confident way of producing the form of the body is to go for absolute minimum line. You will have to make up your mind about a whole passage of the figure and then, as simply and accurately as you can, draw a strong, clear line without any corrections to produce a vigorous, clearly defined outline shape. Only the very least detail should be shown, just enough to give the effect of the human figure you see in front of you. This requires a bold approach and either works first go or not, but of course you can have as many shots at it as you have time for. It really teaches economy of both line and effect and also makes you look very carefully at the figure.*

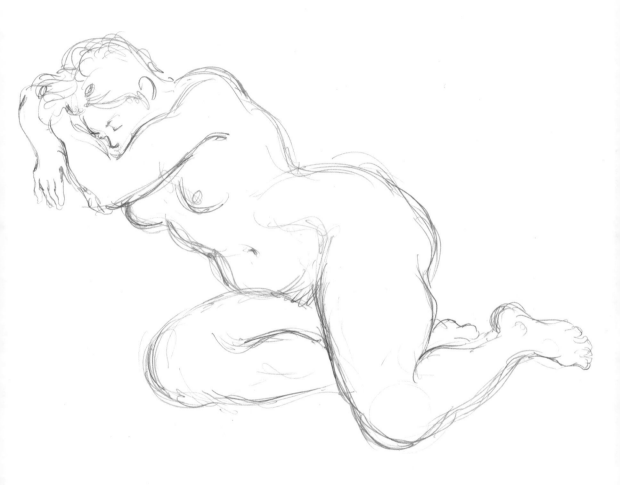

Allowing your pencil or pen to loosely follow the model's form in such a way that you produce a mass of weaving lines around the main shapes helps to express the softness and fluidity of the figure. This allows you to gradually discover the shape by a series of loosely felt lines that don't pin you down too tightly. What it loses in sharpness it gains in movement and flow of form.

## MAPPING THE BODY

A more gradual and time-consuming approach which many artists have used is to decide exactly where each point of the figure appears to be in relation to all the other points around the figure from your viewpoint. Thus a mark is made, for example, at the top of the head; then, very carefully, another mark at the back of the head, then the point where the eyes are, all in relation one to another. It is a very time-consuming method but most artists who use it are assured of producing very accurate renderings of the forms in front of them.

Conversely, you can map the body very fast with scribbles that delineate the form quite accurately but without much detail. Try different techniques to see whether the free or more painstaking approach suits your personality best.

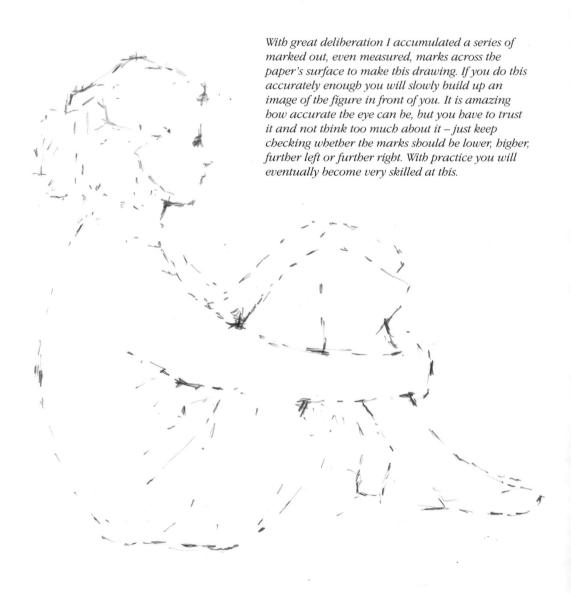

*With great deliberation I accumulated a series of marked out, even measured, marks across the paper's surface to make this drawing. If you do this accurately enough you will slowly build up an image of the figure in front of you. It is amazing how accurate the eye can be, but you have to trust it and not think too much about it – just keep checking whether the marks should be lower, higher, further left or further right. With practice you will eventually become very skilled at this.*

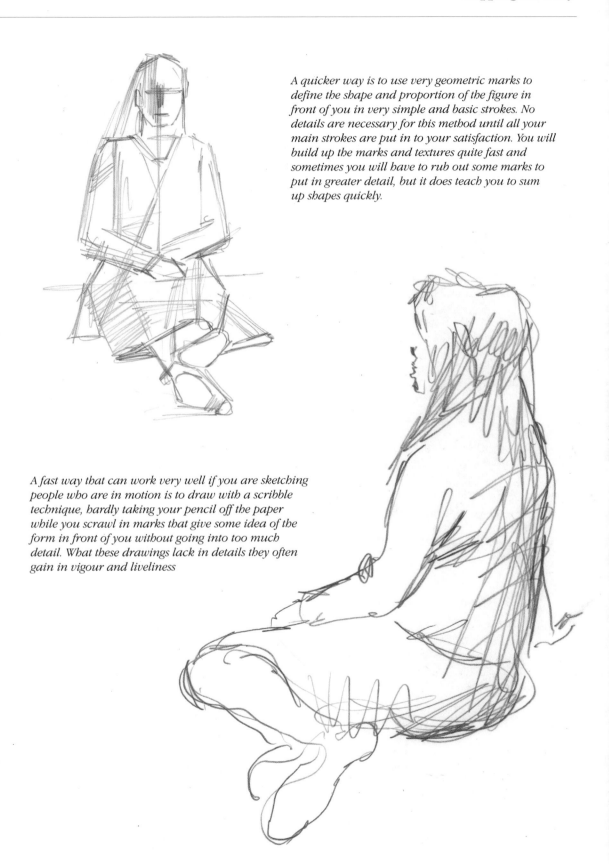

*A quicker way is to use very geometric marks to define the shape and proportion of the figure in front of you in very simple and basic strokes. No details are necessary for this method until all your main strokes are put in to your satisfaction. You will build up the marks and textures quite fast and sometimes you will have to rub out some marks to put in greater detail, but it does teach you to sum up shapes quickly.*

*A fast way that can work very well if you are sketching people who are in motion is to draw with a scribble technique, hardly taking your pencil off the paper while you scrawl in marks that give some idea of the form in front of you without going into too much detail. What these drawings lack in details they often gain in vigour and liveliness*

## DRAWING WITH TONE

So far we have been examining different ways of drawing with line, so it is quite a departure to think about creating the figure almost entirely from tone. Instead of following an outline, you will need to consider instead laying down tones that will not only describe volume but also define edges. You can use a range of media to do this, ranging through soft pencil smudged with a stump, charcoal, crayon, ink and wash, and an eraser to define some of the lighter areas by going over the tones and reducing them.

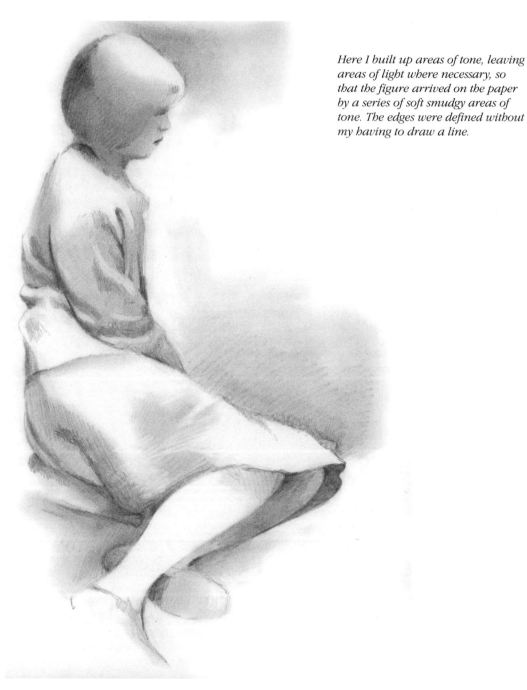

*Here I built up areas of tone, leaving areas of light where necessary, so that the figure arrived on the paper by a series of soft smudgy areas of tone. The edges were defined without my having to draw a line.*

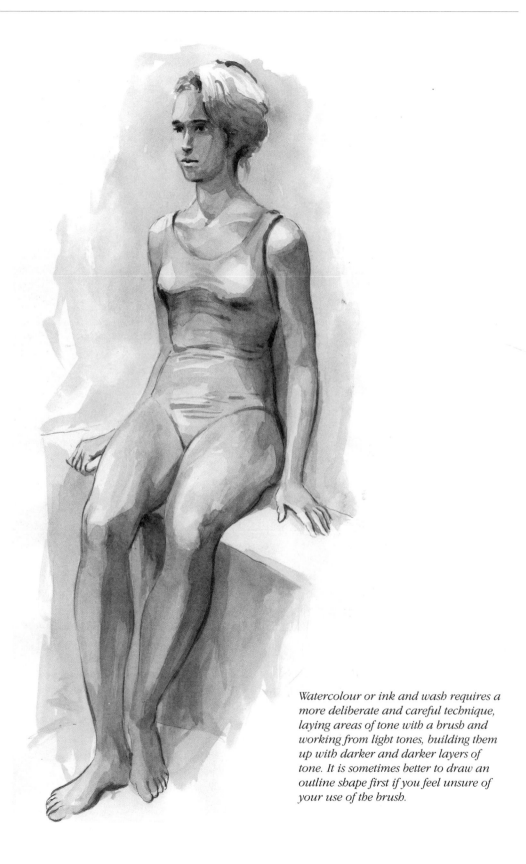

*Watercolour or ink and wash requires a
more deliberate and careful technique,
laying areas of tone with a brush and
working from light tones, building them
up with darker and darker layers of
tone. It is sometimes better to draw an
outline shape first if you feel unsure of
your use of the brush.*

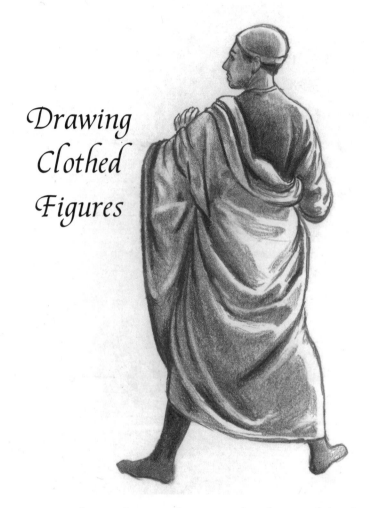

# Drawing
# Clothed
# Figures

*I*n the previous section we explored ways of drawing
the human figure in its basic, natural form, but most
of us do not have easy access to nude models; even
professional artists draw from life only part of the
time. So this section of the book looks at drawing the
human form with clothing, which is how we are most likely to
find our models.

One of the problems with drawing the clothed body is that
people often wear garments which tend to hide, or seemingly
change the shape of the figure. Artists, in their efforts to see
the essentials of anything that they draw, must be able to make

educated guesses from the clothing about the shape of the body beneath. So, even with bulky or clumsily shaped garments, it is crucial to understand the form supporting the clothes, rather as the understanding of the skeleton and musculature of the body under the skin informs our drawings of the surface of the unclothed figure. It is these studies that help you get the shape of the clothed body correct, as you will know about the shapes and bumps of the body that cause the material to behave in a certain way.

The softness or stiffness of different materials needs to be observed too; showing how they drape or crease around the body and limbs. The materiality of the garments that people wear can, in fact, help to show what the limbs and torso are doing under the clothing.

At different times in history, fashions in clothing have tended to either reveal or disguise the shape of the figure. In the Napoleonic period in Europe, both men and women were dressed variously in flimsy and revealing costumes; in the Victorian era, the male figure would be quite clearly shown by close-fitting tailored clothes, whereas the female figure was usually hidden under shawls, crinolines and bonnets. During the first half of the last century, although clothes were reduced in bulk from those of Victorian times, men generally wore loose fitting, heavily tailored suits and women covered up or revealed parts of their figures in alternative decades. Nowadays, there are so many variations of dress that you may find people showing off their figures one day and hiding them under heavy or loose garments the next.

Whatever the prevailing fashion, as artists we need to understand how clothing sits on the human figure and to use the sharpened perception that should come from constant practice at drawing both the clothing and the figure underneath. So let us look at how this might be done.

## THE DRAPED FIGURE

With a draped figure the artist has to look for the points that help to reveal the shape of the figure. Although the figure may be entirely hidden by opaque fabric, the arrangement of the fabric can still inform you of the disposition of the form beneath. Notice what happens to the cloth as it drapes across the figure and the effect of the weight of the cloth on its folds.

*This figure draped with a soft woollen-type cloth has many points that give clues about the proportions of the body. (1) and (2) are the points where the main weight of the material is hanging over the shoulders and so the angle and width of the shoulders are easily seen.*
*The model has her weight mainly on her right leg, which has the effect of producing a contra-posto position where as the hip on one side is pushed up, the shoulder on the other side is also raised. Consequently, in this case the model's left shoulder is higher than the right.*
*This also means that the right hip is thrust further forward than the left hip and the arm resting on the hip pushes out the material on that side (point 4). The model's right breast also pushes out the cloth, albeit more softly (point 3). On the other side, at point 5, the bent elbow of the arm which is raised to grip the material as it is draped around the neck also creates a pushed-out fold. The bent left leg of the model catches the long fold as it drapes around the body at the knee (point 6). Then the weight of the cloth produces folds around the feet where it touches the ground either side of the toes, which protrude beyond the hem of the material.*

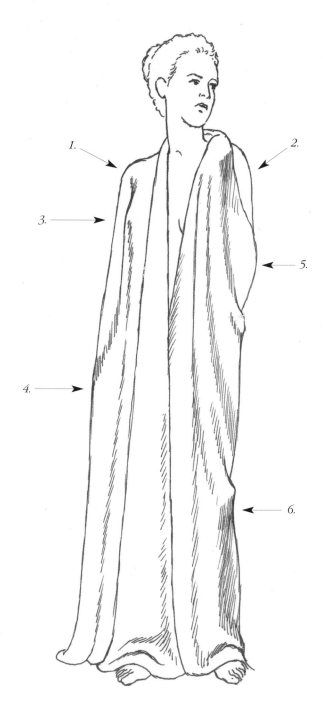

*Looking at the second figure with its shaded area showing the outline of the figure under the cloth, it is easy to see how the weight and downward pull of the material creates the heavier folds at points (7), (8) and (9).*

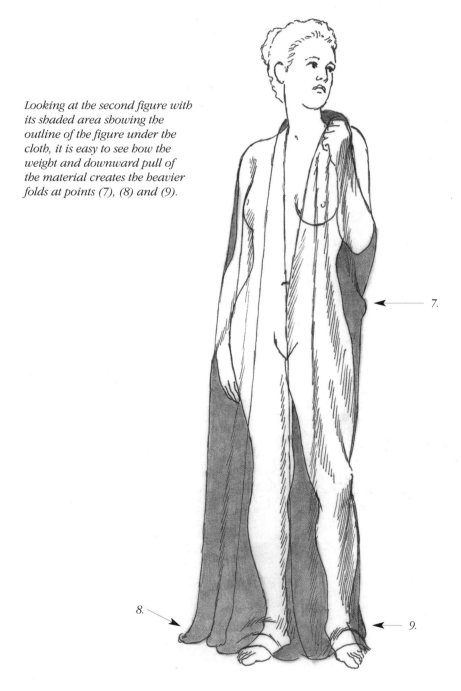

7.

8.

9.

Studying classical drapery in museums and books will give you a range of subjects to consider. Taking specific works, set yourself the task of noting how the artists have used drapery to describe the form and motion of the human figure beneath it. Your own drawings will benefit greatly from such close analysis of the work of artists from earlier eras.

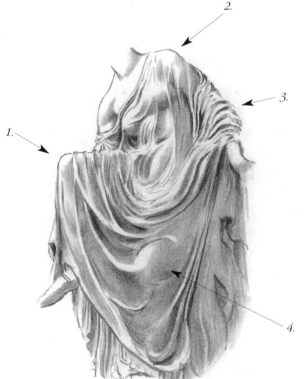

*This example taken from an Athenian sculpture (410 BC) of a Nike, or Victory, figure shows how the folds of the thin cloth reveal the figure underneath. At point 1, the raised knee of the figure projects outwards as the female figure leans over to fix her sandal. This knee creates a series of large folds across the whole width of the figure from the opposite elbow (point 3) and produces the main curve of the drapery. Notice also how the cloth draped over the shoulder at point 2 folds and reveals the upper part of the torso showing both breasts and the curve of the stomach area. At point 4, the other knee creates a large area of cloth pushed outwards with sharp folds created either side and above. The cloth falls in many close, narrow folds around the arm and elbow point 3.*

*This example of another active Greek figure, dating from 160 BC, shows how the tie around the waist of the figure (point 1) pulls in many small sharp folds in the draped cloth, both above and below the waist. The figure's backward-thrust leg (point 2) disturbs the heavier, longer folds of the main swirl of the skirt, which then produces a rhythmic curve of folds hiding the other leg.*

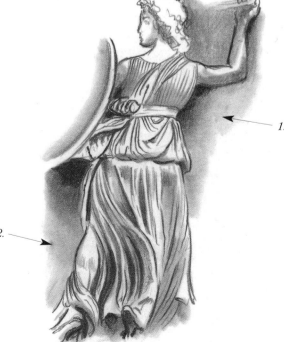

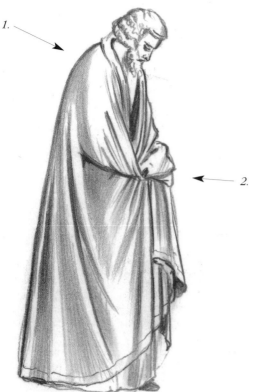

1.

2.

In the Giotto figure (AD 1305) the material is draped in a similar way to our very first draped figure, hanging off the shoulders (point 1), in simple, heavy, long folds. The way the hands are holding the cloth bunched towards the front of the figure (point 2) creates the deep pulled-in fold under the forearm and the shorter, tighter folds hanging down from the hands at the front of the figure.

The Roman figure (430 BC) shows a toga draped around the shoulder and pushed out by the right hand which projects over the edge of the cloth (point 1), creating strong, lateral curves almost like a balcony. The hand on the hip under the cloth (point 2) pulls the folds around the forearm and creates several sharply folded pieces of drapery below along the more relaxed leg (point 3). The hip pushed outward (point 4) creates the more open folds down the figure's right side.

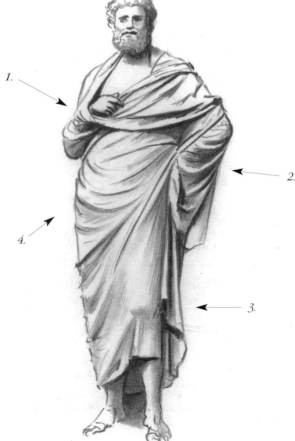

1.

2.

4.

3.

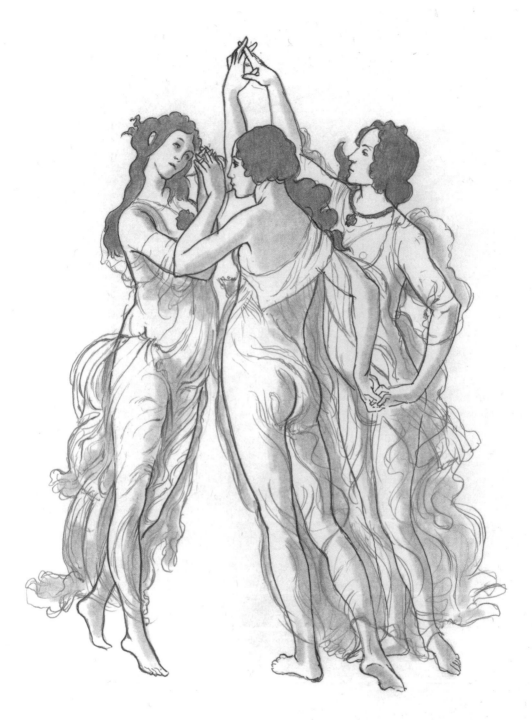

This famous trio of goddesses from Botticelli's *Primavera* shows a variant on the clothing where, instead of hiding the limbs, the flimsy chiffon-like garments show quite clearly the shape of the body. I have simplified the picture by making the hair one tone and outlining the figures in black. The folds of the robes are drawn in very lightly, as they are in the painting. A good reproduction of this will give you a better idea of the subtlety of the concept, but the drawing here does give some idea of the way the fine folds float around the limbs and are formed by their substance.

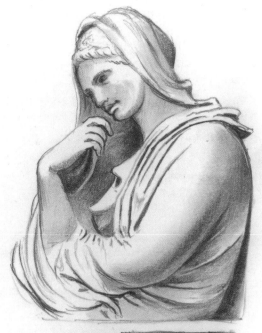

The drawing from a Greek statue (4th century BC) shows how the folds of cloth drape down from the head to the neck and then around the shoulders and back. You can see how the bent arm pulls the folds across the body.

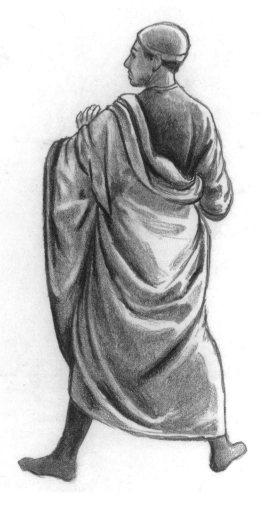

The man from Ghirlandaio's Stories of the Virgin fresco is a much more substantial piece of materiality, the heavy, probably woollen, cloak hanging in large solid folds that swing from side to side across the stalwart figure of the man. It is easy to conceive of the three-dimensional figure under the substantial material.

FIGURES AT REST

This collection shows figures that are all resting, in either a seated or prone position. Dating from the 18th century to the present day, the paintings are less classical in nature and the attire of the figures is less formalized. Nevertheless, the same rules apply as to the formation or gathering of cloth around the torso and limbs.

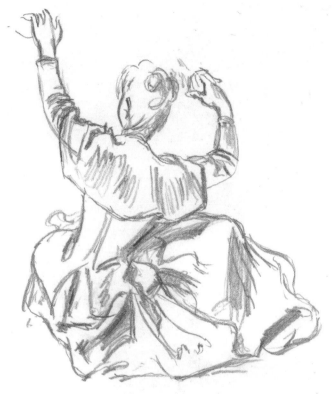

*In this drawing after the 18th-century French artist Watteau, a girl is about to be helped up from a sitting position, her silky but voluminous skirts all bunched up around her bent legs. The bodice is figure hugging, with the cape and sleeves of a stiffer quality, making very strong folds where the arm bends. Watteau's loose, quick lines make us realize this was drawn from life and he has captured the effect of formal dress material in a most economical way.*

*A more schematic method of drawing by Tamara de Lempicka, the 20th-century artist with Vorticist or Futurist tendencies in her work, shows the large rounded folds across the girl's short loose dress with softer folds around the resting arms. The dress is very simplified in the treatment but nevertheless the main folds as they sweep across the body from shoulder to hip and across the lap give a very clear idea of the sitting posture of the figure underneath. The way the edge of the skirt curves across the legs helps to provide clues as to the shape of the limbs.*

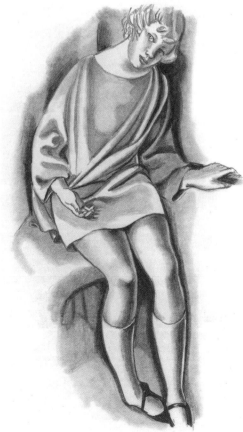

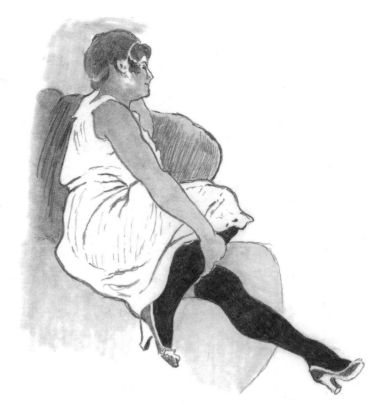

The graphic painting style of Toulouse Lautrec gives a clear understanding of the creases and folds in the girl's thin cotton petticoat, drawn with the minimal of modelling but expressing very clearly the solidity of the body under the garment.

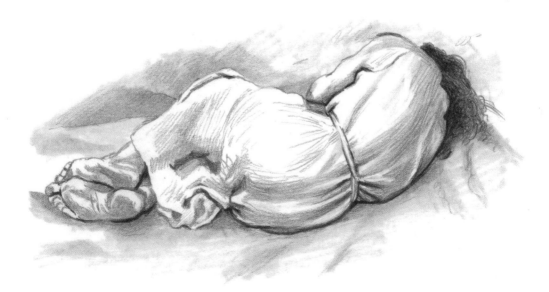

Lucien Freud's curled-up sleeping figure with its cotton dressing gown wrapped closely around it also gives a very unvarnished vision of the bulk of the body under the soft towelling material. The cluster of small, almost angular folds behind the back of the legs contrasts well with the pulled-out areas across the haunch and back, which again contrast with the cinched-in folds at the waist. This is a well-drawn way of depicting the modelling of the body disguised by the wrappings of clothing.

EVERYDAY CLOTHING

Your main source of models will probably be figures clad in loose modern garments such as skirts, trousers and loose coats, and here your task can be harder. These do not reveal the figure underneath in quite the same way as the rather more draped clothing on the previous pages, but nevertheless there are clues in the shapes. Unless the subject is rather stout, the characteristic shapes shown by clothing tend to be the bony parts of the figure.

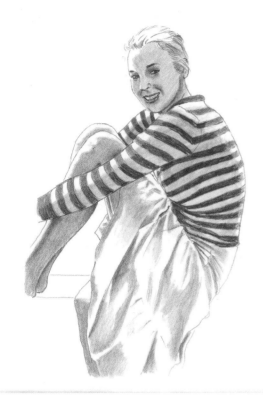

*This drawing of a girl sitting on a window sill with her knees clasped up to her chest shows the effect of a loose lightweight skirt rucked up in small folds and then hanging in open undulations down over the wall. You can see how the legs join to the torso, but only by inference. The upper close-fitting garment is also very interesting in that the horizontal stripes curving round the arms and torso give a very clear idea of the shape of the body underneath.*

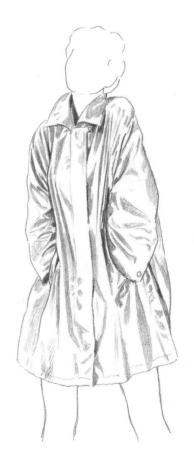

*The loose lightweight coat hugged around the figure of the girl with her hands deep in her pockets creates a tent-like shape, with the sharp, narrow folds giving some indication of the shoulders, the bend of the arms and a slight curve indicating the chest.*

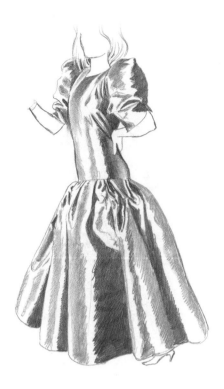

The stiff taffeta dress shows only the upper part of the body, but this is almost reduced to a tube shape. The skirt is so bouffant and stiff that it could disguise anything underneath and the only clue to the legs would be where the feet might be seen.

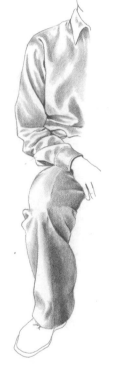

With the shirt and trousers, the lateral folds give a clear indication of the fairly bony arms under the shirtsleeves while the loose flopping folds of the lower part of the trousers define the knee. The thigh is shown because the leg is bent and the trouser is stretched across its muscles.

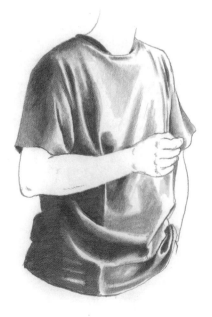

The more masculine garments here are two very typical pieces of materiality, part-disguising and part-revealing the shape underneath. The T-shirt shape is loose and floppy, and the solidity of the shoulders and chest is obvious. The way the folds hang down round the lower part of the torso leaves very little to go on to discover the figure underneath. The only noticeable feature is the slight curve of the edge of the shirt around the hips.

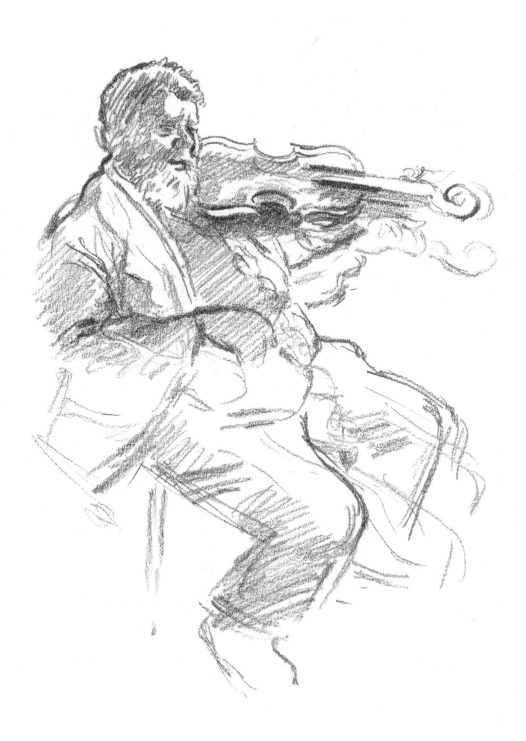

*Despite the sketchy nature of this charcoal study after Degas, we gain an immediate understanding of the bulk of the violinist enveloped in his sturdy 19th-century suit. Although the suit is cut, like all suits of the time, to hide the figure, the solid dimension of the man is not hidden from us; the rounded quality of the sleeves and legs of the garments and the generous protuberance in front make it very obvious that the clothing is covering a sizeable body.*

*This figure after Lucian Freud is covered by a raincoat, jumper and trousers, which go a long way towards disguising the figure beneath. The only clear indication of the figure is at the shoulders and where the arms bend, so we can tell that the subject is quite thin. The coat is loose and thick enough to create heavy folds around the body. The trousers are also loose and shapeless and we could be looking at a mere skeleton hidden by clothing. It is not an easy task for the artist to see such a figure beneath the costume, but Freud is a significant artist who has still managed to give some feel of the body.*

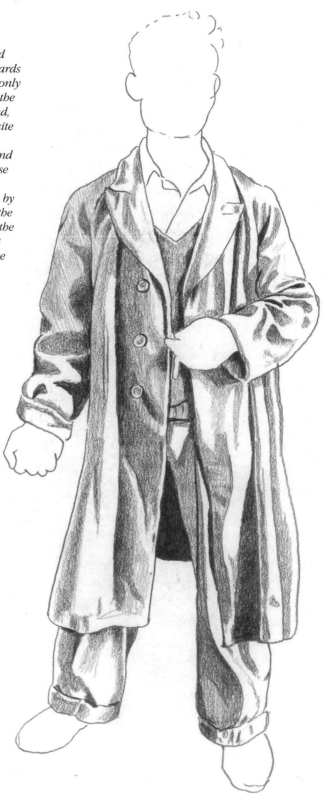

## DESCRIBING AND DISGUISING

These two pages show the contrast of how the human body can be represented quite graphically, by the way the form is dressed or, at the opposite extreme, can be disguised to appear very different to its real form. This interesting variation on the use of clothing to portray or distort the figure has been noticeable throughout history, with costume moving from one extreme to the other over the centuries.

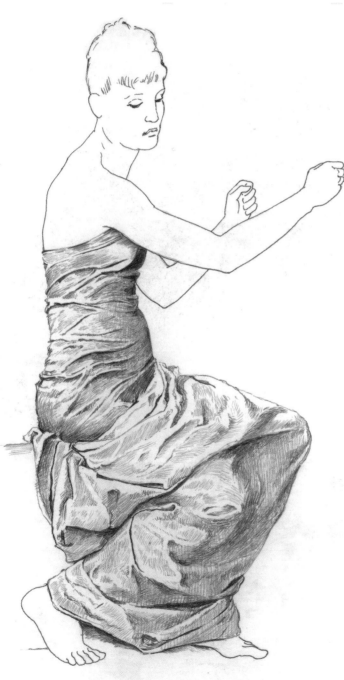

*In this example the artist Otto Greiner dressed his model in such a way as to show clearly how the female figure looks wrapped in thin cloth which accentuates the shape. The lateral wrinkles and folds pulled tightly around the body give a very sharply defined idea of the contours of the torso, while the softer, larger folds of the cloth around the legs show their position but simplify them into a larger geometric shape so that the legs form the edges of the planes of cloth.*

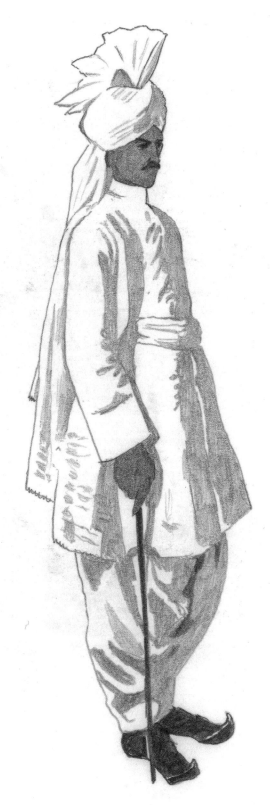

This Indian official is dressed in an elegant costume that seems to be designed to hide the real shape of its wearer. The turban gives extra height, but the close fit of the jacket around the shoulders opening up to a wide skirt, accentuated by the folds of cloth hanging down the back from the turban and the very wide trousers, produces a figure that is widest at the knees and narrowest at the shoulders. This is almost the reverse of the masculine figure underneath.

USING SUBTLE VOLUME

Shown here are two drawings after Thomas Gainsborough and Camille Pissarro. Both were master draughtsmen capable of showing form with very little in the way of significant marks; they managed to convey bulk and solidity without having to labour the point with highly detailed contour hatching.

*The Gainsborough is of a fashionable lady drawn at Richmond, glancing back at the artist as she walks past in her beautiful floating silk dress and big black hat. The solidity of the body under the garments is implied by little touches of chalky lines, smudged tones and white body colour, which tells us of the fascinating form of this rather coquettish young woman. What is very obvious is that this is a human body, youthful and light-footed but also substantial.*

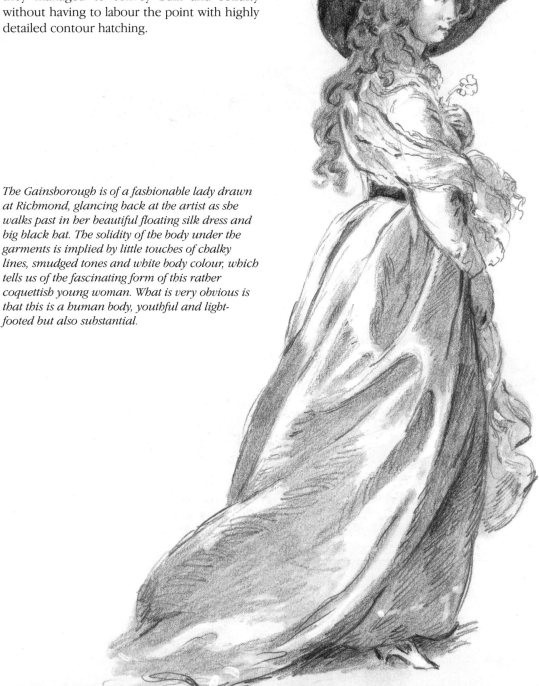

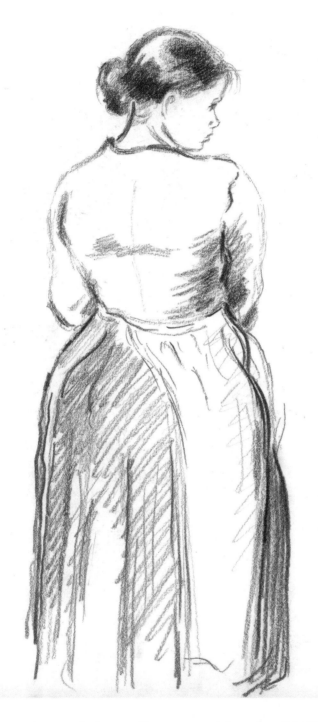

Pissarro's young peasant woman is drawn with the maximum of economy and the minimum of marks on the paper. Although the lines are very sparse there is no doubt in our minds that this is a solid, earthily substantial young woman with sturdy limbs and torso. The shoulders look strong and the waist solid. Although there are probably layers of petticoats under the skirt, it looks as though she is probably well developed in the hip area as well. Despite the scarcity of marks to depict it, this body looks firm and strong; our eyes fill in all the spaces to see her as the artist did.

# *Drawing From Life*

*D*RAWING FROM LIFE IS THE TIME-HONOURED way for students to improve their skills, and even the greatest artists recognize the need to continue the practice. There is no better way to develop your skills of observation and your hand/eye coordination.

There are many ways of drawing from life, both formal and informal. The majority of artists, and particularly students, carry a sketchbook around with them. And whereas professional artists use sketchbooks in the more formalized way of keeping them as reference sources, even they often

carry a small one around just in case the opportunity for a quick sketch presents itself.

There is no substitute for drawing directly from life; although copying photographs and other drawings is good practice, it does not give the heightened perception that comes from drawing the real thing. Drawing the world about them is the way artists learn about life, rather like the scientist does by testing and observation.

I found that when I was a student, carrying a small sketch book with me at all times was very useful as I would make drawings of figures in tube trains, buses, shops and parks – wherever I happened to be. You soon get used to drawing in such a way that other people hardly notice what you are doing.

So, in order to improve your figure drawing, consider the possibilities for finding models. One obvious way of doing this is to go out and look at people en masse. Find a place that is busy with human activity and make as many drawings as quickly as you can to get the essence of the figures' proportion and movement. For this exercise, just draw the main shape rather than details.

For more considered, detailed study, joining a local life class is ideal. These will usually offer both nude or clothed models, and you will get the benefit of two or three hours steady drawing, with expert advice from the tutor. If you cannot find one available in a local college, consider forming an art group with other like-minded artists and splitting the cost of the model between you.

If this is not possible or practical, the next best thing is to persuade a member of your family or a friend to pose for you. You may not be able to expect too much from them as far as the time they will give you and the poses they will adopt, but if any of your friends are also interested in drawing there might be a possible trade-off of alternating as artist and model.

MAKING QUICK SKETCHES

One of the best ways to learn to draw figures without worrying about the results is to take your sketchbook to a busy event in the summer where people are enjoying their leisure time. You will see all sorts of characters, both stationary and in motion, and if they are engrossed in their doings you will not feel self-conscious about sketching them.

Draw in as few lines as you possibly can, leaving out all details. Use a thick, soft pencil to give least resistance between paper and drawing medium and don't bother about correcting errors. Keep drawing almost without stopping. The drawings will gradually improve and what they will lack in significant detail they will gain in fluidity and essential form. Only draw the shapes that grab the eye. Don't make choices; just see what your eye picks up quickly and what your hand can do to translate this vision into simple shapes. This sort of drawing is never a waste of time and sometimes the quick sketches have a very lively, attractive quality.

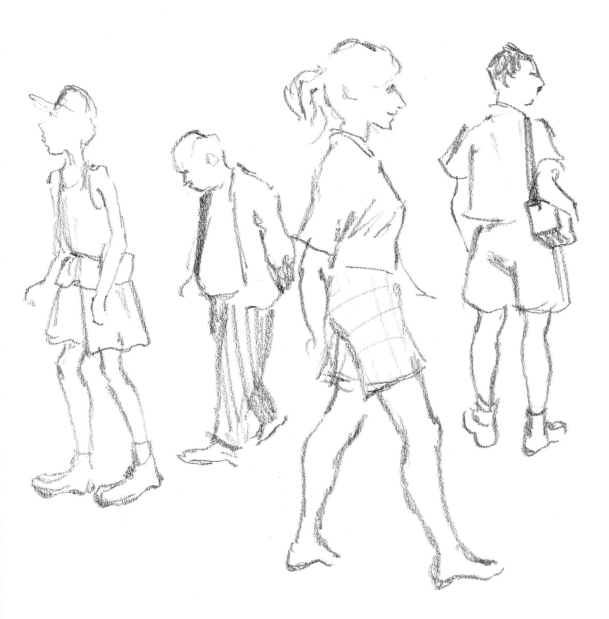

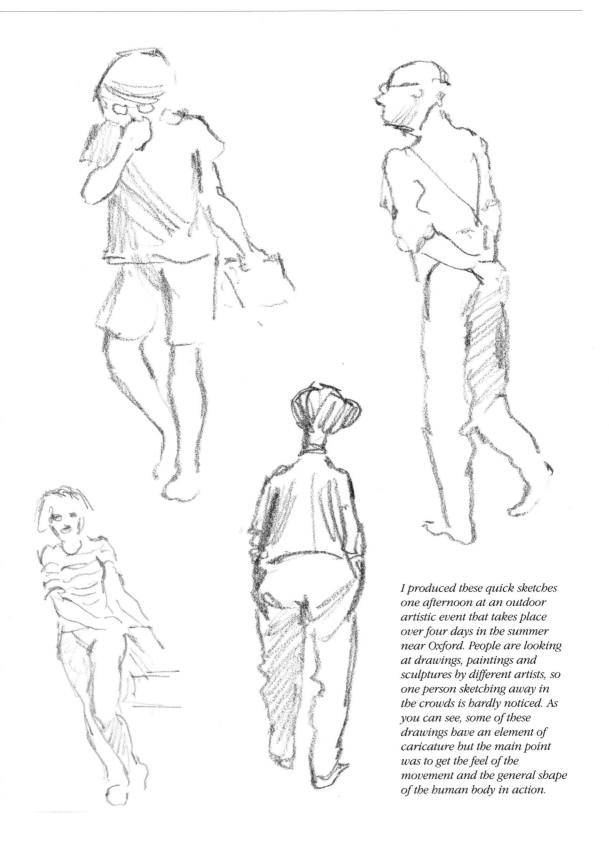

I produced these quick sketches one afternoon at an outdoor artistic event that takes place over four days in the summer near Oxford. People are looking at drawings, paintings and sculptures by different artists, so one person sketching away in the crowds is hardly noticed. As you can see, some of these drawings have an element of caricature but the main point was to get the feel of the movement and the general shape of the human body in action.

LIFE DRAWING CLASSES

Drawing from life is the foundation of all drawing and of course this is particularly so in the case of figure drawing. The human body is the most subtle and difficult thing to draw and you will learn more from a few lessons in front of a model than you ever could, drawing from photographs or the like.

In most urban areas, life drawing classes are not too difficult to come by and if there is an adult education college or an art school that offers part-time courses it would be the most excellent way in which to improve your drawing. Even professional artists will attend life drawing classes whenever possible, unless they can afford their own models. These classes are however limited to people over the age of 16 because of the presence of a nude model.

One of the great advantages of life classes is that there is usually a highly qualified artist teaching the course. The dedication and helpfulness of most of these teachers of drawing will enable you to gradually improve your drawing step by step, and the additional advantage of having other students from beginners to quite skilful practitioners, will encourage your work by emulation and competition.

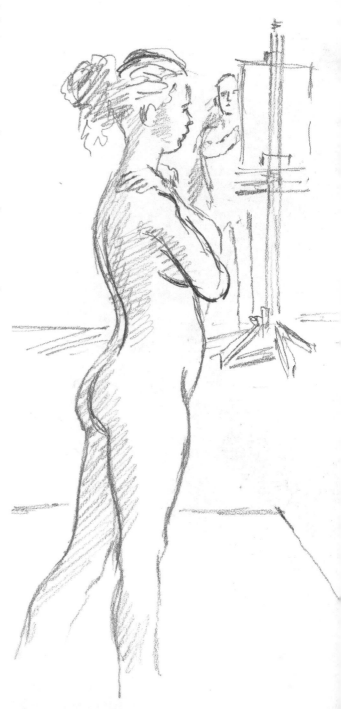

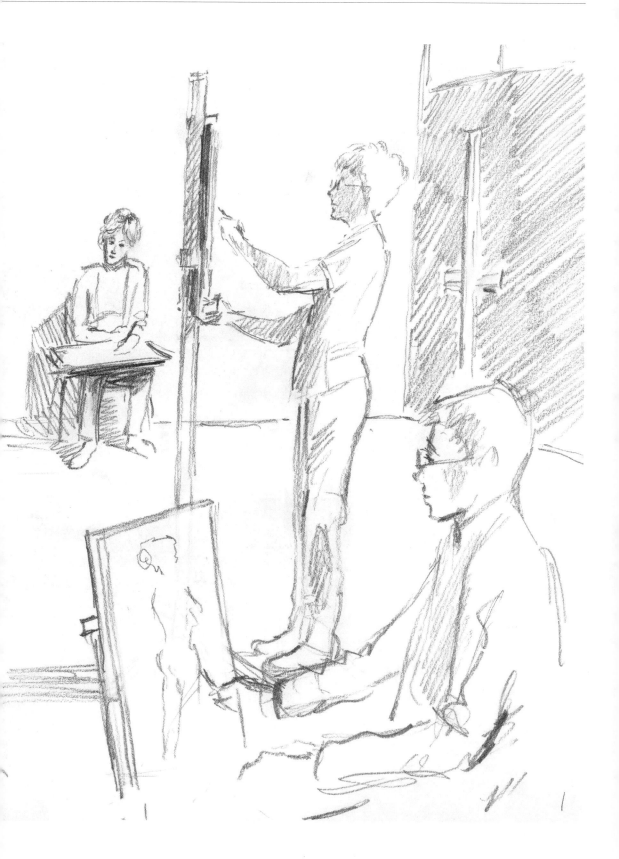

DRAWING FRIENDS

The greatest difficulty when drawing your friends is to persuade them to sit still for long enough. A professional model is accustomed to holding a pose for quite a while, but you may need to offer your friends some inducements to get them to do the same. Don't try to make them remain still for too long, though – even professional models get rests in between posing and someone not used to it may find it difficult to sit still for longer than 20 minutes. Nevertheless, in that time you should be able to take in the whole figure, even if it is not very detailed, and you will gain excellent drawing practice.

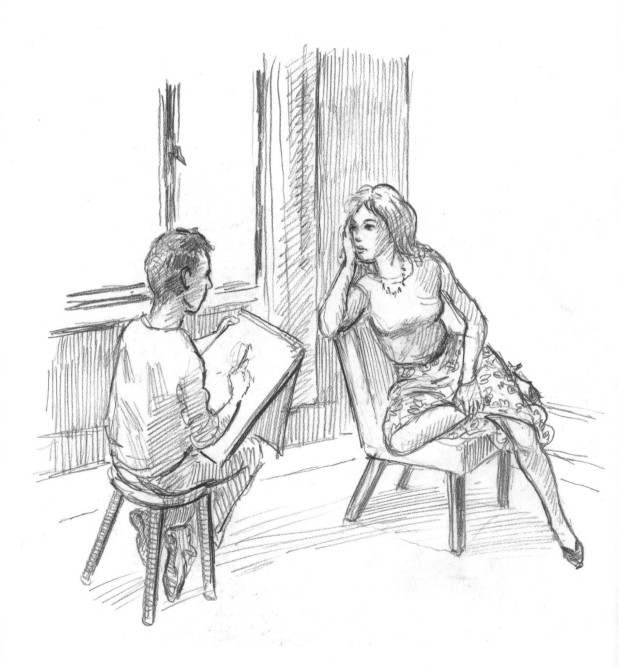

Indoors, make sure that you sit near a large window but again without direct sunlight falling into the room. Place yourself side on to the window and get your friend to sit in an interesting but comfortable pose – not too complicated or they will find it difficult to maintain the position.

Draw outdoors as well when you are able to because the light is different and you can often see much more clearly when the light is all around the figure. Try to do it on a day on which the sun is not strong: a cloudy warm day is best, because the light is even and the forms of the figure show more clearly.

## LIGHTING THE MODEL

In order to make your drawing work more effectively it is necessary to take the way the light falls onto the figure in to consideration. Natural light is the norm in life drawing, except in winter when it may not be available for sufficient hours in the day. Most artists' studios have north-facing windows because they give light, without the harsh shadows caused by sunshine. With north light the shadows tend to be even and soft, showing very clearly quite small graduations in tone so that the changes of surface direction can be quite easily seen.

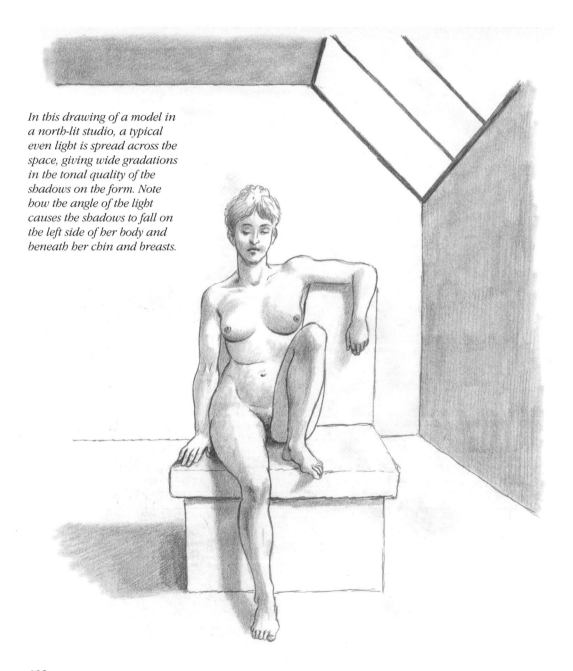

*In this drawing of a model in a north-lit studio, a typical even light is spread across the space, giving wide gradations in the tonal quality of the shadows on the form. Note how the angle of the light causes the shadows to fall on the left side of her body and beneath her chin and breasts.*

## LIGHTING FROM THE SIDE

This picture gives a clear indication of how strong directional light produces harsh shadows and very brightly lit areas. This can produce very dramatic pictures: the Italian artist Caravaggio, for example, was known to have had massive arrays of candlepower to light his models in order to produce his very dramatic contrasts in light and shade, known as *chiaroscuro*.

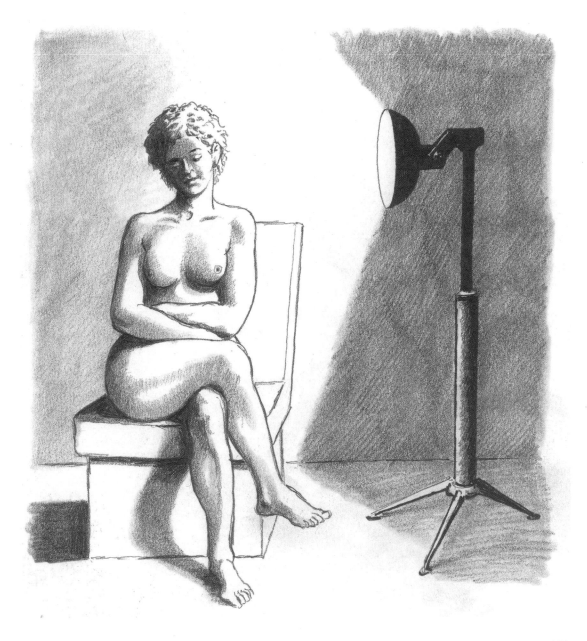

## LIGHTING FROM ABOVE

In most cases even light is the best for accurate drawing, and if you can achieve it is very useful. However, there may be occasions when this is not what you want and then you will either have to wait for sunlight to give you sharp clean-cut shadows and very brightly lit surfaces or invest in some powerful directional lamps which you can adjust to suit your purpose.

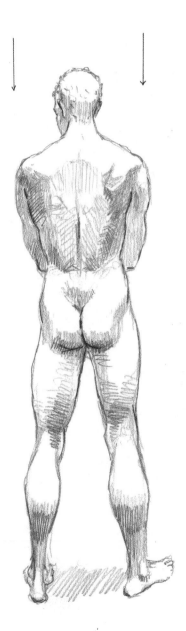

*Light from directly above the model has a very strong dynamic, but when the model is standing heavy shadows form under the shoulder blades and down the length of the back, under the buttocks and on the lower thighs and calves of the legs. Light coming only from above does not occur frequently, so the standing figure will also look unfamiliar. When the model is lying down the effect is not quite so dramatic and looks more natural.*

## LIGHTING FROM BELOW

Lamps will give you the chance to explore dramatic lighting effects that strongly influence the mood of your drawings, but light that is diffused shows more graduation of tone than direct light. Soft candlelight gives a very different effect from floodlight. Explore a range of different light sources, using different angles and strengths of light, and noting how they affect how the shadows appear on the model's body.

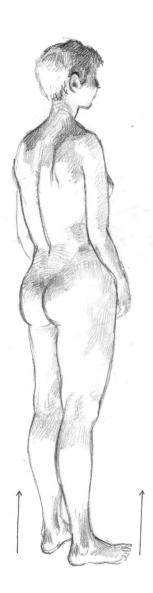

*Lighting from below is very unusual and looks rather unnatural. The calves, buttocks and middle back get most of the light, but it also falls on the back of the head and, at the front, the lower belly, ribcage and breasts. There is also a lot of light under the chin, which gives a rather ghostly look. This kind of dramatic lighting from below was often used for the demonic characters in old horror films.*

## FRONT AND BACK LIGHTING

Light sources coming from behind or in front of the model present the most difficult challenge to the artist in terms of drawing the form and substance of the figure. When the light is directly in front of the model the effect is to flatten the form so that the obvious planes of light and shade tend to disappear into the overall light tone. Consequently, this lighting will result in a drawing that is more of an outline, with just a few subtle tonal areas shown. Lighting from behind has a similar effect, but in reverse. This time the only area with light shining on it is the edge of the form – usually the top edge.

*With the model lit from the front, there is a large area of light tone with a few tiny edges of darker tone where a curve of the body turns away from the light.*

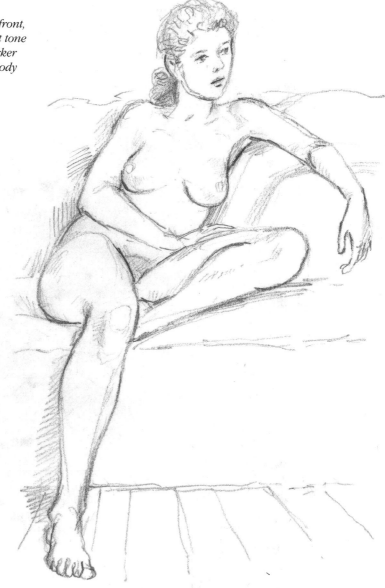

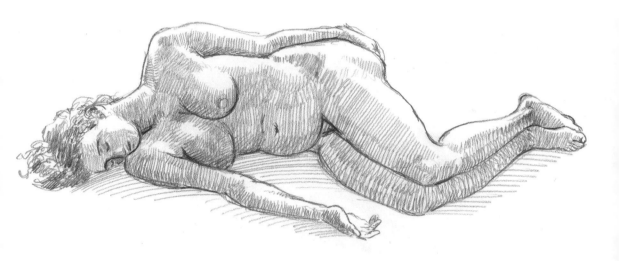

In this reclining model I have depicted slightly more line along the edge than you might see when the drawing is entirely contre jour *(against the light)* so that it is easier to understand the point. Sometimes you might only see an outline silhouette with bright light all around. The effect is exactly the opposite of frontal lighting in that the large area is of a dark tone with light edges appearing where the light hits. With both types of lighting the outline drawing is the key, so it is important to get the outline shape as accurate as is possible.

# Composition

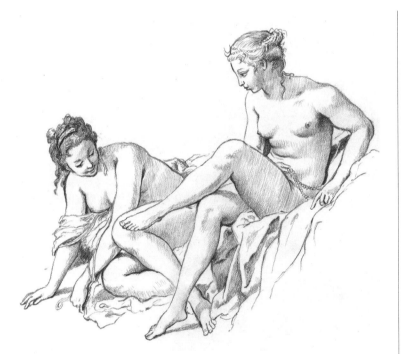

**W**HEN YOU FIRST BEGIN TO STUDY FIGURE drawing your aim is to draw the model from a range of viewpoints as you build up your understanding of how the human body looks. The information and experience you gain by doing this is of enormous help to the development of the artistic skills necessary to cope with drawing the figure. However, there will come a time when a quick drawing will no longer be the point and you will want to draw the figure either to be seen as a completed picture or to fit into a composition with other figures. This section of the

book looks at the composition of the figure both in relation to the shape of the paper you are using and in conjunction with other figures to produce a picture worth hanging on the wall.

Bringing composition into the equation requires a slightly different approach to your drawing. First, looking at the model in front of you, you will need to make sure he or she is in exactly the pose you wish to draw and then decide whether your angle in relation to the model is what pleases you most or whether you should change your position to gain a different viewpoint.

Next, you will have to consider objectively how the shape that you see will be placed on the surface that you are drawing on. Will it take up all the space or only some of it? Will the position on the paper divide up the space in an interesting way if you draw it to one side, in the middle or above or below the centre point? You are now considering the relationship of the shape of the figure within the boundaries of the surface you are working on, and in doing this you are composing your drawing as a completed picture.

This process becomes more complex when there is more than one figure to place in the picture, and as you will probably not draw them all at the same time you will have to consider their relationship to each other and how they will fit into the designated space. Sometimes it may be necessary to make several drawings of models in different poses and then assemble them to produce your composition. This may mean changing the scale of one or more of the figures, so there is quite a bit of work involved in producing an effective composition. However, no matter how much time it takes, it is the most interesting part of figure composition because it is the intellectual process of turning ordinary sketches into art.

FRAMING THE PICTURE

A very useful tool to help you to achieve interesting and satisfying compositions is a framing device such as is shown here. It can be made cheaply by cutting it out of card to any size and format that you wish to work on. Holding it in front of you to look through it and moving it slightly up and down and from left to right will allow you to examine the relationship between the figure and the boundaries of the paper and visualize your composition before you actually begin to draw. It will also help you to see the perspective of a figure at an angle to you, as the foreshortening becomes more evident. Dividing the space into a grid will assist you in placing the figure accurately within the format when you draw it.

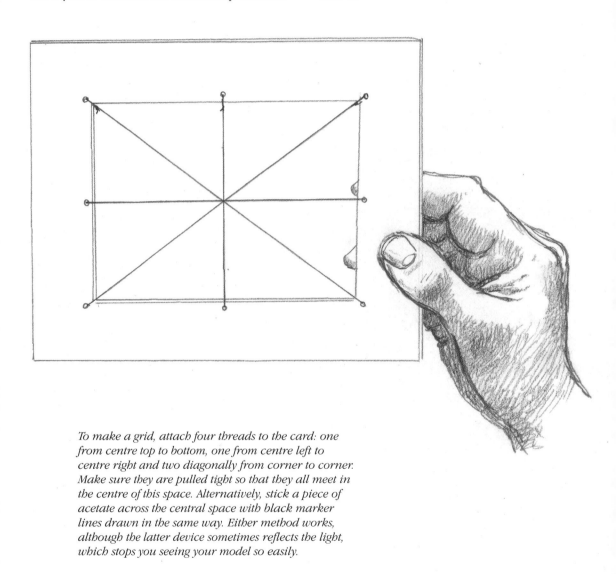

*To make a grid, attach four threads to the card: one from centre top to bottom, one from centre left to centre right and two diagonally from corner to corner. Make sure they are pulled tight so that they all meet in the centre of this space. Alternatively, stick a piece of acetate across the central space with black marker lines drawn in the same way. Either method works, although the latter device sometimes reflects the light, which stops you seeing your model so easily.*

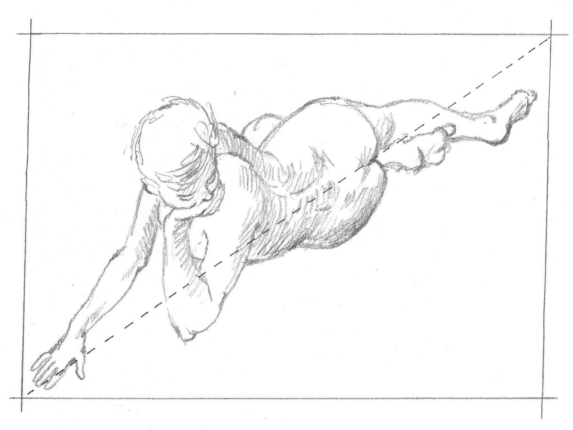

Here the edges of the frame are placed so that the figure appears to stretch from the upper right-hand corner to the lower left-hand corner. The centre of the picture is taken up by the torso and hips and the figure is just about balanced between the upper and lower parts of the diagonal line.

This would give you a picture that covered the whole area of your surface but left interesting spaces at either side. You will find that it is quite often the spaces left by the figures that help to define the dynamics of your picture and create drama and interest.

USING SIMPLE GEOMETRY

The two figures shown here still fill the whole shape effectively but now leave rather less space and create different effects. Both have a triangular composition. Looking for simple geometric shapes such as triangles and squares will help you to see the overall form of the figure and achieve a cohesive composition within your format.

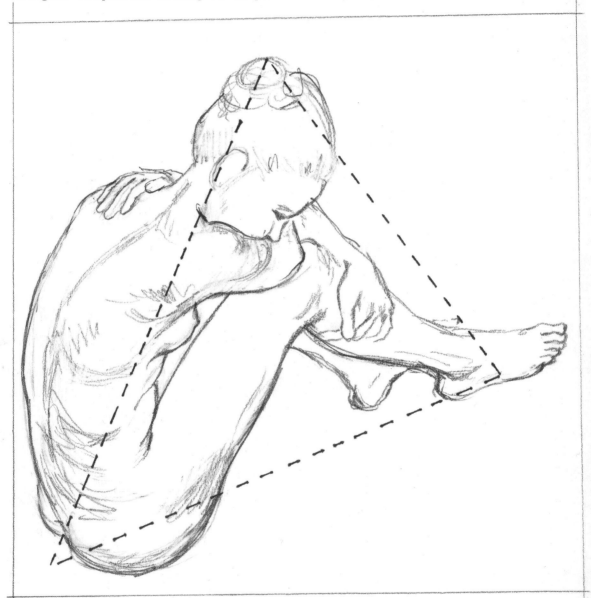

*This female figure, from a drawing by the famous medical illustrator Louise Gordon, is emotionally less obvious, but the simple triangular composition between her feet, her buttocks and the top of her head creates a calm, restful effect, with some depth of thought emphasized by her cheek resting on her upper arm. The torso, being pushed over to the left-hand lower half of the space, creates a more upward movement than is seen in the drawing of the man and the two spaces to the upper-right and lower-right corners seem to make the figure look light and almost floating in space.*

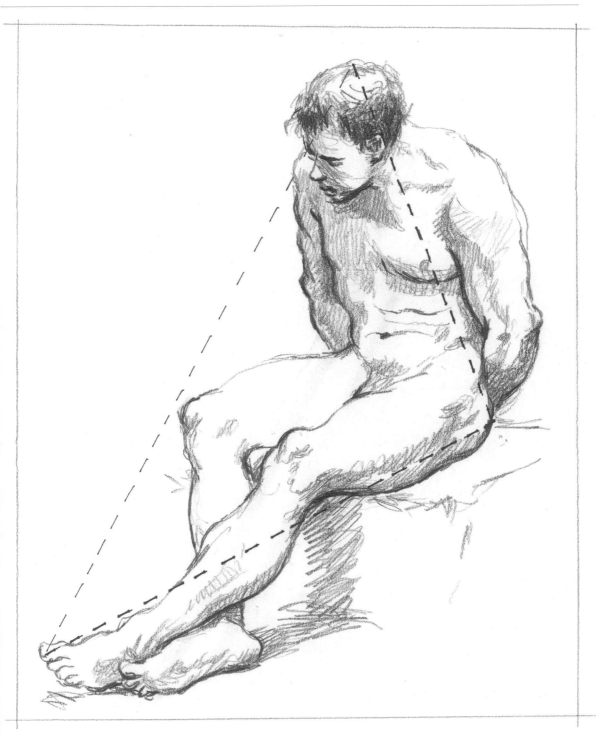

This seated man with his hands behind his back, based on a drawing by Natoire in the Louvre, fits into an elongated triangle with the corners at the top of his head, the back of his hip and the end of his toes. The bulk of his body is between the sides of the triangle, and because the emphasis is on the stretch of his legs to the bottom left-hand corner of the picture there is a strong dynamic that suggests he is under some duress – perhaps a prisoner. This simple device produces an emotional effect in the drawing.

113

## USING SPACE

Think about the areas of paper around your figures; they should fulfill a purpose rather than appearing by default. Space in your composition can suggest as much about the mood of the piece as the pose of figure itself. Planning ahead is what transforms a drawing of a figure into a complete composition that affects the emotion of the viewer.

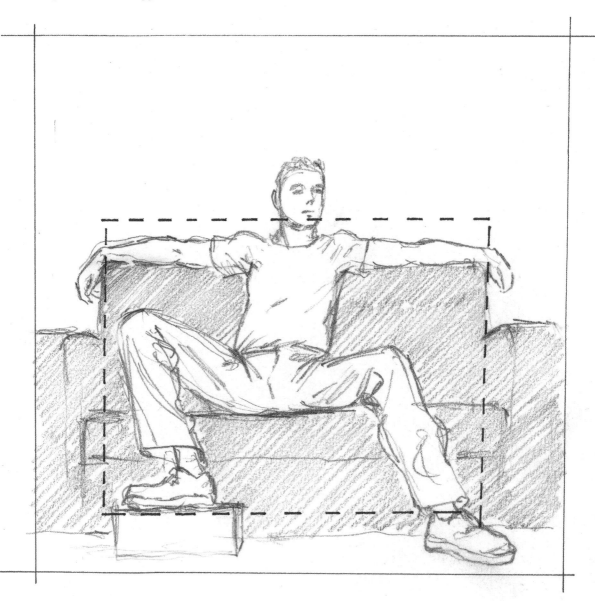

*In this rather static pose, a young man is stretched out on a sofa. The pose is very foursquare, so that he looks extended to the rectangular shape of the seat. The only elements that slightly disrupt this solid pattern are his slightly raised leg and his head, which juts up above the main shape. He is set across the bottom half of the space with a significant area of space above him, creating a very steady, immobile composition. He not only inhabits the space, he takes it over.*

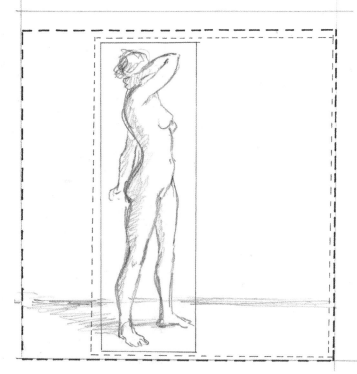

The standing figure of the girl turning away from the viewer is a gentle dynamic pose with a strong, straight, upright shape. You might choose to fit the edge of the picture closely around her, as shown by the unbroken line. This is the simplest possible composition, making the figure fit in as in a box. Alternatively, you could use a space as shown by the rectangle with the lighter broken line, which encloses a large amount of space over to her right. Here she is on one side of the composition and the space suggests airiness and the light that is falling on her from the right.

A third choice of composition, shown with the heavier broken line, places her in a space which gives her room on both sides, making a dynamic out of the larger space to the right and the smaller space to the left. It also seems to set her back into the square more effectively, lending distance to the view that didn't occur with the first two compositions.

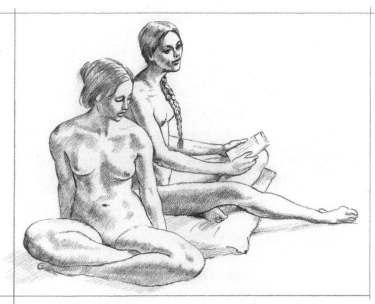

On introducing another figure into the composition you must decide whether you want one figure to be more dominant than the other or if they should have equal billing. In this simple combination called Two Sisters *by the American artist Seth Jacobs, from his book* Drawing with an Open Mind, *he shows one figure firmly in front of the other. The combined solidity of the two torsos creates a very solid mass with only the arms and* one leg of the girl further back protruding from the main shape. This interesting composition helps to define the space around the shapes of the figures and although the foremost figure has dominance in area, the rear figure's face is turned more towards the viewer which seems to make her livelier. There is a good balance of solid shape and extra interest in the face, hands and leg of the rear figure.

## USING MULTIPLE FIGURES

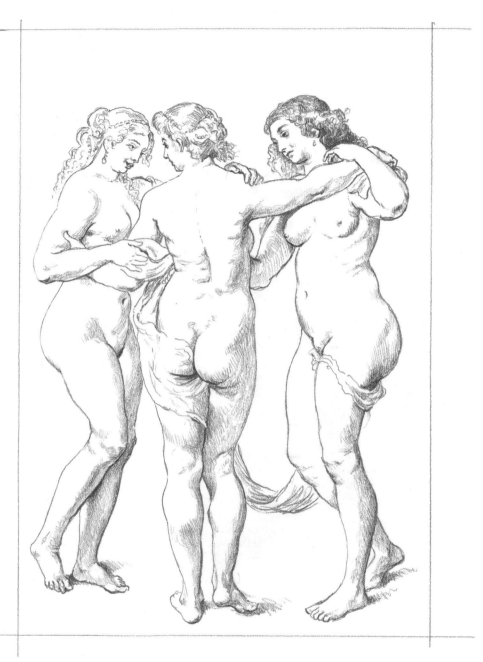

For an example of a three-figure composition I have drawn The Three Graces by Peter Paul Rubens, the great master painter of Flanders. He chose as his models three well-built Flemish girls, posed in the traditional dance of the graces, hands intertwined. Their stances create a definite depth of space, with a rhythm across the picture helped by the flimsy piece of drapery used as a connecting device. The flow of the arms as they embrace each other also acts as a lateral movement across the picture, so although these are three upright figures, the movement across the picture is very evident. The spaces between the women seem well articulated, partly due to their sturdy limbs.

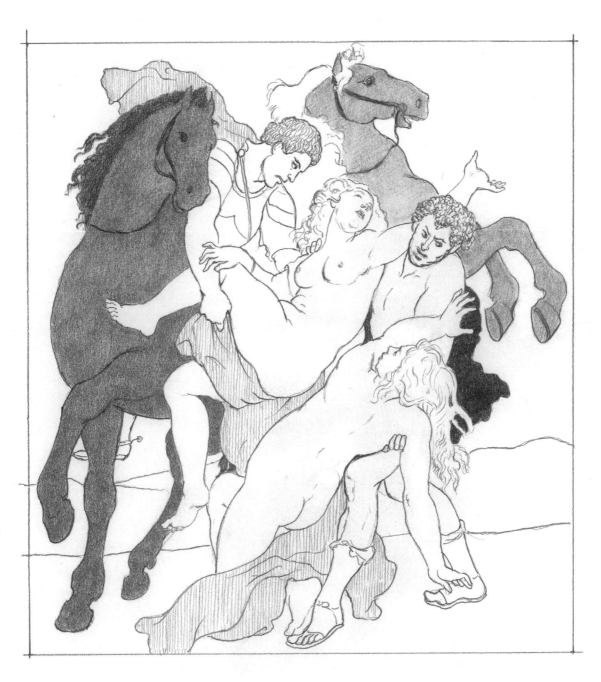

*In Rubens' picture* The Rape of the Daughter of Leucippus *the composition is of four figures; the two horses act only as devices to lift the figures off the ground. The extremely vigorous swirl of movement between the two girls being dragged off by the men, with the figures all leaning at different heights and angles, creates a tumultuous composition. The struggling bodies and the prancing horses were probably based on Leonardo's turbulent horsemen in his sketch drawings for the* Battle of Anghiari *fresco that Rubens copied.*

DYNAMIC ENERGY

When you are deciding on your composition you will have some theme in mind that will influence the way you pose and draw the model. Generally, the pose falls into one of two types: the dynamic, energetic pose or the relaxed, passive pose. Shown here are four examples of ways to produce the former, showing power, energy or movement. We understand the message they carry partly because of the associations we have with particular movements of the body and partly because of the activities the figures are engaged in; the drawings of a footballer kicking a ball and of the runner starting from the starting blocks immediately inform the eye of the dynamics involved.

*The runner exploding off the starting blocks is a sharp diagonal towards the edge of the picture, also helped by the hand and feet being right on the frame. The man with the starting gun gives a strong, stretched form from top to bottom of the picture from which the runner is angled off in a very dynamic shape.*

*In a classic fashion pose, the model is thrusting out one hip and both her elbows and bent knee are also pushed out to create strong angles all along the length of the body. Although we are aware that this is a static pose, it has the movement implicit in the angled, arched torso, the uneven bending of the arms, one to the head, one to the hip, and the attitude of head, feet and shoulders. It has the look of a dance movement, which helps to maintain the dynamic. Again the framing of the figure helps by being as close in as seems effective.*

These two figures are apparently startled, turning to see something that may be alarming or surprising. They are looking above the head of the artist, bending towards each other, their arms seeming to indicate disturbance. There is some feeling of movement about to take place, but there isn't a real source of activity; it is just a pose. However, the movements of the bodies, their juxtaposition to each other and the apparent focus of their attention outside the picture frame helps to produce a dynamic, energetic set of forms, which we read as movement. The way the figures are framed also helps this feeling, with the outstretched arm of the man almost touching the top edge and their legs being out of sight below the knees. The diagonal forms of the two torsos, leaning in towards each other away from the lower corners of the frame, also help this appearance of action.

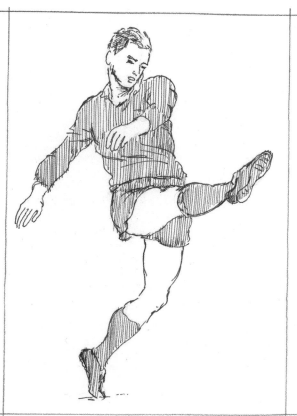

This straightforward drawing of a footballer kicking a ball with his body twisted, head down, shows that an individual figure can also produce dynamics. Again, the frame of the picture cuts in very close to the extended arms, legs and top of the head. This close framing helps to produce the movement, which seems to continue outside of the frame.

RELAXED POSES

Here the basis of the pose is more relaxed, without the active dynamism of the poses on pp118–119. This is of course a much easier way to pose a model, because most people can keep still in a comfortable reclining or sitting position. When you want to do longer, more detailed drawings you will always have to rely on more static poses.

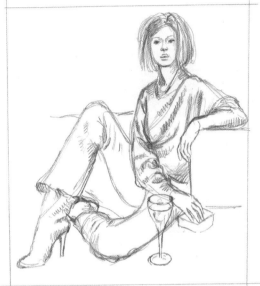

*Sitting upright on the floor, the model has her legs bent, one tucked underneath the other. Her fashionable appearance and the wine glass on the floor in front of her helps to give a static easy-going composition which looks as if she is engaged in a conversation at a party. The arrangement of the legs crossing each other and the arms bent around the torso help to give a fairly compact appearance to the arrangement.*

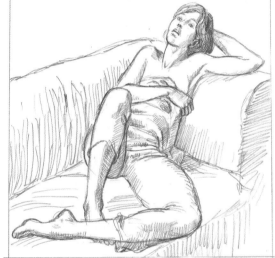

*The second figure is even more relaxed and literally laid back, with the head supported on one bent arm resting on the side of the couch and the other arm bent across the torso, holding a garment across the body. The legs are tucked around each other in a way similar to the previous pose but even more loosely arranged. The viewpoint from the foot end of the body does give a certain dynamic, but the energy is reduced to give an effect of rest. The head bent back onto the hand and the arm of the couch helps this passivity.*

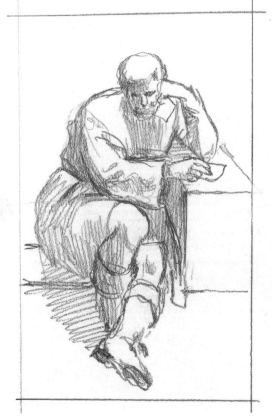

*This sitting figure taken from a Raphael design in the Vatican, is in a pose that looks both thoughtful and relaxed. The figure is of a philosopher about to write his thoughts, a pose that is obviously going to be static for some while.*

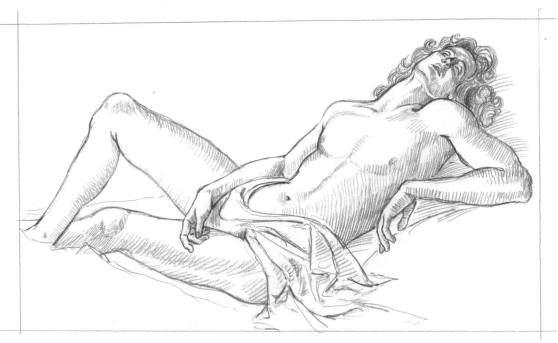

*I based this drawing on Botticelli's picture* Venus and Mars, *which can be seen in London's National Gallery, in which the reclining figure of Mars is* totally surrendered to sleep. As a reclining figure it is one of the most relaxed-looking examples of a human figure.

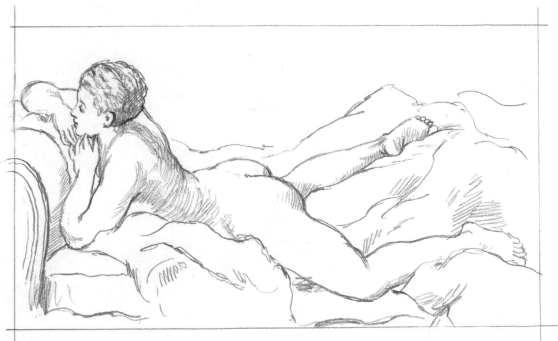

*In this drawing, based on a work by the French 18th-century painter François Boucher, a nude girl is reclining on a couch, posing for the artist. Although her head is erect, supported by her* hands, and her back is hollowed, she is in a pose that doesn't suggest action on her part at all. The side view of a reclining pose is always the most calm and peaceful in effect.

121

GEOMETRIC GROUPS

The use of geometric shapes to compose and 'control' a group of figures is a well-tried method of picture composition. It can become a straitjacket if it is taken too seriously, but it is a good method to use as a guide because it puts a strong underlying element into the picture. All the obvious geometric shapes can be used – a circle, a triangle, a rectangle, a parallelogram – although it can lead to a rather forced composition if you are not careful.

*The triangle here is formed by two figures, the female reclining to produce the base of the triangle and her head and forearm one of the corners, and the male figure producing an apex with the top of his head and an indication of one side with his arm.*

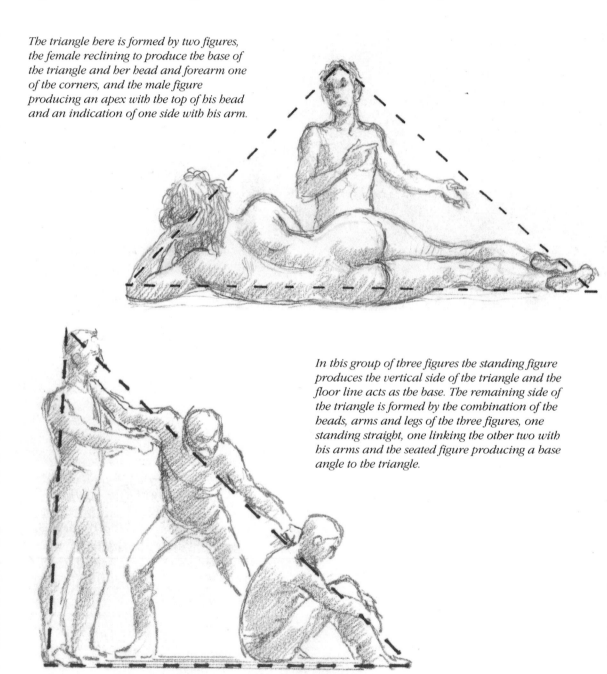

*In this group of three figures the standing figure produces the vertical side of the triangle and the floor line acts as the base. The remaining side of the triangle is formed by the combination of the heads, arms and legs of the three figures, one standing straight, one linking the other two with his arms and the seated figure producing a base angle to the triangle.*

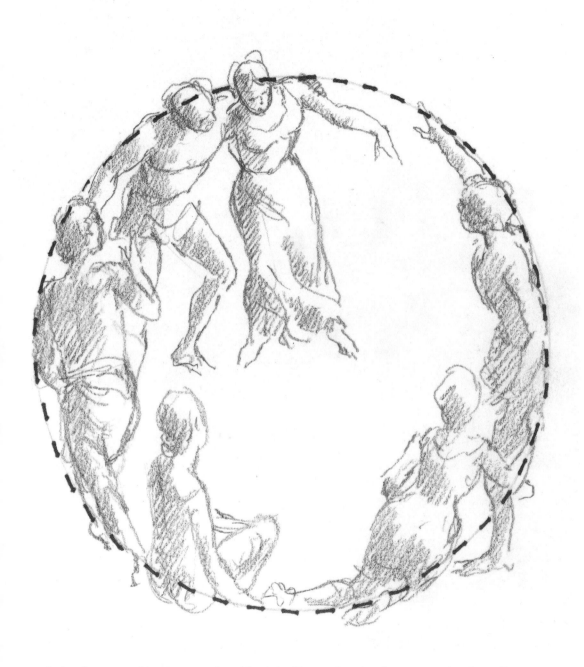

A circular composition is unusual and lends itself mostly to dance movements of groups of figures. This group of three couples suggests some formal movement which could develop into a dance, with the lower edge of the circle indicated by two females about to stand up but still sitting or kneeling. The gestures of two of the male and female figures with their outstretched arms help to create the circle and the beginning of a dynamic, dancing movement.

COMPLEX GEOMETRY

Make a practice of studying complex compositions to see where geometric shapes link to hold the figures together. Doing so will help you to think about incorporating such shapes into your own pictures as a matter of course and your compositions will benefit from this method of working.

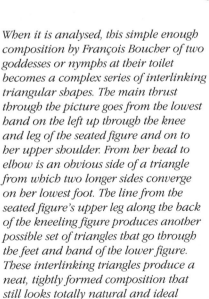

*When it is analysed, this simple enough composition by François Boucher of two goddesses or nymphs at their toilet becomes a complex series of interlinking triangular shapes. The main thrust through the picture goes from the lowest hand on the left up through the knee and leg of the seated figure and on to her upper shoulder. From her head to elbow is an obvious side of a triangle from which two longer sides converge on her lowest foot. The line from the seated figure's upper leg along the back of the kneeling figure produces another possible set of triangles that go through the feet and hand of the lower figure. These interlinking triangles produce a neat, tightly formed composition that still looks totally natural and ideal*

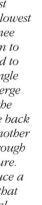

This scene is taken from Raphael's fresco in the Vatican of the School of Athens. *Here are two loosely related groups of figures set on a staircase that are part of a much bigger composition. In order to make a crowd scene work so that it is not just a random dotting of figures over the setting, Raphael carefully produces closer groups of figures within the large crowd. He helps them to adhere as a composition by using the direction of the individuals' sightlines. For example, note how the uplifted face of the youth in the centre of the group at the bottom right of the picture starts the flow of movement as denoted by the arrowed line.*

*Similarly, one figure by a gesture links one or two figures with another group – see how a double-handed gesture includes the slumped, reclining figure; sometimes figures face in towards each other to produce a centre to a composed set of figures. Raphael also uses the kneeling, sitting and reclining figures to set off the overall standing figures to stop them becoming too vertically dominant. Raphael was a master of this sort of composition, and it is worth studying just parts of large paintings by masters to spot these internal groupings within larger groups and discover how the whole dynamic of the composition works.*

## FIGURES IN INTERIORS AND EXTERIORS

When you are drawing figure compositions the scene has to be set in some location, either inside or outside, or your figures will be appear to be floating in limbo. Two of the most famous Dutch painters of the 16th century were Vermeer and de Hooch, both of whom excelled at interiors that depicted the orderly calm of the households occupied by the bourgeoisie. The main difference for the artist between interior and exterior scenes is that the former tend to have more directional light, often from just one window. Studying the work of Vermeer and de Hooch, two masters, will help you to consider ways to use light to explain your composition to the viewer. Even with very few objects to set the scene, the way the light falls on your figure will indicate whether it is set inside or outdoors.

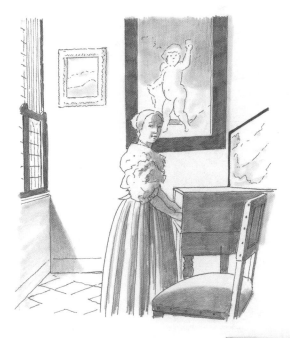

*Vermeer always placed his figures very carefully in a specific interior with light coming from a window and musical instruments or other appurtenances of the household included in the composition. He would place large pictures or maps on the wall to act as a foil to the human figure. The furniture was arranged to make the spatial element in the picture more evident.*

*De Hooch often included quite a large area of the inside of a house, particularly the family rooms. In this example, his interior spaces are very considered and help to create an aspect that goes through the room into the next and then out of the window to the outside world. The little dog sitting opposite the doorway draws the eye through to the larger space. The mother and daughter placed well over to one side sit in front of a cupboard in which the bed is set, making a dark, enclosed interior area. This juxtaposition of light open space and dark inner space gives the composition a lot of interest, apart from the presence of the figures.*

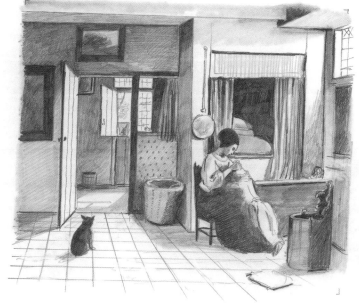

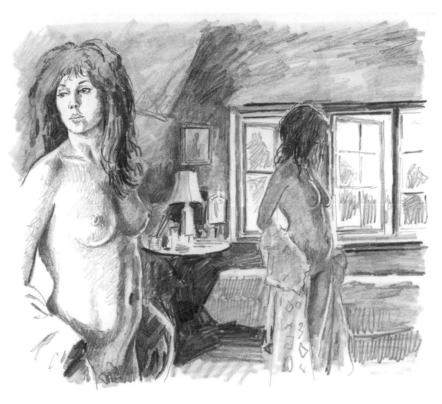

In the Peter Kuhfeld composition shown here, the nude girl in his studio faces towards the window, casting a reflection in a large mirror behind her that shows her opposite side and the window looking out across gardens. In effect we see two figures from different angles. This creates depth and added interest in the picture and we feel we only need to see a little more to one side to view the artist also mirrored in the scene.

In this outdoor scene by Peter Kuhfeld a girl is seated reading at a table in the garden. She is surrounded by flowers and foliage and there is just the indication of a window in the background. The table has been used for refreshments and perhaps once again the presence of the artist is hinted at in the utensils on the table. As with the nude girl in the studio, this is a very intimate scene but the enclosed space is now outside and we understand the open-air feel with the expanse of white tablecloth, iron chairs and abundant surrounding vegetation.

# Figures in Action

**O**nce you have begun to produce drawings that look like convincing pictures of human beings you will soon want to have a go at drawing figures in movement. This is more difficult, but artists are helped a lot these days by photographs which have caught the mobile figure and show us how the movement breaks down into its various parts, and by videos which can be freeze-framed. Nothing quite takes the place of quick sketches of people moving about, but obviously you need to have a good enough memory to get some sort of reference drawing onto paper immediately after you have seen a fleeting movement. You can then supplement this by

looking at photographs of people in similar motion.

It is also helpful to ask someone to model for you, slowly performing the action you want to study. This way you can draw the action at different stages, out of which you can pick a final image. Observation is the key to drawing movement and you have to keep watching people and noticing how their balance changes, how their arms move, how their weight shifts and how their head turns. All these elements give you clues to the movement and if you can capture them in a drawing the figures will look more mobile.

Part of the problem with drawing figures in motion is that to get the best pose of the figure, you have to choose a moment where the maximum dynamic of the movement is shown. This is sometimes best at an unexpected or difficult-to-pose point: for example, as the foot leaves the ground, as the figure is actually in mid-air, as the foot returns to the ground, or as the arms move at maximum extension. All these points can often show the quality of the movement more effectively than the most obvious image we have in our minds of how a particular action looks. It is also necessary to consider the sort of lines or marks you make in order to give the effect of the moving body. Sometimes a fluid, loose line works better, while at other times a sketchy, angular line will give a more effective description of what is happening.

There are many different ways of approaching the drawing of figures in motion, but the key to the whole exercise is observation, over and over again; once you begin to see clearly how movements progress the images tend to remain in your mind even after they have been completed so that you can draw them from memory. At this stage of your drawing you need to be flexible, take chances and not worry too much if the drawing goes wrong. Constant practice will gradually eliminate the obvious mistakes and help you to produce convincing drawings of moving figures.

WALKING AND RUNNING FIGURES

Photographs are a great boon to the artist wanting to discover just how the parts of the body relate to each other as the model moves, but they should be used with caution as copying from a photograph can produce sterile results. An artist should be looking not just to make an accurate drawing of lines and shapes but also to express the feeling of the occasion in a way that can be understood by the viewer: look particularly at the styles of depiction chosen here. Study photographs, but stamp your own mark as an artist on your drawings.

*The figures shown here are quite precisely based on photographs of people walking and running. A photograph gives you one particular moment in the action and because you can draw it with a precise line, given the benefit of a still image from which to copy, the final result tends to look slightly formalized. This produces a certain stiffness in the drawing which you can overcome by more direct experience.*

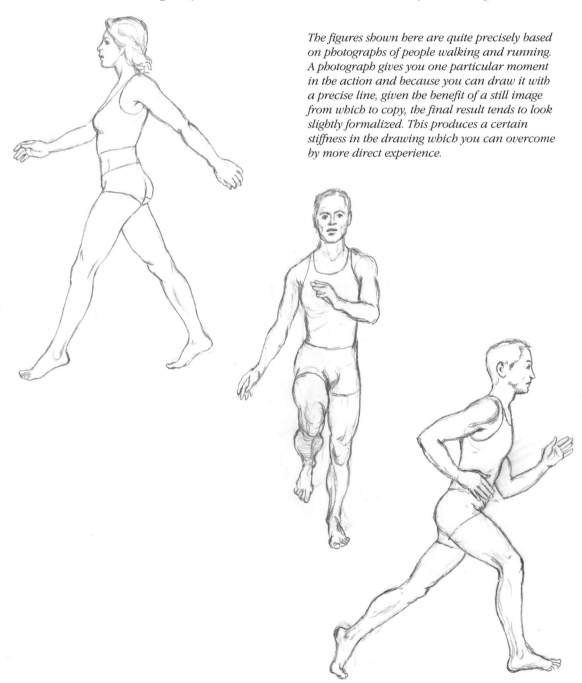

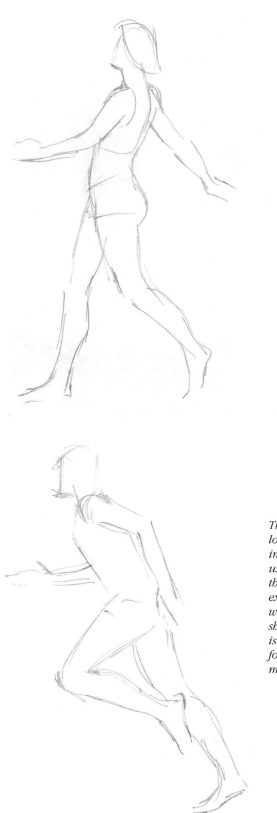

*The next three figures, drawn much more loosely without the aid of photographs, give an impression of the movement. The type of line used helps to produce an image which looks as though it is in motion; none of the lines are exact and in some cases there are several lines, which create a blurred effect. Notice how the shoulders and hips work in opposition; the torso is sometimes vertical but is quite often tilted forward or back at different parts of the movement*

DANCING FIGURES
The figures here show what happens when the body is projected off the ground with necessary vigour; in some cases informally and in others in more stylized poses.

*This drawing of a leaping man shows how the left leg is bent as much as possible while the right leg is extended. The torso is leaning forward, as is the head, and the arms are lifted above the shoulders to help increase his elevation.*

*The girl in a ballet leap shows how she has extended her legs as far as she can in both directions, pointing the toes, arching the back with the arms extended and the head back creating a typical dance pose in mid-air.*

The next two figures of a girl leaping in dance mode show extreme extension of the legs and arms in order to create a balanced figure in mid-air. Notice how the muscles, particularly in the thighs, are very evident because of the effort involved in the action.

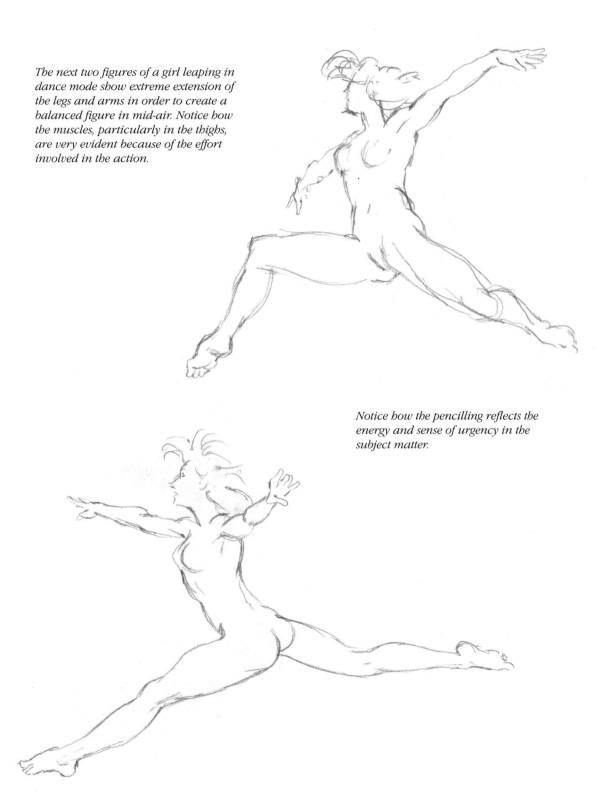

Notice how the pencilling reflects the energy and sense of urgency in the subject matter.

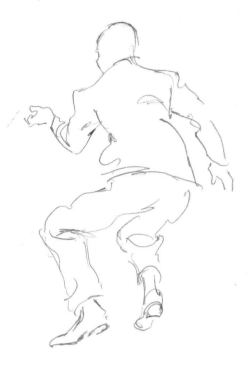

*The drawing of a male dancer leaping shows his suit wrinkled and thrown upwards as his body is projected into the air. He maintains a balanced position because as a dancer he keeps control of his movement so that he will always land on his feet.*

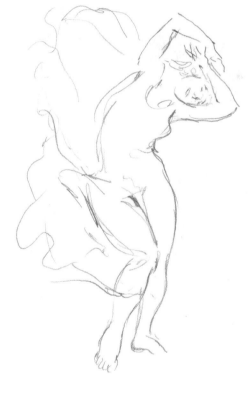

*The sinuous shape of this girl indicates a slower sort of dance, which is accented by the movement of the dress blowing up in the wind. Notice how the lines of the drawing follow the flow of the figure, with no attempt at an exact rendering of her form*

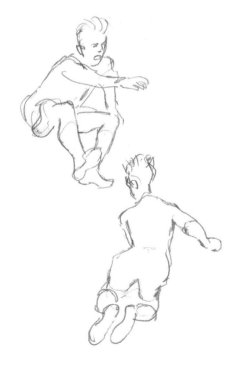

*The two men jumping in the air have pulled their knees up high and are using their arms to maintain their balance and produce a highly energetic leap. The figures are drawn with minimal lines so that although you can tell they are male figures the main point of the line is to show movement.*

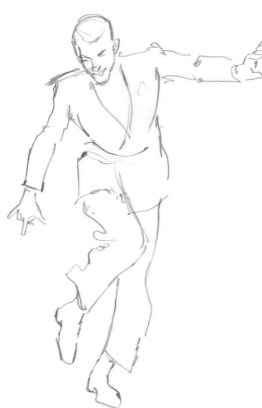

This figure is taken from a film of Fred Astaire dancing, engaged in vigorous, balanced and elegant movement. The body is turned, the feet are tapping and the arms are swinging. The turning of the body is balanced by the disposition of the legs and arms and head.

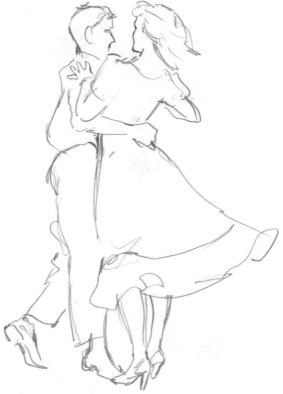

In a classic version of simple ballroom dancing, the girl leans back slightly, the man's arm round her waist. Her skirts and hair swing out while his stepping feet direct the movement of the dance. Again the drawing is kept minimal with just enough movement in the clothing to show its type, but with no details evident.

## SEATED AND RECLINING FIGURES

Sitting or reclining are hardly considered to be movements, and yet the dynamics of the figures do suggest a quality for potential activity as their poses suggest imminent movement

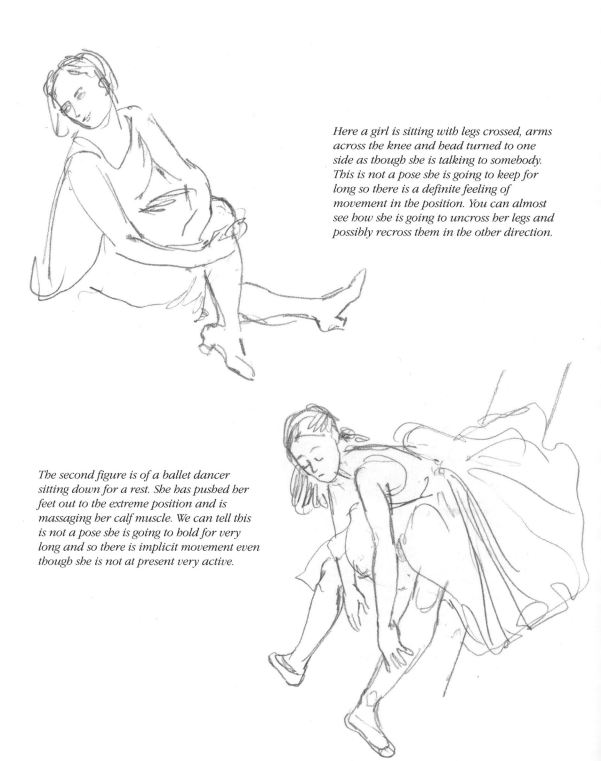

*Here a girl is sitting with legs crossed, arms across the knee and head turned to one side as though she is talking to somebody. This is not a pose she is going to keep for long so there is a definite feeling of movement in the position. You can almost see how she is going to uncross her legs and possibly recross them in the other direction.*

*The second figure is of a ballet dancer sitting down for a rest. She has pushed her feet out to the extreme position and is massaging her calf muscle. We can tell this is not a pose she is going to hold for very long and so there is implicit movement even though she is not at present very active.*

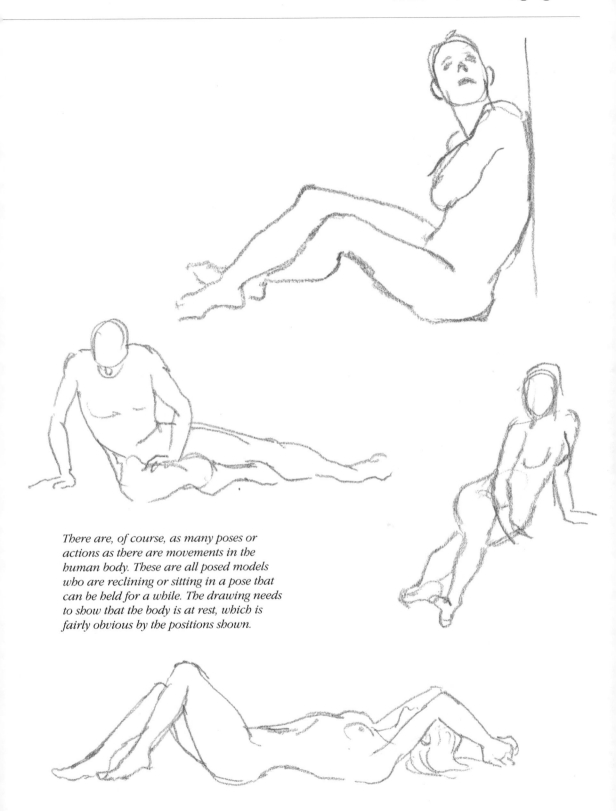

There are, of course, as many poses or
actions as there are movements in the
human body. These are all posed models
who are reclining or sitting in a pose that
can be held for a while. The drawing needs
to show that the body is at rest, which is
fairly obvious by the positions shown.

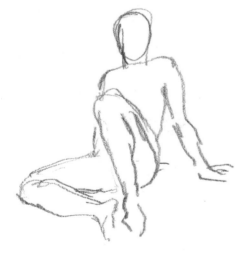

*These are slightly more tightly organized poses than those on the last two pages. This often gives a more sculptural quality to the arrangement and in a drawing produces a more contained effect. The poses also present some different challenges to the artist: foreshortening and form are two areas that will need more attention when drawing these models.*

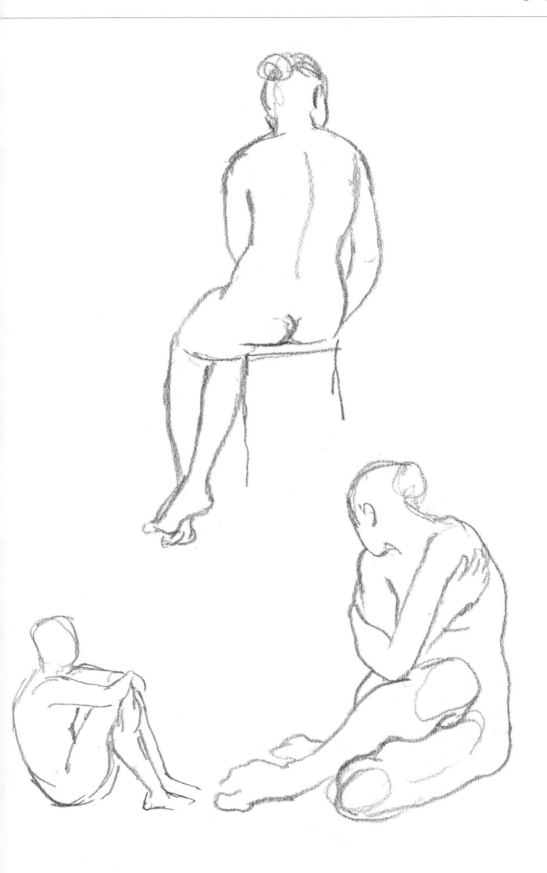

## BALANCE AND IMBALANCE

It is an interesting exercise to try to draw someone at the point where they have lost their balance and begun to fall over. It is not easy to do, because even if the occasion presents itself your reaction will probably be to try to help rather than take advantage of the situation. However, an accident such as this is often clearly imprinted on your memory for a short time, so you can sometimes remember enough to make a sketch shortly afterwards. Asking someone to adopt a falling pose is never quite the same, but it is worth trying.

Conversely, people engaged in an activity such as throwing a ball or climbing rocks and trees are usually in a state of perfect balance. Here the body is under tight control, with deliberate movements – note how careful pencilling reflects this control.

*The main thing about drawing the figure falling is to show that it is not in balance. There are obvious things to note, such as the alarm or surprise on the face, the attempt to save oneself with outstretched arms and other details. Here a man who has tripped over his own leg has thrust out his hands to save himself.*

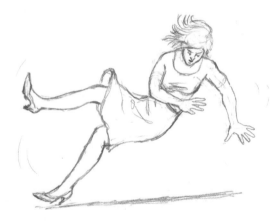

*A girl who has slipped over is trying to turn to protect herself from a bruising. Again, there is an instinctive attempt to cushion the fall with the arms, and her untidy hair and alarmed face reinforce the message that she has temporarily lost control of her body.*

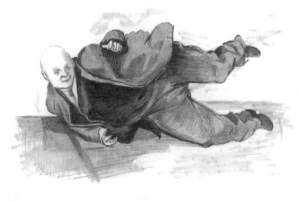

*The example is from a painting by Michael Andrews. The expression on the rather rotund businessman's face as he crashes to the ground, probably about to roll over; the ineffectual movement of the arms and hands which will obviously not save him from the bump; and the movement of the coat and trousers indicating the passage through the air of his descent all go to make this a remarkable piece of work. In the original there is in the background a woman with her hands to her face, shocked by the accident, which helps to increase the effect of the falling body.*

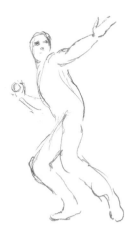

The action of throwing something is quite a dynamic subject for a drawing. In this figure throwing a ball the body is drawn back, with the free arm stretched to help with the aim. You can see that when the body is unleashed the ball will go far.

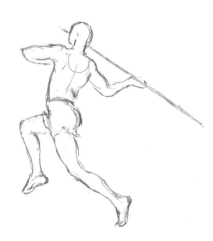

Here an athlete is in the run up for the casting of his javelin. His arm is back, his body is turned and his legs are poised for the final twist as the object is sent flying.

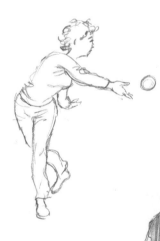

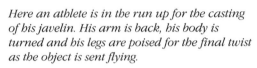

This young woman is throwing a ball underarm with a sudden twist of the body. The effort is more gentle than the previous two and suggests that she hopes the recipient, perhaps a child, will catch the ball.

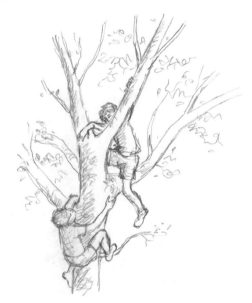

In an activity such as climbing, balance and grip are two very necessary parts of the success of the enterprise. Here a young person is scaling an almost vertical rock face or climbing wall in which his hands and feet are firmly placed. His body is hugging the rock and his head is up to see where the next handhold is. All the climber's attention is on not making any false moves.

With the two figures climbing a tree the emphasis is on effort and a certain sense of risk, where the youngsters seem to be taking chances. The lower boy is in a rather tricky position from which he might have to drop down or wait for the upper boy to help him. The upper boy is climbing up quite fast and looks agile and strong. The balance is there but less deliberate than with the rock climber.

## SPORTING FIGURES

In figures playing sports, the feeling is of controlled power and often fast action. The figures are acting with concentrated purpose and they are carrying out movements that have been rehearsed over and over again, so their balance and coordination are carefully tuned.

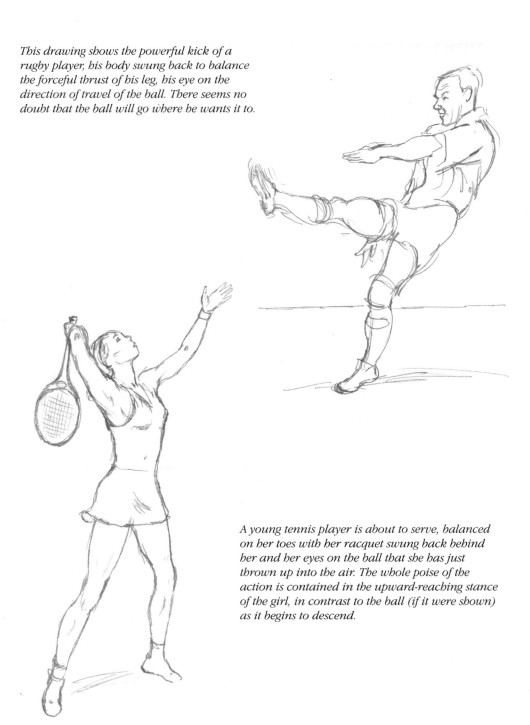

*This drawing shows the powerful kick of a rugby player, his body swung back to balance the forceful thrust of his leg, his eye on the direction of travel of the ball. There seems no doubt that the ball will go where he wants it to.*

*A young tennis player is about to serve, balanced on her toes with her racquet swung back behind her and her eyes on the ball that she has just thrown up into the air. The whole poise of the action is contained in the upward-reaching stance of the girl, in contrast to the ball (if it were shown) as it begins to descend.*

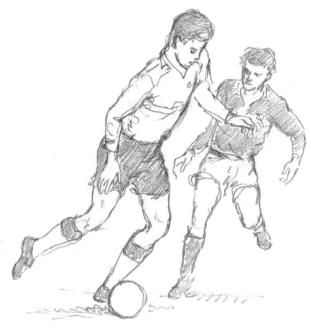

*The two footballers are balanced over the ball as one goes to pass it and the other comes in to tackle him. Both are in a position of dynamic energy that is concentrated around the position of the ball and the proposed next action of each figure. A decisive moment is about to happen.*

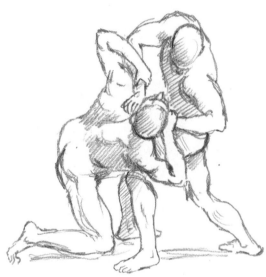

*Wrestling figures can be posed quite successfully and there are also numerous photographs of wrestlers available from which to sketch. Here we see the dominant figure concentrating his strength on imposing a stranglehold on the lower figure, who has been forced to one knee and is struggling to remove the grip of the upper man. The balance here is between the two figures, with one trying to force the other into submission.*

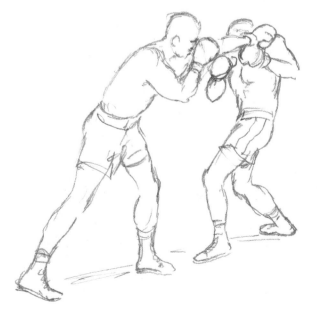

*With the two boxers the balance relates to both figures but each fighter is also in balance himself. The one striking the blow is extended but both feet are on the floor and his guard is up. The other has moved to the side with both hands up to defend himself from the incoming fist and be ready to strike back. His feet are also firmly on the floor and his body weaves in order to retain both balance and hitting power.*

SWIMMING AND DIVING

Swimming is a very difficult activity to draw because the water partially hides the body and distorts the shape of it beneath the surface of the water because of the surface movement and refraction of light. In the case of a diver you have about one second to catch the position and you might have to make many attempts before you catch the exact point that you wish to draw. Here again, visual memory is all-important. Of course you can take photographs, but you will get a better result if you observe and draw on the spot as well.

*This position probably lasts for about a second as the diver falls through the air. Therefore, you must train your visual memory, or use a camera to record the pose .*

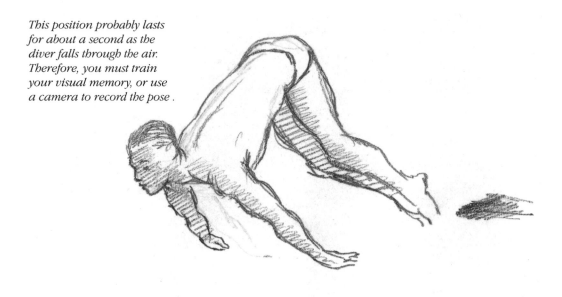

*The overarm swimmer is making so much splash on the surface of the pool that all that can be seen of his body is limited to the parts out of the water. Compare the effects to the calm rock pool and gentle swimming opposite.*

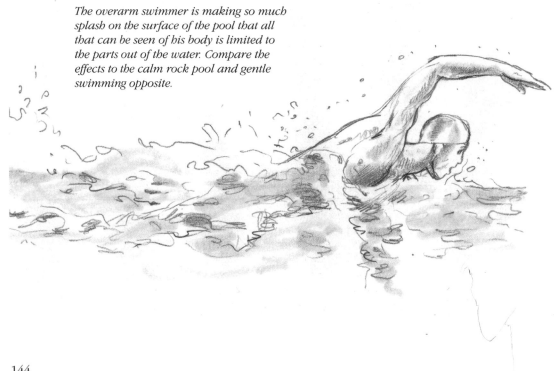

144

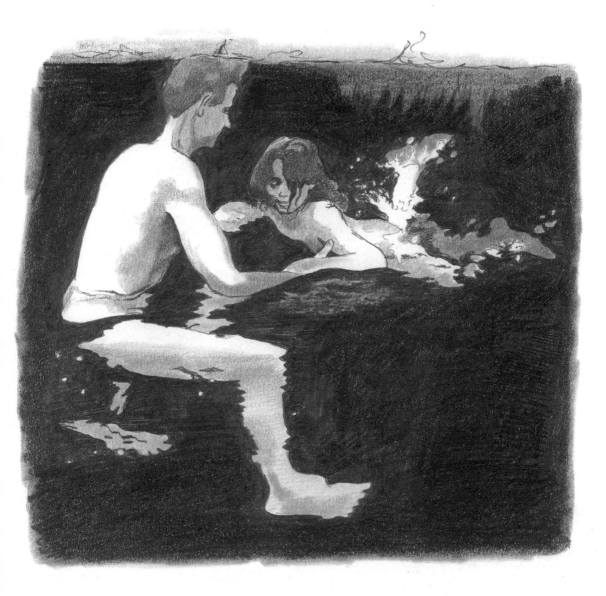

The artist Michael Andrews painted a picture of himself and his daughter in a rock pool, where he is helping her to learn to swim. Here he has obviously used photographic imagery to produce this rather attractive painting and he uses the refraction and rippling effect well in depicting the parts of the body below water. He has reduced the splashes to a minimum, making them show up sharply against the dark depths of the pool. The balance of the large, almost vertical figure and the small horizontal one helps to create an interesting compositional element.

## SOCIAL SETTINGS

Figures in social settings are much simpler to draw than those engaged in energetic sports. Their movements are slower and calmer they will stay in one spot for longer. Their gestures and body language will tend to be repeated again and again, giving you plenty of time to observe them and draw them accurately. Notice how they may change as people begin to relax in the company of someone they have only just met.

*These three figures engaged in conversation look relaxed and are fairly still. The animation tends to be in the hands and faces while the bodies take on poses of comfortable balance rather than energetic shapes.*

*A group around a table at a meal is even more static and here you will probably see only the upper half of the bodies with any clarity. Again all the animation will be in the faces and it is the glances and direction of the turning heads that help to create the dynamic. Lighting helps here and drama can be enhanced by candlelight, which tends to obscure details.*

Social settings outside tend to be more dynamic in terms of body movements and poses. Here, at a garden party, a group of young people are seen eating and talking. One leans aside to replenish his plate, while the girl with her back towards us gestures to the table. The man opposite her is partially obscured but one can get the effect of some rather direct expression from him. The other woman points to herself with hand on hip, all this against the background of foliage and roofs.

Street scenes are less easy to draw because people don't tend to linger much and it is difficult to find places where you can obtain a good view. However, the dynamics of this group of shoppers as they pass each other, commenting on their purchases, makes an interesting balance of figures across the pavement with other figures lightly indicated in the background.

# Figures in Detail

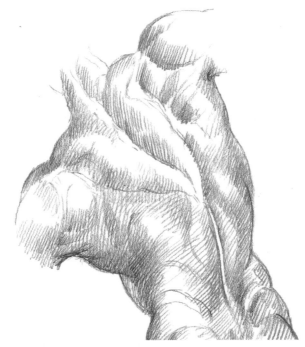

*E*arlier in the book I drew and annotated the skeleton and musculature of the body as a preliminary to drawing quite anonymous figures engaged in various activities. However, as you become more skilled you will want to characterize your figures and to do this you need to learn more about how the human figure is constructed and drawn, this time in finer detail

   The starting point is to take each part of the figure and look at it from many different angles. This book is not big enough to show every viewpoint, but what we can do is to look at the most

normal variations that arise over and over again when drawing the human figure. You will never finally draw every possible view of every different type of human figure because the variety is too great, but you should be able to get a very good vocabulary of figure details that will eventually make the difference between whether your drawing carries conviction or not.

You can even use yourself for a model, drawing parts of your body in front of a mirror. This is very useful when no other models are around although you need to be very objective about your own body.

Don't forget that although it is very useful to draw from photographs and other drawings you will learn more by drawing from life. This means that you need to use all your friends and family as models in some form. Probably only professional models will pose nude for you, but you can spend hours drawing the parts of body that are more readily seen. And if you take your sketchbook with you when you are at a swimming pool or on the beach, you will have plenty of nearly nude models around.

The overall understanding of the construction and shapes of the human body is very necessary to draw well, but eventually one has to fine-tune one's knowledge by observing every detail and learning how that detail can be drawn from all viewpoints. This practical experience is never wasted and can make all the difference to a drawn figure, which without it might lack conviction because of poor understanding of how to draw a hand, a foot or even an ear, for example.

By drawing the parts of the body repeatedly and extensively, you will begin to build up a clear and realistic picture of how the human form looks. Eventually it will be possible to draw a fairly accurate human being directly from your imagination, but it takes time to do that well and even after years of practice I find that I still need to regularly draw the human figure from a model in order to keep my technique fresh and convincing.

## THE HEAD

Although this book is concerned with figure drawing as a whole, the head is one of the most important components of the body and so deserves close attention. Study of its form and shape is necessary so that it will look natural on your drawings of figures. Here we look at it from all angles and get some idea of its dimensions and characteristics.

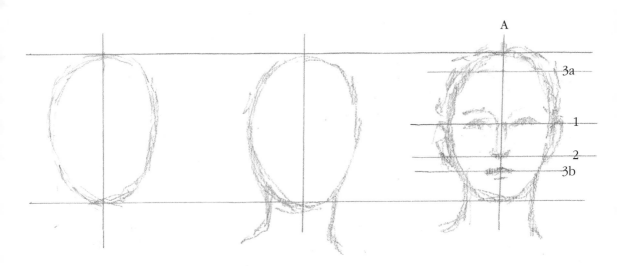

*Getting the basic proportions of the head right is the starting point, and these drawings show how the features are distributed. The eyes are placed halfway between the top of the head and the base of the chin (1); the end of the nose comes to about halfway down the lower half of the face (2), and the hairline and the mouth are roughly the same distance from the top edge and the bottom edge of the head (3 a and b). Draw a central line across which the features are balanced (A).*

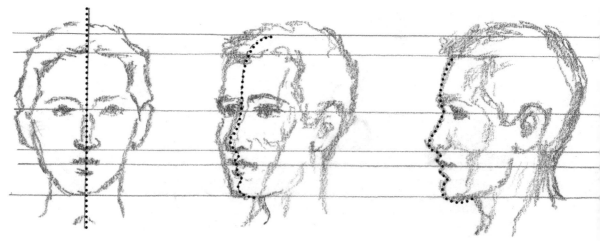

*Looking at these views of the head as it moves round from full-face to profile, notice how the central line (dotted) maintains its position relative to the eyes, nose, mouth and chin. The proportional positions of the features down the length of the head remain the same as long as the head is not tilted backwards or forwards. For comparison, see the page opposite.*

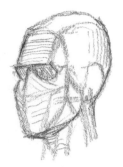
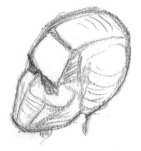
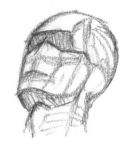

*This trio of heads shows how you can reduce the complexities of the shape into simple blocked-out shapes. Notice that the eyes are just planes across the sockets. The nose and mouth don't really appear, but*

*you have to make sure that the shape has the general prow-like look of the lower face. The forehead in contrast is broad and relatively flat, but be careful that you do not lose the roundness of the head.*

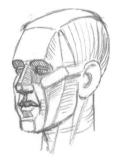
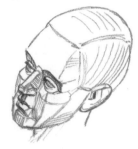
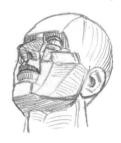

*These are more detailed renderings, but still in a blocked-out style. Each shape on the head can be simplified into a block form so that the simpler version of the head gives a very solid look.*

*If you retain some of the blocking-out but just soften the edges of the blocked shapes, the head will easily begin to resemble that of a real person without losing its solidity.*

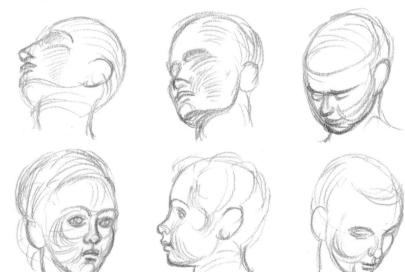

*These forms are more naturalistic and show the roundness of the head, making it seem more fleshy. It is still a highly simplified form of drawing, but it describes the features very well and looks quite realistic. The different viewpoints given of the head are useful to get a fuller idea of how it is formed.*

*Make a practice of drawing the parts of the figure from many angles in order to fix in your mind what it really looks like, then draw exactly what you see as accurately as you can, whether using formal techniques such as these or drawing more naturally. You will certainly begin to see your efforts pay off.*

151

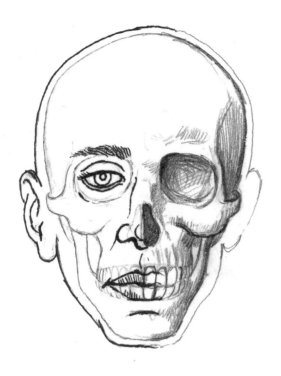

These diagramatic heads explain how the shape of the head is formed. The first shows the structure of the skull inside the fleshier shape of the head and how the eyeball sits in the socket of the skull, the nose cartilage forms its shape around the nasal cavity, the mouth and lips lie across the ridges of the teeth, and the ears sit just at the back of the zygomatic arch.

The diagram below shows how the various muscle groups are placed in the facial features. Listed here are all the expressions that are produced on the surface of the face when these muscles go into action. The groups of muscles in the cheek, which connect parts of the jaw and mouth with the upper skull, produce an enormous amount of movement on the face.

Frontalis: moves forehead and eyebrows

Corrugator: pulls eyebrows together

Orbicularis oculi: closes eye

Levator labii alaeque nasi: lifts lip and wrinkles nose

Levator labii: raises upper lip

Zygomaticus minor
Levator anguli oris: raises angle of mouth
Zygomaticus major: upward traction of mouth
Obicularis oris: closes mouth, purses lips
Risorius: lateral pulling on angle of mouth (as in grinning)

Depressor anguli oris: downward traction of angle of mouth
Depressor labii inferioris: downward pulling of lower lip

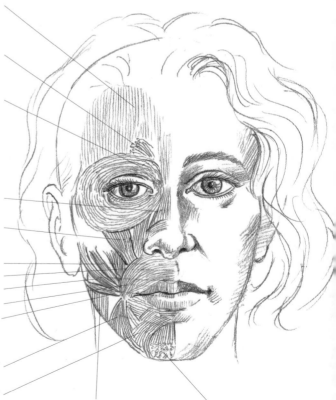

Masseter: upward traction of jaw

Mentalis: moves skin on chin

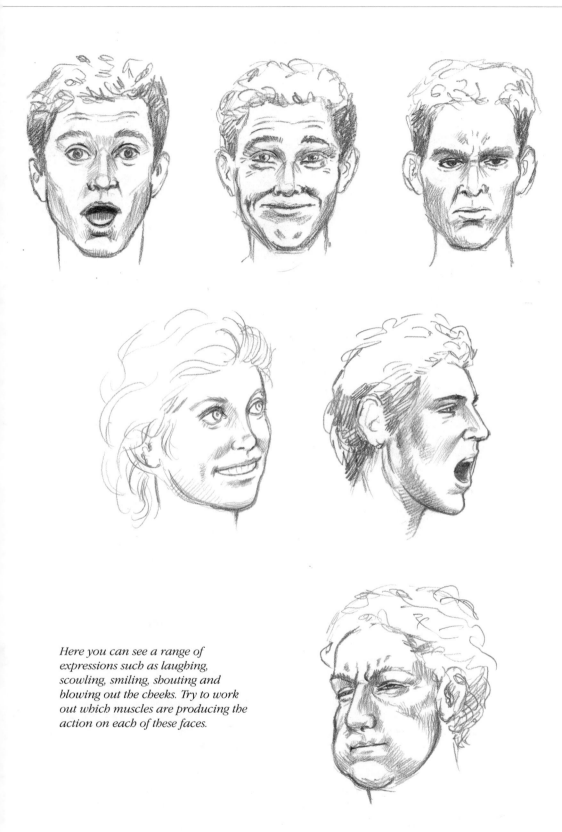

*Here you can see a range of expressions such as laughing, scowling, smiling, shouting and blowing out the cheeks. Try to work out which muscles are producing the action on each of these faces.*

THE TORSO
Next I look at the torso, the main trunk of the
body from which the head and limbs depend.

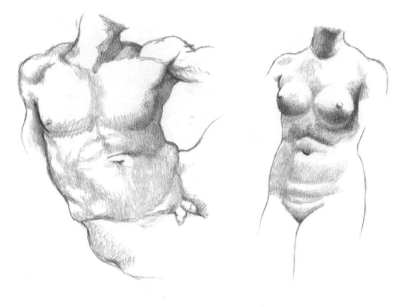

*Here I show two classical
interpretations of the
human physique at its
most beautiful and
powerful, produced by the
great Renaissance artist
Michelangelo showing the
torso of Adam, the first
man, and the body of the
goddess Venus in a roman
copy of a Greek original.*

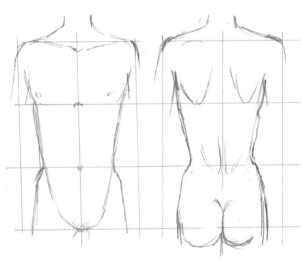

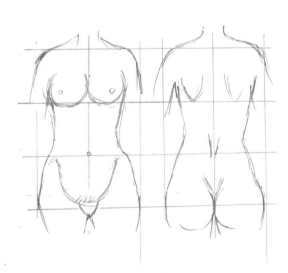

*These diagrams of the male and female torso show
their proportions. The central vertical line is
divided horizontally by four lines which denote,
from top to bottom, the top edge of the clavicles
(collar bones), the lower end of the sternum, the
level of the navel and the lower edge of the pubic
bone. Seen from the back, the same lines mark the
top of the clavicles, the lower edge of the shoulder
blades, the small of the back at the level of the*
*navel, and the base of the sacrum of the iliac. The
latter is hidden by the fleshy part of the buttocks.
The female proportions are the same, but generally
on a slightly smaller scale. The main difference is
the widest point, which on the man is invariably
the shoulders and on the woman may be the hips
instead. The divisions are all one head length
apart from each other, so there is a proportion of
about three head lengths to the torso.*

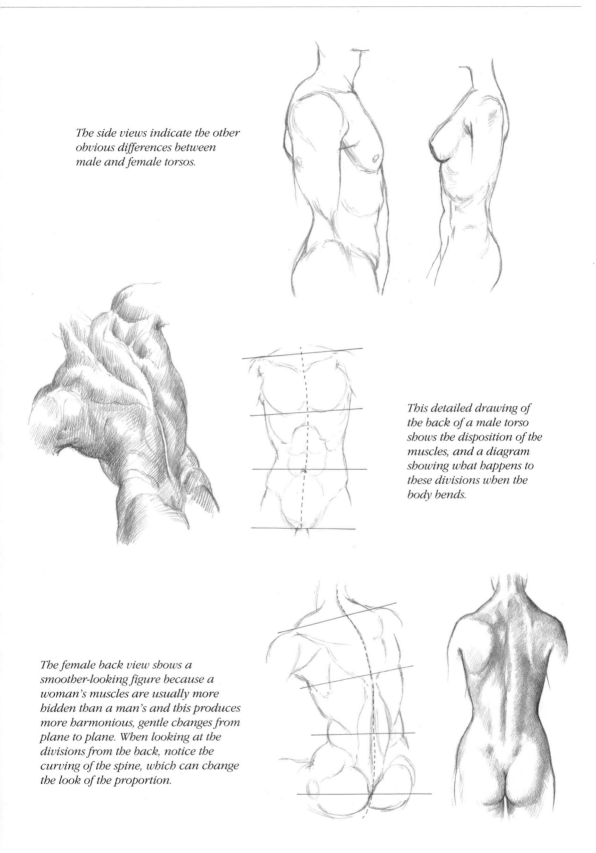

*The side views indicate the other obvious differences between male and female torsos.*

*This detailed drawing of the back of a male torso shows the disposition of the muscles, and a diagram showing what happens to these divisions when the body bends.*

*The female back view shows a smoother-looking figure because a woman's muscles are usually more hidden than a man's and this produces more harmonious, gentle changes from plane to plane. When looking at the divisions from the back, notice the curving of the spine, which can change the look of the proportion.*

THE ARMS

The upper limb is a very flexible part of the anatomy, and there will never be enough examples of the different views you will get of the arm. I have tried to show some of the most obvious and characteristic poses. The three main views are the whole length of the arm, the view from the hand towards the shoulder and the view from the shoulder towards the hand.

*Here is a selection of arms, both male and female, seen from different angles. Notice the relationship of the size of the hand with the length of forearm and upper arm. See how flexible the arm is as it moves up and down, bends and stretches. Some of the muscles show clearly, while others disappear. When the arm is pointing towards the viewer, the roundness of each part becomes much larger than the length. Because the arm can twist as well as bend it has a variety of shapes it can make in the air that are well worth studying closely.*

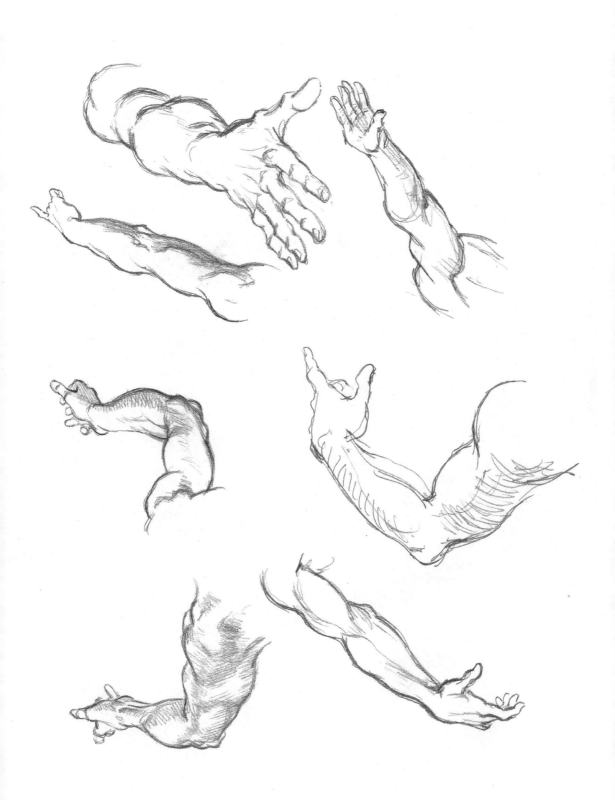

THE LEGS

The legs are not quite so flexible as the arms, but they are much more powerful, and so are much more powerfully built. The large muscles in the thigh and the strong, bony knee give the leg a similarity to the trunk of a small tree, so we understand connotations of strength and solidity. Remember that any part of the limb nearer to the torso is wider than the part further away, therefore calves are smaller than thighs and ankles are smaller than knees.

*Notice how the foot compares in proportion with the length of the leg. Also note how easy it is to see the muscles on the leg because it has to support the weight of the body: the muscles are that much more powerful than those in the arm and so are more defined in the leg.*

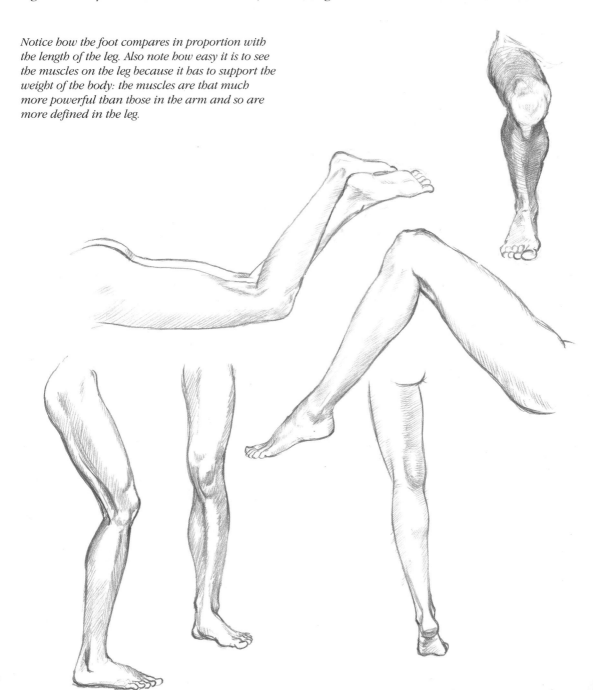

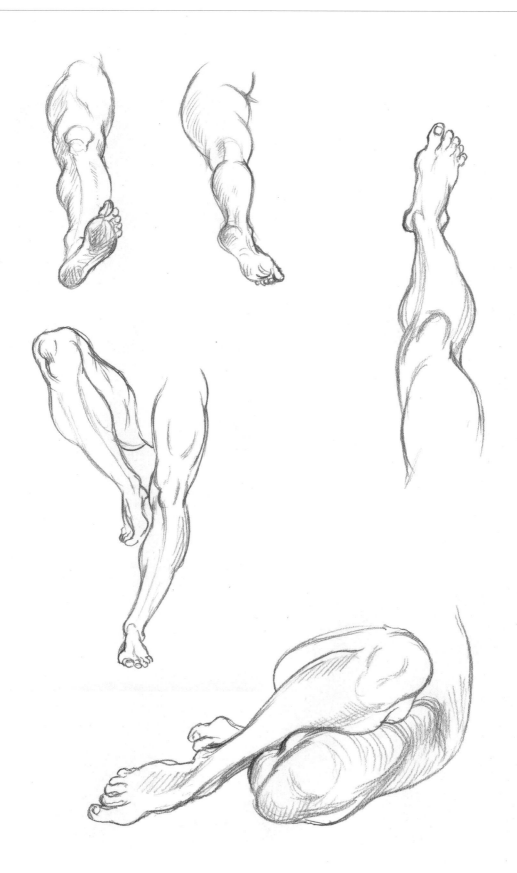

THE HANDS

In the next pages the hand is shown in various positions, but here it is in its most simple pose. To get a clear idea of the reality of the hand, it is a good idea to simply draw carefully round your own, or someone else's hand. Do this for both the left and right hand, both sides, and fill in the details such as nails, creases and knuckles. This sort of simple investigation and observation is very useful, as you will find you remember quite a bit of it.

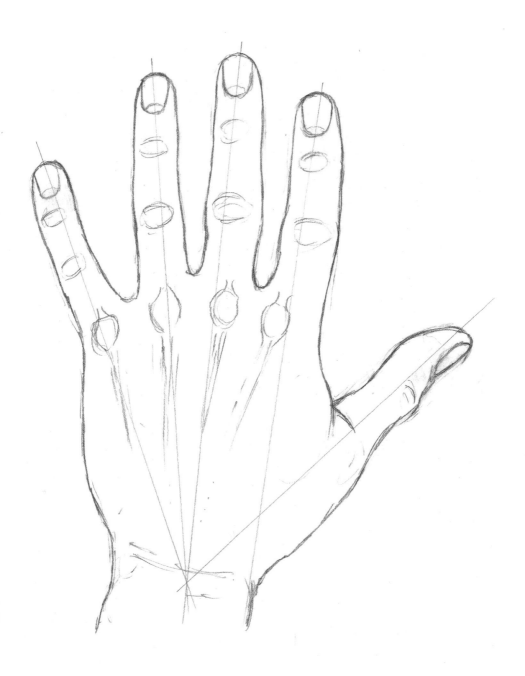

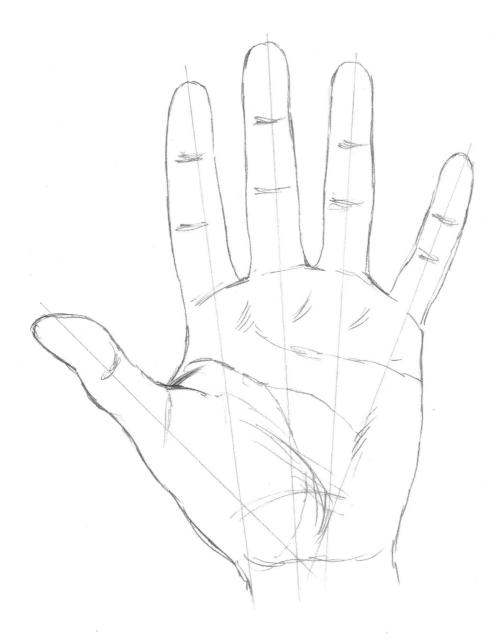

*In these two outline drawings of the hand from the front and back, notice the relationship of fingers to palm. Notice the fact that the fingers taper and the palm has fleshy pads on it, while the back of the hand has ridged tendons and knobbly knuckles. Some hands of course are longer and narrower, some thicker and broader.*

*These hands shown from many angles give some idea of the
complex movements of which the hand is capable. Note especially
the drawings of the hand in perspective, foreshortening the shape
– it is a good practice to try drawing your own hands in the front
of a mirror to see them extending away from you. Try side views
with and without the mirror. Notice the relationship of each
finger to the other and their relationships with the thumb. When
you are really confident about drawing hands try two hands with
fingers interlocked. Be careful you don't draw too many fingers!*

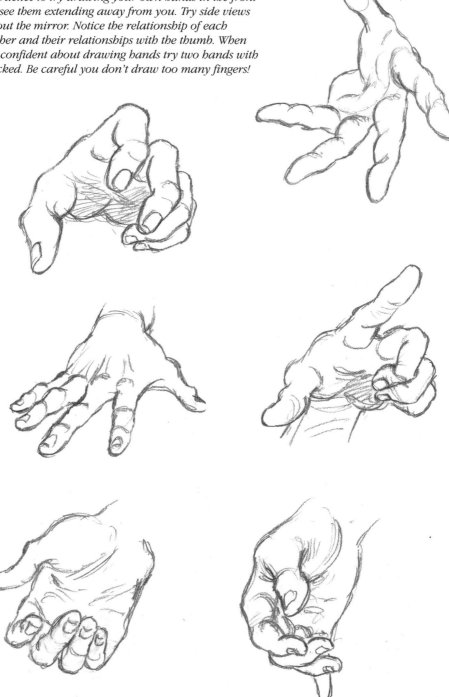

162

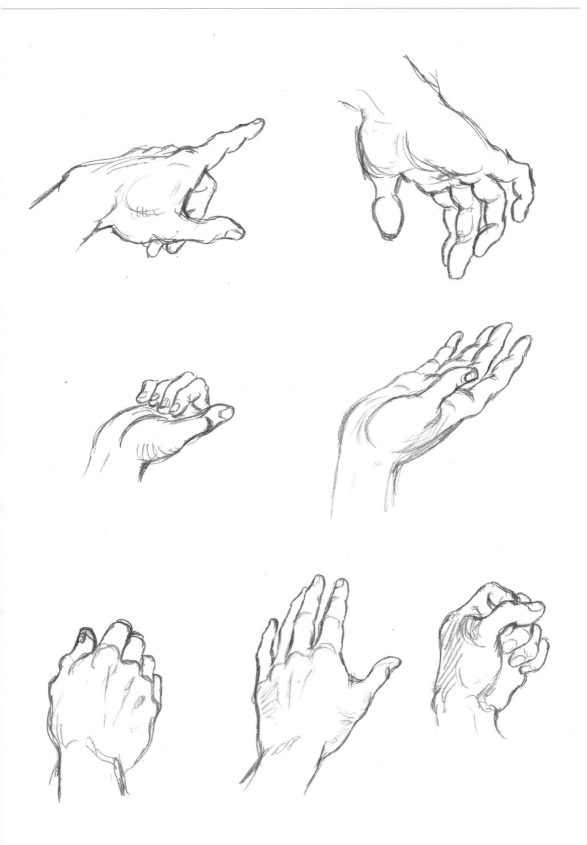

THE FEET

Feet are simpler than hands and don't have the same flexibility but are still quite difficult to draw well, especially when seen from the front or back.

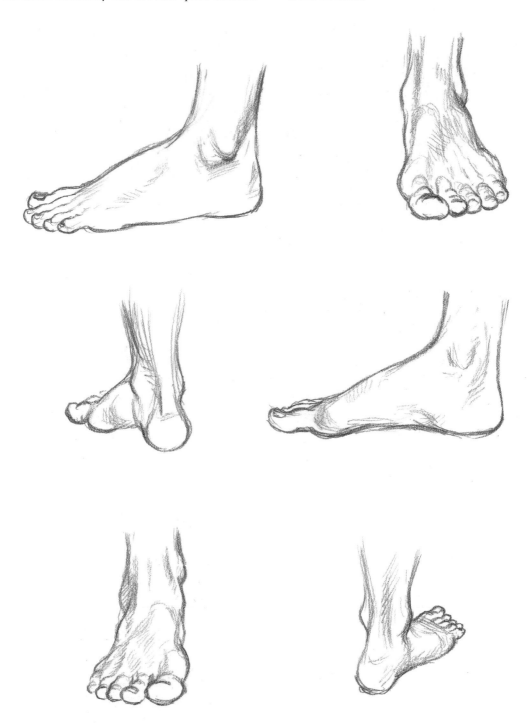

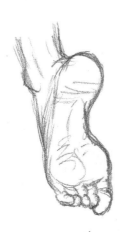

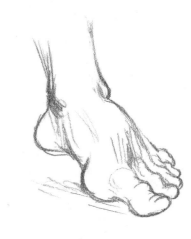

Notice the difference of the inner side of the foot to the outer side view. Notice which ankle bone is higher – is it the inner ankle or the outer ankle? The awkwardness of feet seen from the front has to be addressed because you cannot always draw people in profile; so have a good try at showing how the toes project forward from the solid part of the foot. Don't forget to look at the feet from below as well. When a model is not available, you can practice drawing your own reflected in a mirror.

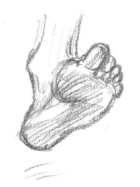

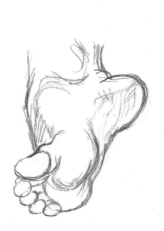

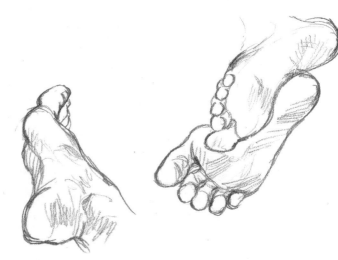

## THE EYES

The eye is basically a sphere, set into a socket in the skull and covered by the eyelids and muscles surrounding the socket. The parts that we see in the mirror or when talking to someone are just a small part of this sphere and are composed of the white part (sclera), the coloured part (iris), the central focal lens (cornea) and the flexible hole that lets in the light (pupil). If you remember it is an orb shape it is easier to draw correctly from observation.

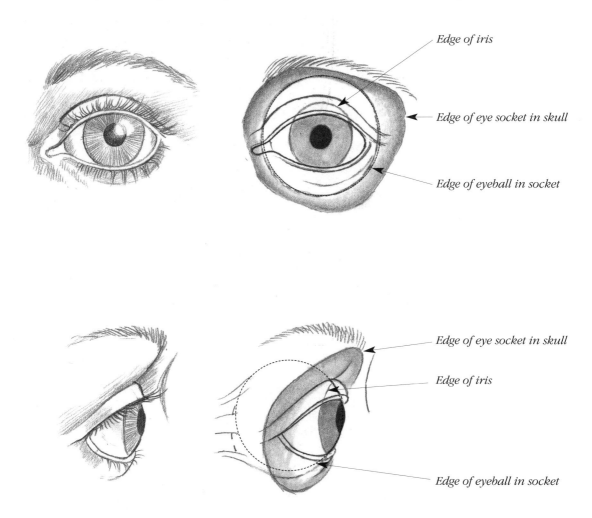

Edge of iris

Edge of eye socket in skull

Edge of eyeball in socket

Edge of eye socket in skull

Edge of iris

Edge of eyeball in socket

*Because the eyeball is set in the eye socket of the skull its rounded shape is only seen clearly in the bit of the eyeball shown when the lids are open. We do tend to forget that it is a segment of a ball we are looking at, but this is especially noticeable from the side view and if you don't draw that curve the eye looks unconvincing. Note that normally the upper lid covers a small section of the iris (the coloured part) of the eye and the lower rim of the iris appears to just touch the lower lid. As soon as the eyelids are stretched a bit, perhaps in alarm, this of course changes and the iris and even the white of the eye around it is exposed. Don't forget that the eyelids actually have a thickness where the base (the roots) of the eyelashes are found. The eyebrow shows the position of the bony upper edge of the eye socket.*

*Now look at the selection of eyes opposite, male and female, old, young, front view, side view, looking down and up. Detailed studies – or even just observation – like these are worth doing whenever you can.*

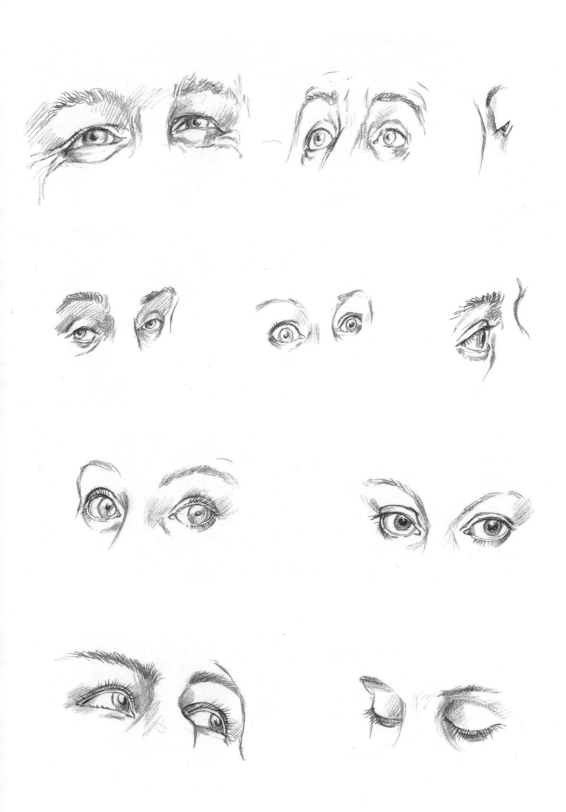

## THE MOUTH

Drawing the mouth does not impose many problems as long as you remember that the most significant and strongest line of the mouth is the part where the lips meet – not the outline of the lips, which is often incorrectly supposed to be more important.

A.

C.

B.

*The upper lips have three pads of thickness and the lower have two (diagram A). Diagram B, of the side view of the lips, shows how the shape alters when the mouth is open and shut. Under most lighting, the upper lip is in more shadow because its plane is angled downwards; there is shadow under the lower lip and the corners of the mouth often have a slight shadow due to the corner tucking in to the flesh of the cheek (diagram C). These are merely general rules and you will still have to observe carefully the individual shape of your model's mouth.*

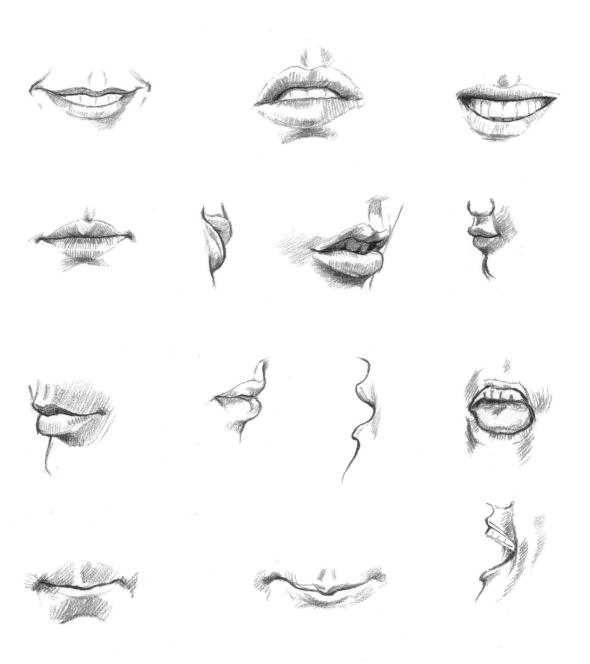

These illustrations show a range of mouths, open, closed, smiling and shouting, seen from above, below and the side. When the mouth is seen partly from one side the farther side will look much shorter and more curved than the side closest to you. In a smile the lips become stretched and so appear slightly thinner. When the mouth is closed it can be full and soft-looking or pressed together and thinner, depending partly on age and disposition. Very young children's mouths are extremely rounded and soft and usually fuller in shape.

## NOSES, EARS AND HAIR

The nose is the most prominent of the features on the head, and although not all that complex, needs some study to be able to draw it convincingly from any angle.

The ear is a more complex shape and because we rarely look at them takes quite a bit of study to get right.

Hair has infinite possibilities, but it is worth considering the basic styles or forms of it and then drawing it from direct observation.

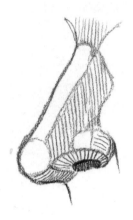

*Noses are much easier to draw in profile than from the front. As the head moves closer towards a facing position you will need to note the facets of the surface which show the solidity of the shape. These images give you an idea of how the average nose has a long, narrow frontal surface inclined upwards, a rounded end surface, side areas of varying shape and then the more complex surfaces around the nostrils. When the nose is facing towards you the nostrils, being holes, are the most dominant feature. Noses vary enormously from the most hawk-like and aquiline beaks to the softest retroussé snub noses. The tilt of the nostrils is often a defining shape.*

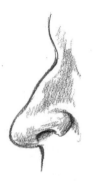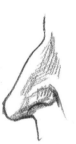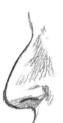

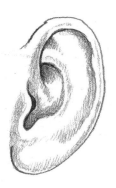

Ears are only difficult because we rarely look at them. The diagram here shows an ear of average shape and although there are many variations the basic structure remains the same. Some ears are much flatter against the side of the head and are not noticeable from the front; others stick out like jug handles and can be quite a strong feature on a head with short hair. Apart from their size and the amount they protrude, they are not an instantly recognizable feature in the human face.

When it comes to hair, the most obvious differences are in length and whether the hair is curly or straight. There tends to be less range in style among men, though the advent of thinning hair with age does tend to change the look of someone's face. Shown here are just four examples of how to tackle short, straight, curly and long hair.

BODY LANGUAGE

The human figure will usually bring some emotional context to a picture. This is mostly shown by the way the figure is depicted moving in the scene and quite often requires the juxtaposition of two figures – for example, a figure waving its fists in the air and confronting a cowering figure would obviously suggest some disagreement or aggression going on.

However, the moods indicated are usually more subtle than this and, particularly when there is only one figure present, the artist has to understand and master the conventions of body-language before the picture will tell the desired story. On these pages you will find some examples of the moods that different poses evoke.

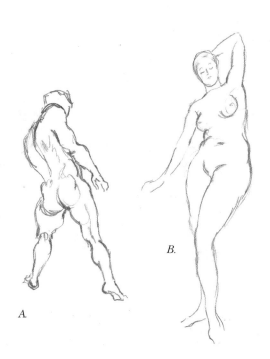

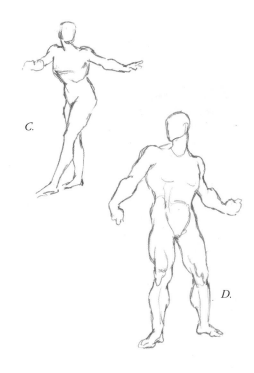

A. The pose of this masculine figure suggests some effort possibly related to pulling or pushing, shown by the braced legs, straight arm and twisted spine.

B. The female figure seems to stretch out in dreamy languor, emphasized by the sinuous quality of her arms and legs.

C. Another female figure, this time one who looks startled by something behind her, with a slightly theatrical gesture.

D. This male figure is obviously aggressive, with his pulled-back fist and fighting stance, reinforced by his heavily muscled form.

E. A female figure with arms aloft appears to be crowing with delight or jubilation, as though she has just won a prize.

F. Turning to look at something behind and at her feet, this figure shows her surprise in a rather dramatic gesture.

G. In a crouching position with head down, this man appears to be moving hastily away from something causing fear or a similar emotion.

H. The kneeling figure shows mental strain of some sort which, with his hand to his head, suggests the conventional pose for agonized thought.

I. This female figure seems to be protecting herself with a pose suggesting the foetal position.

J. A male character sitting back as though on the beach enjoying the sunshine evokes a feeling of simple relaxation.

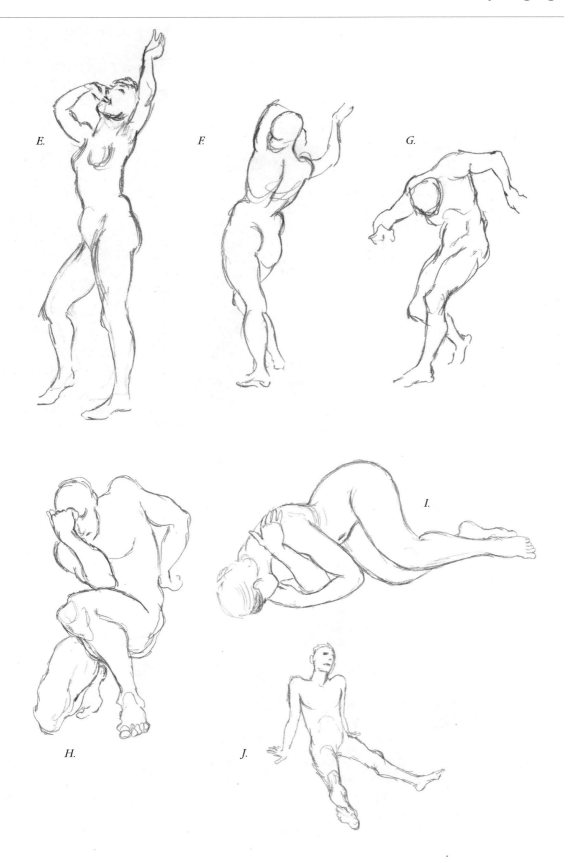

E.

F.

G.

I.

H.

J.

EMOTION IN COMPOSITION

When you draw figures in a scene, their position in the frame of the picture can influence the mood of the piece. Sometimes the pose of the figure may enhance this, but your choice as to where you place the figure in the space has dynamic connotations that will be understood by the viewer without the reinforcement of body language expressed by the individuals. Combining the two will express the mood you wish to portray even more forcefully.

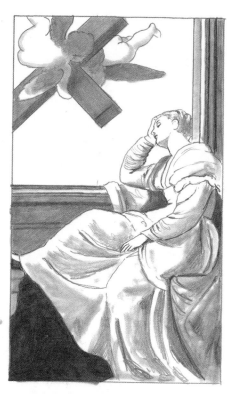

*Paolo Veronese's painting* Vision of St Helena *emphasizes the inner vision of the saint by placing her low in the picture, framing the window space through which we see part of her vision.*

*This picture of two figures looking at a sunset is taken from a painting by the German Romantic painter Casper David Friedrich. The two figures are standing on the dark land silhouetted against the bright sky and the way they are huddled close to each other in the space where nothing else interrupts the horizontal emphasis of the scene suggests some sort of lonely mood. Peaceful but separate.*

*In Delacroix's* Liberty Leading the People, *a revolutionary fervour is emphasized by the main character, Liberty, thrusting up across the top of the picture and moving from the dark masses on* the left of the picture to the clearer but devastated emptiness of the right-hand side. Her position seems to take everything forward towards the viewer and onwards past the right shoulder.

*Titian's great painting of Danaë being seduced by Jupiter transformed into shower of gold suggests the heroine's compliant role by extending her relaxed form along the lower part of the picture with the gold falling towards her from centre top. The position of her extended nude figure effortlessly stretched across the horizontal bedding gives the impression of erotic anticipation.*

175

# Styles of Figure Drawing

THIS SECTION OF THE BOOK SHOWS SOME examples how artists have drawn the human figure in their own style, using a range of media and methods. There is no real limit to the way that you can use different materials in drawing and once you look at other artists' work you will find that although many have employed the same tools and media they have produced widely varying styles of drawing, all successful.

So now I am encouraging you to experiment, and if your efforts don't amount to much at the beginning, try other ways of getting your effects. Style is not something that you need to

think about trying to make your own; it evolves through your practice and the way your vision interprets the world. At a stage when you are still learning you will sometimes find a certain way of drawing suits you best, using a particular drawing instrument you like the feel of. However, as you become more proficient you may find that other ways of using the same instrument produce much better results.

You should try as many different mediums as you can so that you learn to use them and don't feel awkward when drawing in different ways. Not only can you experiment in each medium by iteslf, but you can also mix your mediums so that, for instance, a drawing mainly in ink may have a few highlights in chalk, which will give an added effect to the picture. Trying out mixed media will help you to judge how far you can go. Don't be afraid of making mistakes as it is all experience to the good.

Each medium of drawing has it own limitations and these will to some extent guide your methods, but it is interesting to look at as many artists' work as you can to see how many different ways there are of using the various instruments and materials. It doesn't matter whether they are famous or not – some excellent artists are virtually unknown, but it doesn't mean you can't learn something from them in terms of style and method.

You may not yet be competent enough to exactly reproduce the examples of the artists' work shown in this section. However, copying something another artist has done is often the best way to increase your expertise and with continued practise you will become skilled enough to develop your own style of drawing and painting.

With each artist's work I have shown the material used and suggested how it might have been handled. There are many other media and tools available, so give everything a go until you feel you have discovered what best suits your temperament and developing style.

PENCIL AND LINE DRAWING IN INK
The techniques of drawing with different materials are shown on the following pages, which will give you some idea just how they are done. David Hockney is a major draughtsman of the modern art scene. The examples of his work illustrated on these pages show a quite straightforward way of drawing the human figure.

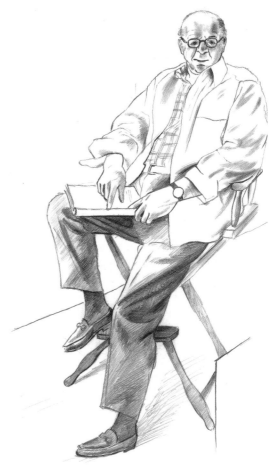

*This portrait of film director Billy Wilder (right) was drawn by Hockney in 1976. He is sitting in a director's chair, the script in his hands underlining his profession. The body is skewed slightly sideways with one leg on a support. The drawing is mostly just a pencil line with some carefully chosen areas of fine-toned hatching. The whole is a* tour de force *of almost classical pencil drawing.*

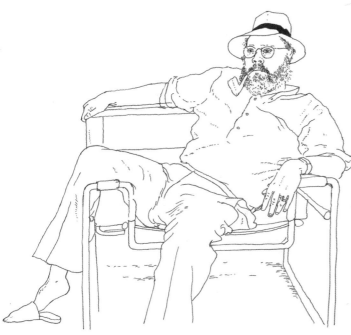

*Hockney's picture of Henry Geldzahler (left), drawn in Italy in 1973, shows his friend relaxing in a big tubular steel chair out in the garden, straw hat and all. Geldzahler liked posing for his portrait and so was always keen to arrange himself in an interesting attitude. The thin, even pen line has a precision about it, but is also quite sensitive to the quality of the material of the clothes and the hair. The slightly cautious, meandering quality of the line gives a feeling of care and attentiveness in the drawing. This style is simple but extremely effective.*

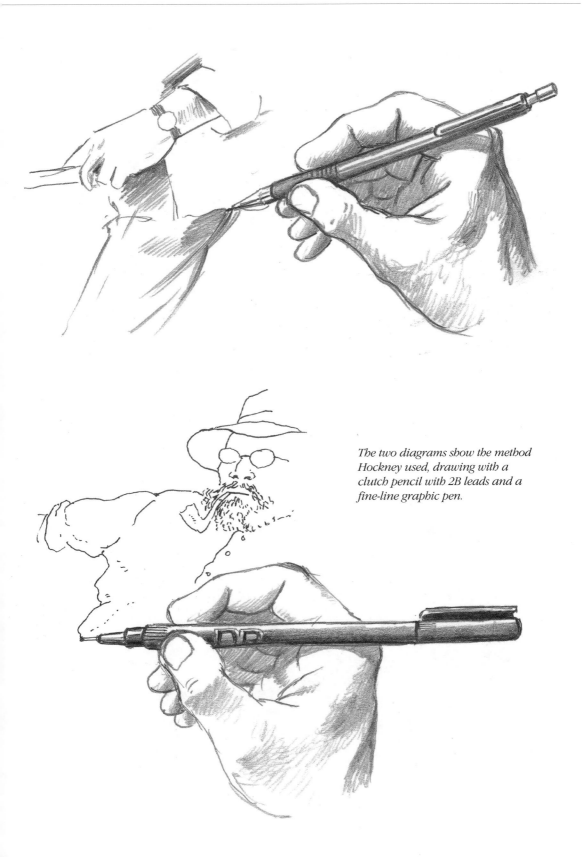

The two diagrams show the method
Hockney used, drawing with a
clutch pencil with 2B leads and a
fine-line graphic pen.

PEN AND WASH AND PASTEL

The use of different mediums are very much a question of choice by the artist working, but it is a good idea to try out the different mediums to give you an idea about which techniques you may want to use when confronted by decisions in drawing.

*Degas's pastel drawing of a ballet dancer practising point exercises is one of many he produced during the 1860s. His brilliant use of pastel gives great softness and roundness to the form and his masterly draughtsmanship ensures that not a mark is wasted. This is a very attractive medium for figure studies because of its speed and the ability to blend the tones easily.*

*This drawing made by the Italian master Guercino in 1616 was a sketch for a small devotional picture of the Annunciation with the Archangel Gabriel descending from heaven bearing a lily, symbol of Mary's purity. The line in ink which Guercino uses to trace out the figures is very attractive, because although it is sensitive it also has a confidence about it which shows his great ability. The drawing has areas of tone washed in with watered-down ink and the wet brush has also blurred some of the lines, as the ink is not waterproof. His handling of dark areas contrasting with light is brilliant, and shows why his drawings are so much sought after by collectors.*

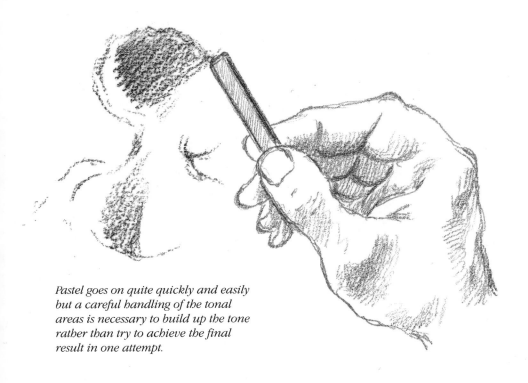

*Pastel goes on quite quickly and easily but a careful handling of the tonal areas is necessary to build up the tone rather than try to achieve the final result in one attempt.*

*This illustration shows the use of pen with wash, alternating the fine line of the pen with the floating on of tone which blurs some of the areas where roundness is needed.*

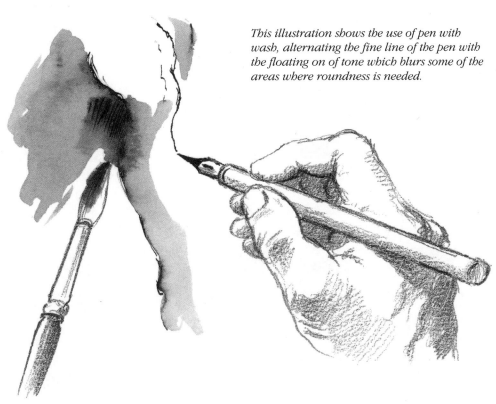

181

VARYING STYLES OF MASTER DRAUGHTSMEN
Here I look at a series of drawings in different mediums
by great artists showing how they used their chosen
medium to great effect.

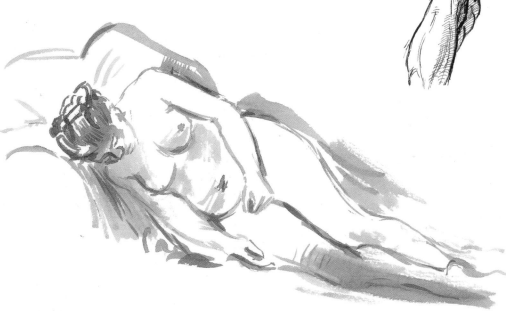

*In this drawing the great Renaissance artist Raphael
Sanzio used a very particular technique of the time
which was probably influenced by Michelangelo's
drawings. The use of ink in clearly defined lines,
some heavier than others, gives a very precise result
in which there is no doubt about the shape and bulk
of the figure. It is a good, albeit rather difficult,
method for a beginner that is worth practising and
persisting with.*

*This drawing of a reclining nude woman by Rembrandt
in 1658 shows how brilliant he was with the use of a
brush. The economy of the line and the handling of the
very light tonal areas give maximum effect with very
little drawing.*

*This beautiful line drawing of a crouching girl by the great French sculptor Aristide Maillol, drawn at the beginning of the 20th century, shows how the soft smoky texture of the chalk line gives a feeling of the roundness of the limbs and the soft quality of the flesh. A line drawing like this is quite difficult to achieve with any degree of quality because you need to get it more or less right first time. However, it is worth trying because of the discipline which it imposes on the artist not to make too many mistakes.*

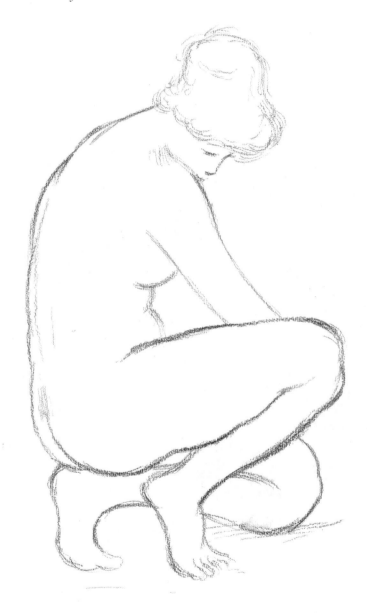

COMPOSITIONAL STYLE

These groups of figures are excellent examples of figure composition and will give you some ideas about ways of approaching your own solutions to creating completed pictures. Composition is very much part of the style and technique of an artist and some use very similar compositional methods in all their work. However, at this stage you should experiment and try out many different ways until you arrive at what you consider to be an effective method.

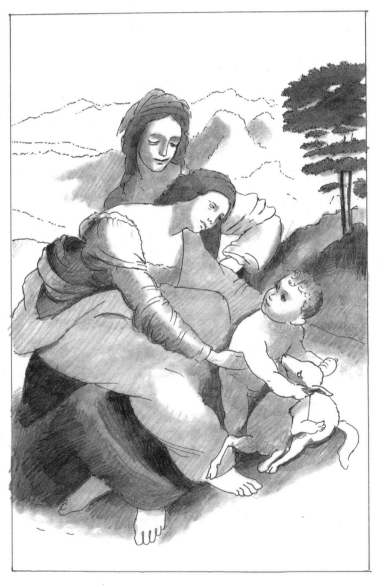

*The great Leonardo da Vinci pioneered several different approaches to figure composition which influenced all the artists of his generation and many years after. This strange composition of Mary sitting in the lap of her mother (St Anne) and leaning over to pick up the infant Jesus as he plays with a lamb creates a large triangular shape rather like the mountains in the background. The composition has great stability even though there is swooping movement curving across it and the two movements contrasting with each other create a very interesting design.*

*This composition by the American social-realist painter Raphael Soyer,* Reading from Left to Right, *painted in 1936, is heavily influenced by the qualities of photographs where shots taken in interiors or on the street often crowd the faces and figures of people together. Here the three workaday figures stand around, not engaged in any obvious activity apart from lighting a cigarette. The painting shows the plight of the unemployed men in the great economic depression of the 1930s when, with neither hope nor work, they would gather together for psychological support.*

## CONTRASTING COMPOSITIONS

Similarly, careful juxtaposition of figures, one to another, is a very effective way of producing a good composition. Picasso's obvious contrast between a reclining and a seated figure makes a powerful statement, whereas Seurat's carefully placed recling and seated figures on the bank of the Seine are extended into the water with the two half-figures.

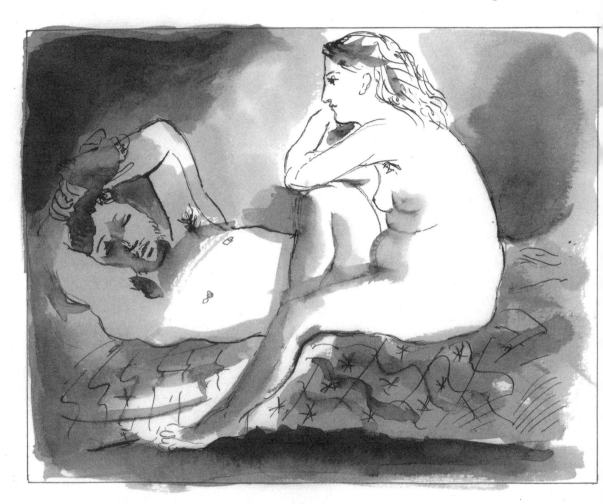

*The Picasso drawing of the girl sitting on the bed beside the sleeping man was one of a series he drew of the relationship between a man and woman whether as artist and model, satyr and nymph or just two lovers. This pen and wash drawing has all his panache and understanding of how to portray figures so that the relationship is obvious in one way, but has overshadowing ambiguity as well. Who are this couple? Are they Psyche and Cupid, or just a woman waiting for her lover to wake up? The point to notice is the interesting juxtaposition of his horizontal upper body obscured halfway down by her curved, thoughtful pose with one leg off the couch. Her pale rounded body set in the darkened room has a stately sort of naturalness about it. Her gaze and his sleeping countenance suggests some bond or tension between them.*

This last composition is probably one of the most carefully thought-out pieces of picture-making of any painting made after the Impressionists. It is Seurat's The Bathers, *painted in his customary fashion from many preliminary drawings and colour sketches of all the figures and parts of the background. He would carefully orchestrate each part of his picture in the studio, painting* systematically from his studies and placing each one so that the maximum feeling of balance and space was made evident in the finished picture. This is a brilliant piece of composition by any standards with its diagonal bank of the river, the horizon about two-thirds up, the still figures placed in the foreground and the expanse of water with trees either side holding the centre space.

# *Step-by-Step to a Final Composition*

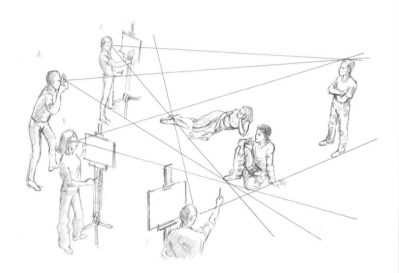

**T**HE FOLLOWING PAGES OFFER A PRACTICAL exercise in ways of producing an effective completed figure composition. There is no requirement that you should always go about picture-making in this way, but you will gain an understanding as to how it can be achieved with maximum input of all the skills you have learnt so far. This exercise will also give you an idea of the problems that you might encounter and how you can solve them to produce something that will be a fairly convincing complete pictorial composition.

The idea is to show a step-by-step lesson in making a figure

composition that will include all the necessary considerations that working with figures in a picture will entail. It is a logical process, but not meant to be the only way to go about it. If you have never drawn a group of figures composed into a picture then it will give you some direction with a clear process of how to proceed. If you are already familiar with drwing such pictures then you may have varying ways of going about it. So this is not the be-all and end-all of the process; just an organised approach to help make the process easier.

There are many parts of this exercise that you might want to dispense with but use at some other time. This system of practice is very versatile, and it can be adapted to your needs and how you wish to work. You don't even have to follow the order given. I have laid out the steps in a sequence I consider to be logical and consistent, but you may prefer to work in another way. Your own standard of ability will dictate your progress, so don't be afraid to juggle the steps around to suit your own capabilities. As your skills increase you will be able to take many short cuts, but only experience will help in this. What I have done is simply put down a process of approach to the subject which I hope will help you to produce a good result and have fun at the same time.

Composing pictures is always a balance between an intellectual appraisal of the task and its organisational problems, and an emotional-visceral response which makes you put down something unexpected but that looks 'right' when you have placed it in the composition. So your natural talent for drawing and seeing should not be ingored even if the more logical side of your mind doesn't always connect. This is chancey, but creative, and often results in a more powerful type of composition. So get going on your figure composition and with a little luck the procedure will produce an interesting result that you will be happy to show as your work.

FOLLOWING THE ARTISTIC PROCESS
Now we have come to the final hurdle – putting all the things that you have learnt into a complete figure composition. By starting from the very beginning and proceeding through to a carefully finished piece of drawing you should be able to produce a convincing scene with human figures in it, if not a great work of art.

Remember that you have to walk before you can run and so even if the final result is not inspired it should be effective enough to show how to construct the final presentation of figures in a scene that is within your capabilities and interesting enough to carry some conviction.

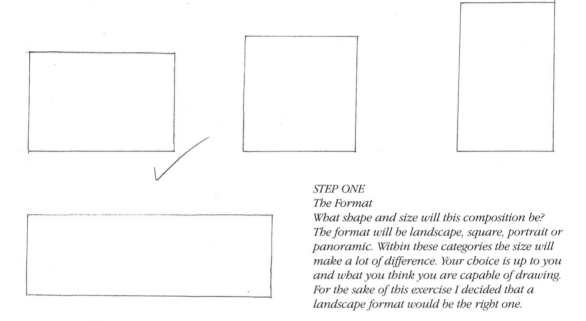

*STEP ONE*
*The Format*
*What shape and size will this composition be? The format will be landscape, square, portrait or panoramic. Within these categories the size will make a lot of difference. Your choice is up to you and what you think you are capable of drawing. For the sake of this exercise I decided that a landscape format would be the right one.*

*STEP TWO*
*The Number of Figures*
*There should be at least two figures to make a composition, but it could be three, four, five or even more. For the sake of simplicity and precision I elected to have three figures in the composition. Added to this the choice had to be made as to whether they would be male, female or both. My initial decision was to have one female and two males, though in this I was open to change along the way.*

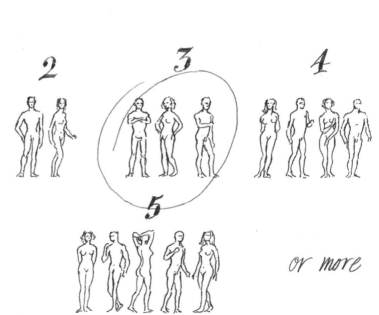

A.

B.

C.

D.

STEP THREE
*What Space Will the Figures Occupy?*
*Will the composition have a large upper space and the figures in the lower area sweeping up to the right side towards the top (see A). Or will there be a more central shape like a hill with small spaces either side in the upper half (see B)? A sort of valley*

*shape with a large central space and figures at the lower edge and up either side might work well (see C). Or why not have a complete sweep of figures across the whole scene covering most of the space (see D)? Because there are only three figures I opted for something that is weighted to one lower side sweeping up to the other higher side.*

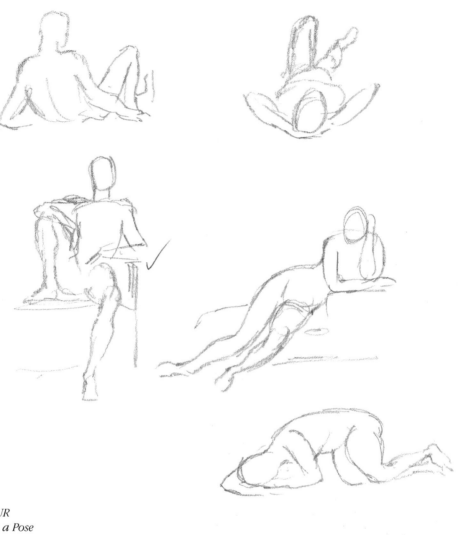

## STEP FOUR
### Choosing a Pose

*In order to reach a decision on what sort of poses to look for, it is a good thing to have some sort of theme. For an easy one that would enable the figures to be in a variety of positions and have an open-air background, I chose the theme of figures in a park in summer, sitting down or lounging around while others walk by. The next step was to start to sketch people sitting, lying down, standing or walking as though they were in a park on a summer's day. It is relatively easy to get people to adopt such poses, and you can probably persuade your family or friends to be your models.*

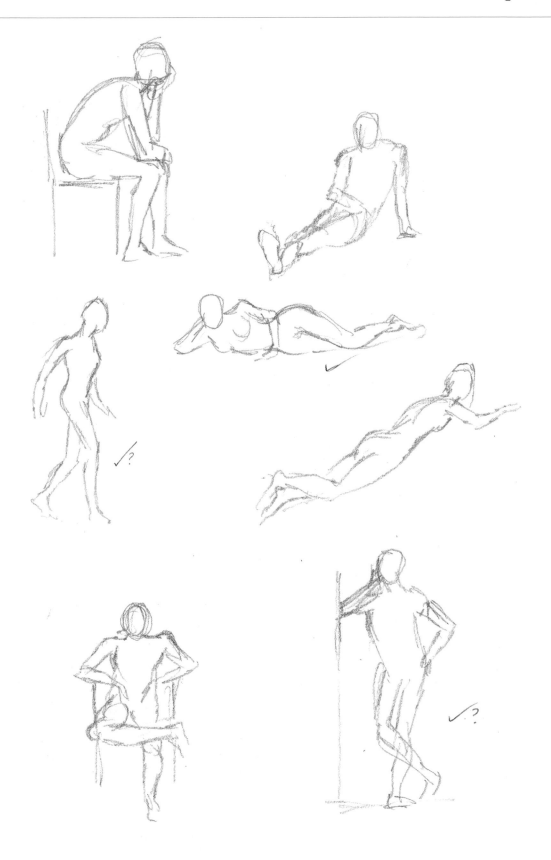

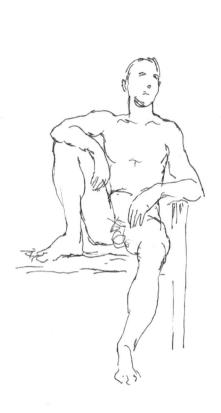

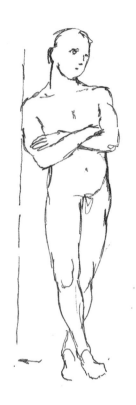

*STEP FIVE*

*Choosing the Main Poses*

*Having investigated a range of poses, the next thing to do is to draw up rather more considered sketches of the poses that you think will work together and then try them out in a series of frames of the same size and format. You will then begin to get an idea of how the composition might be most successful.*

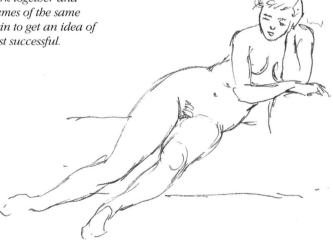

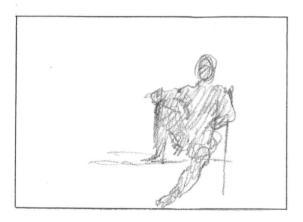

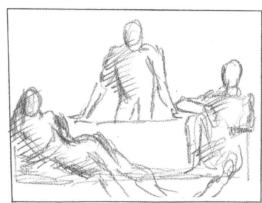

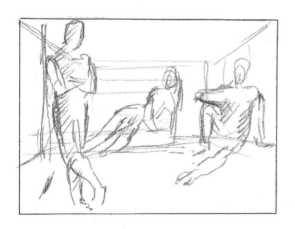

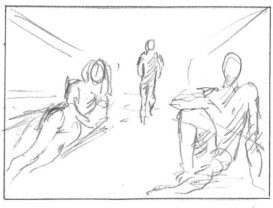

## ARRANGEMENT

This page gives an idea about arranging your models. The page opposite shows how the arrangement would look from the different angles A, B/C and D.

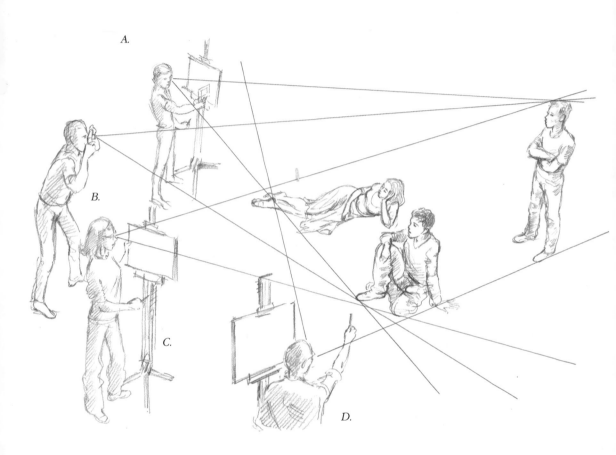

*STEP SIX*

*Viewing Different Angles*

*Now is the time to try to get your three models together to sketch them in some sort of relationship with each other, with space and depth around them. It doesn't matter about the scenery yet but you need to know how the figures will look together in reality. Either get them to pose while you do a quick sketch, or take a*

*photograph (B) to give you an idea of how the composition might work. Even now it doesn't have to be set in stone and if necessary you can still change them around, but a good drawing of how the figures relate is now essential. You might use a card framing device (A), or do it by eye (C) or measure it by judging with your pencil (D).*

A.

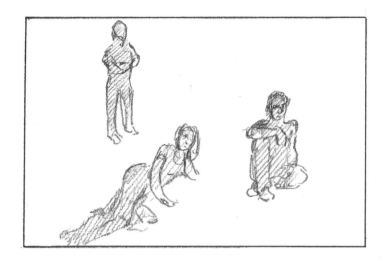

B/C.

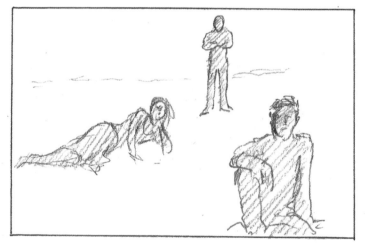

D.

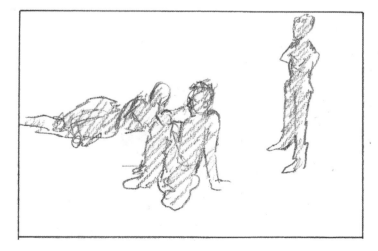

*STEP SEVEN*
*Exploring the Setting*
*Relaxing in the park in summer is the theme, so you will need to make some drawings of background scenes in your nearest parkland or gardens. With your drawings of the three characters to work on, place them in the scene in as many ways as you think fit to get the best effect you require. When you have considered some options, make a choice. All these stages are about making decisions that gradually limit your picture to a pattern that you find aesthetically satisfying.*

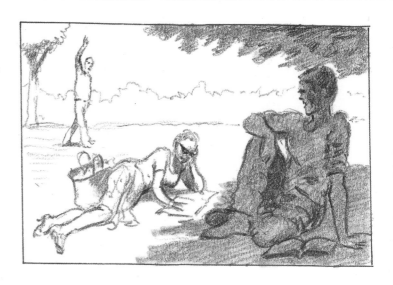

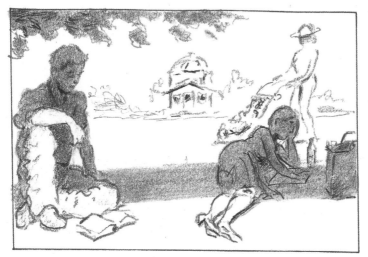

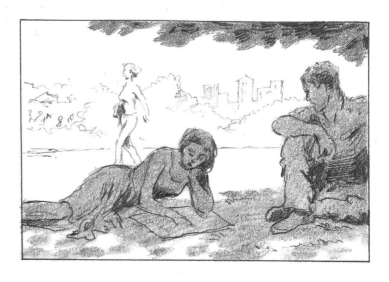

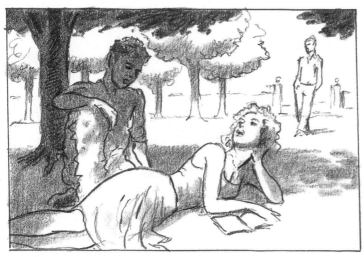

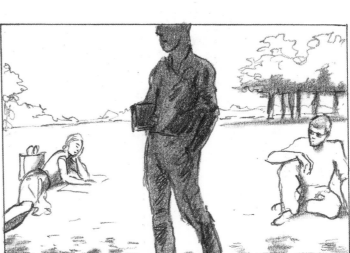

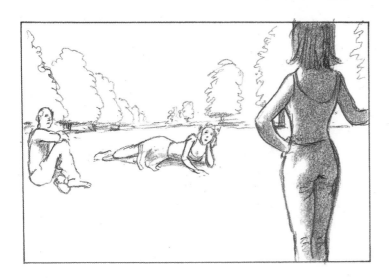

*In all these scenes the dynamics are different although the scene is similar. Each could work and my choice is just that I liked the contrast between the girl lit up in the foreground and the man sitting in the shade behind.*

*STEP EIGHT*
*Detailed Figure Drawings*
*Having chosen your composition you will now have to do detailed drawings of your three figures. This time you can take them one at a time and make a more careful drawing that will have all the information you want in it. This means that now you have to notch up the level of your drawing to something more developed and finished. Take your time at this stage; it is worth getting these drawings absolutely right. It doesn't matter if it takes several days or even weeks to complete them, it will be worth it in the long run and the end result will be all the better for it.*

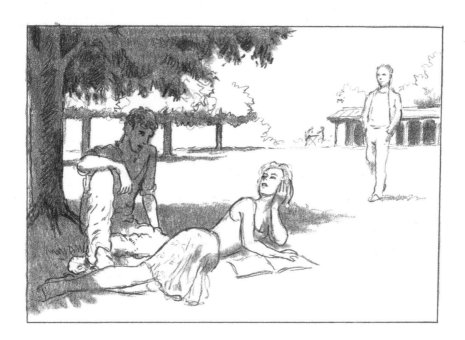

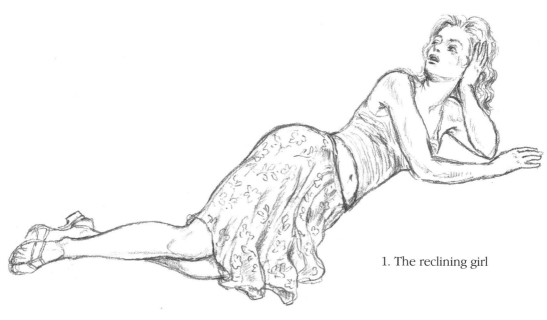

1. The reclining girl

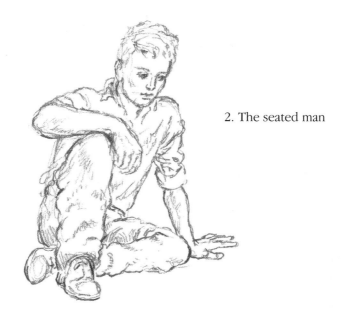

2. The seated man

3. The strolling man

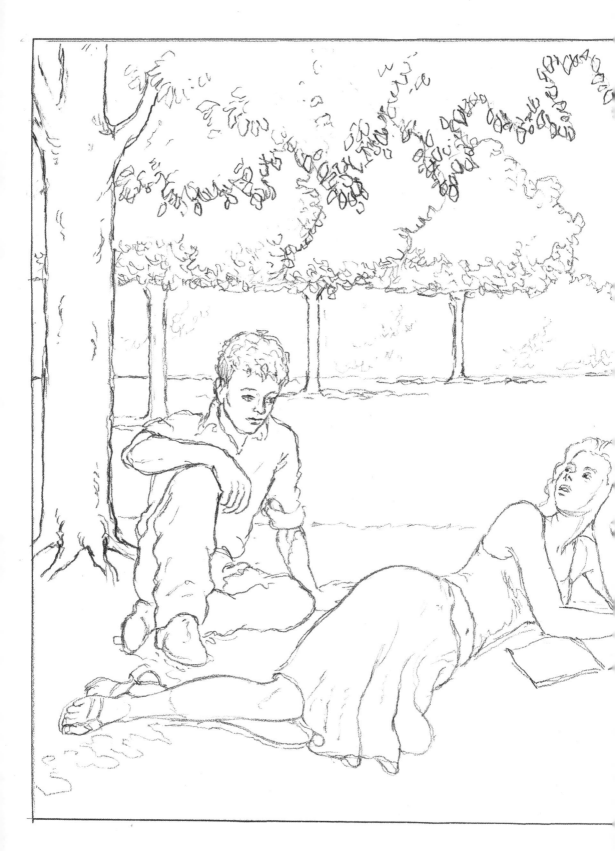

*STEP NINE*
*Putting it All Together*
Now you have three excellent drawings of your characters, you have to fit them convincingly into your scene. You may have to reduce or increase their size as you set the relationship of the three figures for the final piece. Draw them up very carefully, tracing them off in line, and placing them in an outlined drawing of the setting. This is your 'cartoon' in which everything is going to be drawn as the final picture requires. It has to be the same size as the finished drawing and everything should be in it except for tone and texture. At this stage what is required is a full-size complete line drawing in pencil of your composition.

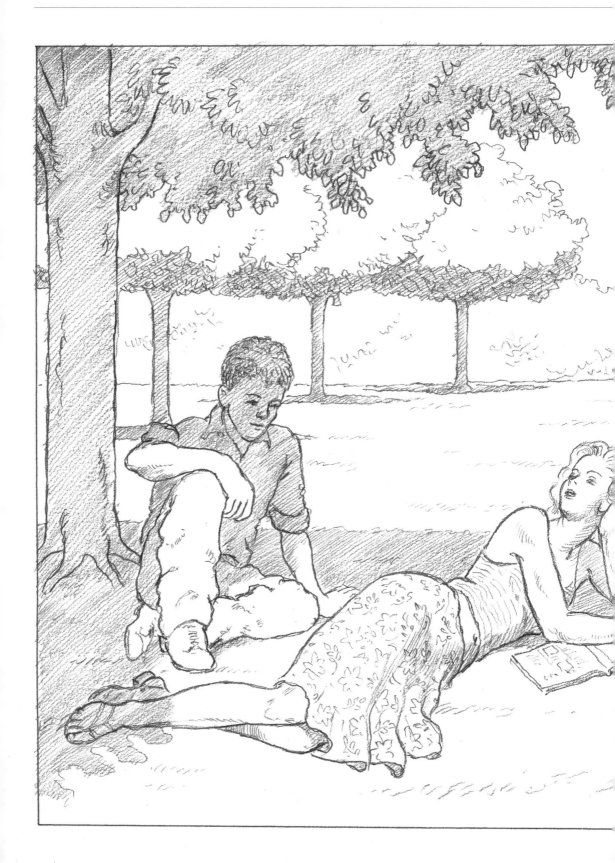